STUART DAVIS

STUART DAVIS

Edited by
Philip Rylands

Essays by
Rudi H. Fuchs, Lewis C. Kachur, Diane Kelder,
Frederica Pirani, Wayne L. Roosa, Ben Sidran, and Karen Wilkin

A BULFINCH PRESS BOOK
LITTLE, BROWN AND COMPANY
BOSTON NEW YORK TORONTO LONDON

Cover
Stuart Davis, *Pad No.4*, 1947
(cat. no. 39)
The Brooklyn Museum of Art,
New York. Bequest of Edith
and Milton Lowenthal

© 1997 by SIAE

© 1997 by The Trustees of the Solomon
R. Guggenheim Foundation

© 1997 by Electa, Milan
Elemond Editori Associati

First North American Edition

ISBN 0-8212-2517-0

Library of Congress Catalog Card Number:
Available upon request.

Bulfinch Press is an imprint and trademark of
Little, Brown and Company (Inc.)
Published simultaneously in Canada by
Little, Brown & Company (Canada) Limited

PRINTED IN ITALY

The present publication
has been published in conjunction
with the exhibition

Stuart Davis

Peggy Guggenheim Collection, Venice,
June 7–October 5, 1997

Palazzo delle Esposizioni, Rome,
October 22, 1997–January 12, 1998

Stedelijk Museum, Amsterdam,
February 1–April 19, 1998

National Museum of American Art,
Washington, D.C.,
May 22–September 7, 1998

Catalogue edited by
Philip Rylands

Federica Pirani, "An American
in Venice: Stuart Davis
at the XXVIth Biennale,"
translated by John Young

The Authors

Rudi H. Fuchs is Director
of the Stedelijk Museum, Amsterdam

Lewis Kachur is Assistant Professor
of Art History at Kean College,
Union, New Jersey

Diane Kelder is Professor
of Art History at the City University
of New York, Graduate School

Federica Pirani is a curator at
the Palazzo delle Esposizioni,
Sovraintendenza ai Beni Culturali
del Comune di Roma

Wayne L. Roosa teaches Art History
at Bethel College, St. Paul, Minnesota

Ben Sidran is a jazz musician, critic
and historian living in Madison,
Wisconsin

Karen Wilkin teaches at the University
of Toronto in Canada and at the
New York Studio School

Lenders to the Exhibition

Addison Gallery of American Art, Phillips Academy, Andover, Massachusetts
The Art Institute of Chicago, Chicago, Illinois
The Baltimore Museum of Art, Baltimore, Maryland
The Brooklyn Museum, Brooklyn, New York
The Chrysler Museum of Art, Norfolk, Virginia
The Cleveland Museum of Art, Cleveland, Ohio
The Crispo Collection
Curtis Galleries, Minneapolis, Minnesota
Dallas Museum of Art, Dallas, Texas
Earl Davis. Courtesy of Salander-O'Reilly Galleries, New York
The Solomon R. Guggenheim Museum, New York
Hirshhorn Museum and Sculpture Garden, Smithsonian Institution, Washington, D.C.
Collection of Robert and Fern Hurst, New York
The Israel Museum, Jerusalem
Herbert F. Johnson Museum of Art, Cornell University, Ithaca, New York
Los Angeles County Museum of Art, Los Angeles, California
Memorial Art Gallery of the University of Rochester, Rochester, New York
The Menil Collection, Houston, Texas
The Metropolitan Museum of Art, New York
Museum of Fine Arts, Boston, Massachusetts
The Museum of Modern Art, New York
National Museum of American Art, Smithsonian Institution, Washington, D.C.
The Newark Museum, Newark, New Jersey
Philadelphia Museum of Art, Philadelphia, Pennsylvania
Rose Art Museum, Brandeis University, Waltham, Massachusetts
Sunrise Museum, Charleston, West Virginia
Fundación Colección Thyssen-Bornemisza, Madrid
Virginia Museum of Fine Arts, Richmond, Virginia
Wadsworth Atheneum, Hartford, Connecticut
Walker Art Center, Minneapolis, Minnesota
Whitney Museum of American Art, New York

Table of Contents

Preface

Peggy Guggenheim's importance in the history of twentieth century art rests with her leading role in the New York art world at the moment when a New York avant-garde of painting, later to be known as American Abstract Expressionism, came into being. The movement was both predicated on and reacting to the European avant-gardes of the previous three decades. As Rudi Fuchs points out in his contribution to this catalogue, Abstract Expressionism—most vividly personified in Peggy's discovery, Jackson Pollock—came to dominate the European perception of American art in the immediate post-war period. Yet prior to all this, one great painter, responding to European Post-Impressionism and Cubism, developed in the 1920s the first truly original American avant-garde painting.

Born in 1892, Stuart Davis was six years older than Peggy Guggenheim and a generation older than the New York school painters. His career and his importance are examined in this catalogue by a number of Davis scholars: Lewis Kachur, Diane Kelder, Wayne Roosa, and Karen Wilkin, to all of whom I am most grateful. The Metropolitan Museum of Art kindly gave permission for the reprinting of Lewis Kachur's study of Davis's painted words. These essays add up to a portrait of an artist of extraordinary integrity and conviction. His openness to the European avant-garde, first revealed to him at the Armory Show, combined with his loyalty to the American scene (which he proudly made the quintessential subject matter of his painting throughout his life, expressing, in a way, his loyalty to Robert Henri and the Ashcan credo), gives him a well-tempered Olympian superiority. His only comparable contemporary in this way was perhaps Georgia O'Keeffe. The development of his painting runs like a straight path through the tangled woods of contemporary art developments. Isms and trends continually tugged at his sleeve: the pure painting of Synchromism, the lyrical elegance of Precisionism, New York Dada, figurative Surrealism, De Stijl-inspired geometry, Regionalism and Social Realism, and then in the forties and fifties—what must have been an enormous temptation—the mythical subject matter and "action painting" of the New York school. But Davis stuck to his Progress, stoically and with the unwavering conviction that he expressed in the writings that are reviewed in this catalogue by Wayne Roosa. If he was isolated in the thirties by the urban and rural "realists" (ironically those artists who isolated themselves from the European avant-gardes), he was isolated again in the fifties by the new American abstraction and by the critical hegemony generated by Clement Greenberg and Harold Rosenberg.

Then again, Davis was always present, always at the heart of things. His whole life was spent in Manhattan or its environs. He never flinched from appearing in public or from publishing his thoughts. Something of his gruff charm comes through the *Night Beat* interview published here. From its earliest days he was one of the favored artists of the Whitney Studio Club and later the Whitney Museum. He was an activist in artistic causes, such as the Artists Union and the American Artists Congress. He

represented America in the first U.S. Pavilion show at the Venice Biennale and in the first São Paulo Bienal. He painted murals for public places and was a participant in the Federal Art Project. He had his first solo museum exhibition at the age of thirty-two, and, from the late 1940s on, he was frequently honored with awards. Museums collected his works throughout his life. He was the Compleat Artist.

All his life Davis was an aficionado of jazz; it was a part of that American scene to which he remained loyal. Ben Sidran, in the first essay of this catalogue, compares Davis's painting to authentic jazz which cannot be rehearsed or written, but is the spontaneous emanation of the musician who becomes the music he performs. Karen Wilkin says much the same, and this may be the best, intangible definition of Davis's *integrity*: the unification of the man and his art, a non-verbal abstracting vision of the contemporary scene around him. Davis was at one with himself and at one with his surroundings.

This is the first museum retrospective of Stuart Davis's paintings ever to be held in Europe, and it is appropriate that it should have been organized and inaugurated at the Peggy Guggenheim Collection, the Italian extension of the Solomon R. Guggenheim Foundation of New York. There are many people who helped to bring this about. My first and affectionate expression of gratitude is to Earl Davis, the artist's heir, and to Larry Salander, of the Salander-O'Reilly Galleries, New York. Together they manage the Stuart Davis estate, and they unhesitatingly adopted the proposal to do this show. By making the holdings of the estate available for the tour, and by placing the skills and the archival resources of the Salander-O'Reilly Galleries at the service of the project, they have, without exaggeration, made it possible. Andrew Kelly, Eve Harrison and Elizabeth Stevens have been patient and tireless. I would like to add here a word of thanks also to John Seiler, of the Galerie Ulysses, Vienna, for the time he dedicated to helping the project in its early days.

The somewhat jaw-dropping revelation that Stuart Davis is virtually unknown to the general European public—even, to put it bluntly, to the educated classes—has been one of the driving forces behind the exhibition. It was critical that from the beginning the project was able to count on the partnership of the Palazzo delle Esposizioni of the City of Rome, and on the enthusiasm of its director Maria Elisa Tittoni. This gave us the confidence to get started. Furthermore, thanks to this, Italy will be privileged with a north-south opportunity to see the exhibition. I am also grateful to Federica Pirani, curator at the Palazzo delle Esposizioni, who has contributed the Italian viewpoint to this catalogue.

The support of the National Museum of American Art of the Smithsonian Institution, Washington D.C., and of its director Elizabeth Broun, has been extremely important. Elizabeth Broun's outspoken emphasis on the importance of making Stuart Davis's art available to a European public convinced several American museum lenders to part, however reluctantly, with their paintings for a sixteen-month period—paintings which normally occupy key positions in the permanent collection displays and educational programs of those museums. I am indebted also to Elizabeth Broun's curatorial input, her early assurance that we could count on loans from the National Museum of American Art, and her determination that the exhibition should present only the best of Stuart Davis. That the exhibition will conclude in Washington renders tangible the established, textbook position of Davis in the history of America's modern art.

Thirdly, Rudi Fuchs, director of the Stedelijk Museum, Amsterdam, has confirmed our conviction of the importance of seizing the opportunity to present the art of Stuart Davis in Europe—an opportunity which presumably will not be repeated in the professional lifetimes of those who have helped to bring it about. In his catalogue essay, for which we proffer the warmest of thanks, he hints at the responsibility of

Opposite page
Stuart Davis, New York, January 1958.
Courtesy of Hank O'Neil.

museums to work to rectify the sometimes overweening and distorting prevalence given to group avant-gardes—from Cubism to Surrealism, to Abstract Expressionism, Pop and Minimalism—by block-busting exhibitions and popular art histories, in which artists of stalwart integrity, quality and individuality may get shunted down sidings. This point of view, with which I agree, exalts the initial, but mere preliminary, excitement that gave rise to the project itself. Thanks to Rudi Fuchs the Italian showings of the exhibition will be balanced by a North European venue, early in 1998.

One museum only in Europe owns paintings by Stuart Davis: the Thyssen-Bornemisza Museum in Madrid. Casting one's net about the Mediterranean, one found a painting by Davis in the Israel Museum, Jerusalem—and I would like to acknowledge that when we first issued our requests for loans the Israel Museum was the swiftest to respond affirmatively. For the rest, it was necessary to prevail upon public museums and private collectors in the United States. Those who have lent are acknowledged separately in this catalogue. The Peggy Guggenheim Collection, as an occasional lender to exhibitions in Italy and abroad, knows how it feels to be deprived, however temporarily, of its major works of art, and by saying this I want to add a note of personal feeling when I say how very grateful I am to the private individuals, the museum trustees and directors, and the staff members of those museums, who have agreed to lend paintings, have graciously suffered the troublesome technicalities of lending and shipping, and shown generous solidarity in enabling us to keep exhibition costs down. The Peggy Guggenheim Collection's colleagues at the Solomon R. Guggenheim Museum arranged for a temporary loan to one of the museums lending to this exhibition, thus making possible the loan on an exchange basis. This was very nice of them. I feel certain that the exhibition will achieve its goal of placing Davis in the cultural consciousness of late twentieth century Europe, and in this way will make the efforts and sacrifices of all who contributed to bringing about this exhibition worthwhile.

This exhibition is the most complex and ambitious that the Peggy Guggenheim Collection has undertaken, and I am grateful to the staff of the Collection who worked with selfless devotion to bring about both the exhibition and its catalogue, and also to the technical consultants of the Collection, Clemente di Thiene, Virgilio Stocchi and Roberto Bergamo.

This is also the most expensive exhibition project we have ever launched, and it would not have been possible without special funding from different sources. The Regione Veneto has subsidized the cultural programs of the Collection annually since 1981. The benefactors who belong to the Peggy Guggenheim Collection Advisory Board, whose names are given at the end of this catalogue, donate annually to the museum's operations. Alitalia is official carrier of the exhibition. Ammirati Puris Lintas of Milan has helped to arrange publicity. Electa has sponsored the production of the catalogue. Last but not least, Intrapresæ Collezione Guggenheim, the international corporate benefactors whose names are justly attached to all communications relative to the Collection's exhibitions, have made it possible over the past few years to develop projects with a two year lead-time, and to do so with the confidence that the necessary funding will be in place. The generosity of these sponsors enables the Collection to fulfill Peggy Guggenheim's own program, set out in New York in the 1940s, of exhibiting her collection side-by-side with important and ambitious temporary exhibitions such as this show dedicated to the genius of Stuart Davis.

Philip Rylands
Deputy Director
Peggy Guggenheim Collection

The Jazz of Stuart Davis

Ben Sidran

Jazz music sprung seemingly full-blown from the soil around the turn of the century. Nobody knows exactly when or where it arrived, but there is much speculation about how and why the blue notes and field chants and quadrilles and ragtime all came together, not in some kind of magical big-bang, but organically, in a kind of musical primordial ooze formed from the great fecundity of the American culture.

Some pinpoint the origins of this music at New Orleans, and certainly the Crescent City was the Rift Valley of jazz evolution, both the *home of the blues* and a place, before the U.S. Government shut down the French Quarter in 1917, where the red light district was a twenty-four hour party driven by flamboyant marching bands and brilliant piano players. The plain truth, however, is that jazz was brewing everywhere, all across the country, especially in the rapidly expanding urban ghettos where a critical mass of African-Americans had enough loose change to make playing an instrument a supportable avocation. Not a career as such, but certainly a way of life.

The musician articulated the news of the day in black America, and as the African-American community spread northward, in his hands the news emerged as a song, a sob, or a reason to have a party. Because of the optimism and drive of this music—and in the context of the wringing poverty all around—his was both the voice of hope and of reason. The jazzman resolved the inequities of daily life, and did it nightly. At the bar-rooms, social halls and rent-parties all across the landscape, in New York, Baltimore, Chicago, St. Louis, Detroit, folks used to say "I love the blues, they hurts so nice."

Of course, there was no pretense of *art* at the time. In fact, not many Americans of the day would have recognized this outpouring of expression as *real music* let alone *art music*. It was not even called *jazz* back then; *jazz* was a word unused in proper society, slang for what went on in the bedroom, which is why it ultimately came to describe this music too; for jazz was born in the brothels and gin joints and *house parties*, where strangers came in off the streets and paid a quarter to drink and get happy. A solitary piano player, sometimes joined by a drum or a trumpet, would rock the house, inventing music out of nothing, pulling snakes and great clouds of joy from thin air while the crowd shouted, "you got it" and "that's it man!" The piano played the *blue* notes of the guitar or the human voice by rubbing a major and a minor third together, resulting in a clash that is a flagrant violation of Western classical harmony and which, therefore, became the hallmark of *ragtime* piano, and later *jazz*.

Back in 1907, however, the music was probably still called *barrel house* or *honky tonk*, when a teenaged Stuart Davis with his pal Glenn Coleman prowled the rough bars of Newark searching out this organic scene. They were, in his phrase, "particularly hip to the jive." What is remarkable is that, at the time, there was no jazz available on phonograph records (this was still several years off) and there was virtually no way a couple of young white boys could even know about its existence, let alone its power. But these rough bars in Newark became the crucible from which the soul of a

young artist was cast. It was here in the heat of the creative moment that the real world and the world of abstraction came together for Stuart Davis.

"These saloons catered to the poorest negroes," Davis remembered, "and outside of beer, a favorite drink was a glass of gin with a cherry in it which sold for five cents. The pianists were unpaid, playing for love of art alone. In one place, the piano was covered on top and sides with barbed wire to discourage lounging and leaning on it, and give the performer more scope while at work. But the big point with us was that in all of these places you could hear the blues, or tin-pan alley tune turned into real music, for the cost of a five cent beer."[1]

Stuart Davis, c. 1930.
Photograph courtesy of Earl Davis

Tin-pan alley tunes "turned into real music," this is the key. For what is "real" is not always what it appears to be—indeed, it is often quite other. What is real is often what is "remembered" to be, the essence of the moment, not the moment itself. Art, then, is the lie that tells the truth. And while tin-pan alley songs were the actual, or literal, artifacts of the day—just as the gas pumps and street signs that Davis painted were the visual artifacts of the day—the Negro musicians invented their own way of pre-serving the everyday essence of mundane songs while, at the same time, exalting their purposes, molding them into something personal, something beautiful, something undeniably modern.

Many years later, Davis would say, "My attitude toward life is realistic, but realism doesn't include merely what one immediately sees with the eye at a given moment— one also relates it to past experiences... one relates it to feelings, ideas. And what is real about that experience is the totality of the awareness of it. So, I call it 'realism.' But, by 'realism' I don't mean that it's a realism in any photographic sense—certainly not."[2]

For the whole of his creative life, Davis would disdain mere abstraction in art and prefer to think of his work as having "a realism that every man in the street has the *potential* to see, but in order to see, would have to see it in himself first. He'd have to give value to those qualities which an artist gives... to whatever is the artist in him."[3] And, when pressed on the subject, he referred to this quality of being "able to see" as being "hip," a term he said he learned "in the jazz bars and saloons."

This new jazz music was straight off the streets. It was people's music. There was no distinction between high or low art in the protean world of jazz, just as there were no such distinctions at the Henri School, where Davis absorbed the tenets of a radical, anti-academic perspective on painting. There, he reported, "art was not a matter of rules and techniques... It was the expression of ideas and emotions about the life of the time... The idea was to avoid mere factual statement and find ways to get down some of the qualities of memory and imagination involved in the percep-tion of it... It took art off the pedestal and, by affirming its origins in the life of the day, developed a critical sense toward social values in the student." Therefore, as in jazz, "any preconceived ideas about racial, national or class superiorities, could not thrive in its atmosphere."[4]

Indeed, Stuart Davis went beyond a mere egalitarianism to see the world of black music as a kind of metaphor for the plight of the arts in America. As he wrote to a jazz critic in the 1940s: "This discrimination against Negroes as a race, which also included the Negro as an artist, is the fate of most genuine artists, regardless of race or class. It is a simple fact that most people, without relation to their social or economic status, do not give art a place of importance in their living scheme. Their indifference to the great Negro bands and solo artists remains the same when they are confronted with a modern painting."[5]

Often, during key moments of his career, Davis returned to the imagery of jazz, to describe his situation. A striking example was the remark he made after attending the famous 1913 Armory Show, where, for the first time, he saw the paintings of the European Fauvists and Cubists *en masse*. Immediately, he reported in his diary, he sensed an "objective order," particularly in Gauguin and Matisse, that gave him "the

14

same kind of excitement I got from the numerical precisions of the Negro piano players ... and I resolved that I would quite definitely have to become a 'modern' artist."[6] To Davis jazz was a paradigm of modern creation.

One could speculate that jazz might literally have acted as a catalyst for him, particularly the music of pianist Earl "Fatha" Hines, his favorite musician from the late twenties until his death. Hines's flashing, angular lines, and especially the clusters of colors and trills that he threw off so effortlessly, had their analog in the high key colors of Davis's work. Stuart Davis did, on occasion, connect his own painting directly to various jazz techniques. For example, of the painting *Hot Still Scape for Six Colors – 7th Avenue Style* (1940, Museum of Fine Arts, Boston), he wrote that "six colors were used ... as the instruments in a musical composition might be, where the tone-color variety results from the simultaneous juxtaposition of different instrument groups."[7] If one wanted to be literal, one could say that his colors were his chord voicings, and the juxtaposition of planar surfaces his harmonic structures.

Stuart Davis, *Hot Still Scape for Six Colors – 7th Avenue Style*, 1940
Oil on canvas
Museum of Fine Arts, Boston.
Gift of the William H. Land Foundation and the M. and M. Karolik Collection, by exchange

For what a jazzman does in his "spontaneous composition" is take the standard chord changes from a popular song—the planar surfaces of the song—and work his way through and around these sign posts, these "objects" of everyday experience. It is not the objects themselves that are important but the way in which the musician weaves his tale. Gradually, a great player develops a way of doing it, a gesture that is recognizable as his own path through the harmonic underbrush. That same gesture can then be extracted and used in a new context in future compositions, so that ultimately, even though he is still working on a solution to the problems inherent in playing, for example, the second four bars of Gershwin's *I Got Rhythm*, it sounds nothing at all like that song. The chord changes become his excuse to make and remake that particular gesture, to re-experience the feeling that was there the first time. In time, alternate chords are substituted for the standard ones, like new planes of existence, and additions, refinements, and extrapolations are added. But still, one is essentially working on the memory of those four bars from *I Got Rhythm*.

Just so, just as a chord sequence from a standard song can be resolved in any number of ways and then reinserted into a future composition, so too Stuart Davis used the reduced essence of ordinary things—a schooner's mast, an eggbeater—over and over again in new ways. These then became the chord changes of his own compositions. While the high key colors became his "tone," the *sound* of his artistic voice, the planar surfaces became his harmonic structure, his compositional signature.

Stuart Davis often, perhaps inadvertently, described his personal experiences in terms any jazz man can understand. Once, for example, during the twenties, in Gloucester, Massachusetts, after years spent dragging a sketching easel, large canvases and a back pack along with him, "looking for things to paint," it suddenly dawned on him that "packing and unpacking all this junk" was irrelevant to his purpose. Subsequently, he went out with only a small sketch book, and the results were both dramatic and freeing. As he remembered: "It seems that in all this tramping around with full equipment I had actually learned something. All that was required to cash in on some of this information was to stop lifting things up and putting them down for a while."[8]

Sly humor aside, Davis is reporting a basic tenet of the jazz life: at some point, one must stop studying the information and *become* the information. A jazzman might say, as Charlie Parker once did, "If you don't live it, it won't come out of your horn." As the practice of art is transformative, so the music is a by-product of this transformation.

During the 1920s, after Davis finally stopped dragging the easel to the sea coast, he began using the schooner in new, unimagined ways. "In abandoning the weighty apparatus of the outdoor painter, I did not at the same time abandon nature as subject matter," he wrote. "My studio pictures were all from drawings made directly from

nature. As I had learned in painting out doors to use a conceptual instead of an optical perspective, so, in my studio compositions, I brought drawings of different places and things into a single focus. The necessity to select and define the spatial limits of these separate drawings, in relation to the unity of the whole picture, developed an objective attitude toward the size and shape relations. Having already achieved this objectivity to a degree in relation to color, the two ideas had now to be integrated and thought about simultaneously." Then, Davis used the musician's argot to describe the future: "The 'abstract' kick was on."[9]

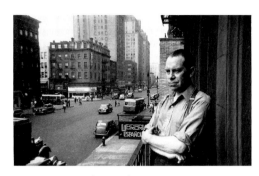

Stuart Davis at the window
of his studio, 43 Seventh Avenue,
New York, Summer 1935.
Photograph courtesy of Earl Davis

For six decades, jazz fueled the art of Stuat Davis. Together, they grew up, matured, became sophisticated. But always, they kept the pulse of the people on the street, and in the little clubs and hangouts where the real news was being passed along. By the 1940s, Davis had gravitated to musicians, like George Wettling of the Eddie Condon mob, who had their own scene and stood for anti-commercial, small combo jazz, and stayed liberally doused with portions of straight whiskey. They talked a hip dialect designed, in part, to exclude those who were not initiated or "in the know," and were notoriously unable to feign accommodation for middle class options on any subject. Davis's own speech was a wonderful melange of intellectual gambit and jazz slang, a Damon Runyon-esque drawl that matched the sly humor of his work with a deep affection for the musicians' scene. These social pioneers held forth in rooms large and small, uptown and down from Harlem to The Village overhung with a pall of bluish smoke, the blurred hum of conversation and the insistent musings of a good jazz band.

And if, in Davis's terms, the artist's canvas was "a cool spot in a hot environment," the music continued throughout his career to be the fire that kept the pots boiling. Like the musicians around him, he continued to challenge the supremacy of European tradition, redefining modernism with a thoroughly American humor and spirit. And like those jazz musicians, he persevered in the face of yawning indifference from the critical establishment for many years. For just as academies were slow to pick up on Stuart Davis, so too jazz was a cultural stepchild in the "legitimate" press until well into the 1930s. Perhaps Rudy Vallee, the musical idol of the day, spoke for most Americans when he said, "I have no definite conception of what 'jazz' is, but I believe it should be applied to the orchestral efforts of various bands up in Harlem. They have a style all their own, and at times it seems as though pandemonium had broken loose. Most of the time there is no distinguishable melody... it is absolutely impossible for even a musical ear to tell the name of the piece."[10] That review, with the substitution of a very few words, might well have been written around the same time by an American art critic about the work of Stuart Davis.

And yet, both Davis and the music he loved prevailed and were vindicated. Jazz supplanted the European tradition and, ultimately, found its analog in Davis's paintings, particularly such masterpieces as *Rapt at Rappaports* (cat. no. 45) and *Owh! in San Pao* (cat. no. 44). Davis's hip visual poetry created an iconographic language, composed of hot colors and modern slang, that captured the harmonic rubs and angular, syncopated grooves of the music he loved. It was as if jazz had come to three-dimensional life through his art.

In his diary of October 11, 1948, Stuart Davis wrote, "Art... has nothing to do with Logic or Sensibility. It has to do with Intuitive impulse carried out as an Act. The Act is the Fact, and all the Art quality is in it." Nothing could sum up the spirit of jazz more succinctly.

[1] Excerpted from *Stuart Davis*, American Artists Group Inc., Monograph no. 6, 1945, pp. 1–10.
[2] Interview with John Wingate for *Night Beat*, 1956. See p. 67 below.
[3] *Ibidem.*
[4] *Op. cit.*, American Artists Group Inc., Monograph.
[5] Collection of Earl Davis.
[6] *Op. cit.*, American Artists Group Inc., Monograph.
[7] *Parnassus Magazine*, December, 1940.
[8] *Op. cit.*, American Artists Group Inc., Monograph.
[9] *Ibidem.*
[10] M. Stearns, *The Story of Jazz,* Mentor Press, New York, 1956, p. 132.

Stuart Davis: American Painter

Karen Wilkin

I am strictly a European (French, that is) man myself, altho forced by birth and circumstance to live in the American Art Desert as exile.[1] Stuart Davis, 1953

Stuart Davis is an American original, a home-grown Cubist whose irreverent paintings resemble no one else's. He stands alone among the U.S. painters of his generation, his uninhibited work declaring its independence equally from the nationalist cant and social realism of his conservative contemporaries and the tasteful geometry of his more adventurous ones. Davis's pictures, with their boisterous sharp-edged shapes, their razzle-dazzle color, and their irrepressible vernacular spirit, are unmistakably his own, typical of no trend or movement, yet at the same time their energy, speed, and disregard of established rules make them emblematic of the best aspects of modern American culture. Like that quintessentially American invention jazz—which Davis loved as passionately as he did painting—his images depend on improvisation and dissonance; like jazz, too, they are at once unfettered, spontaneous, and firmly rooted in everyday experience.

Davis was a sophisticated artist, well aware of the aesthetic legacy of his predecessors and the innovations of his contemporaries, but throughout a career that lasted more than fifty years the generating force of his art was everyday life in its most random and ordinary particulars. From the intimate, realist works of his early years to the bold abstractions of his last decades, he made plain his delight in every part of his surroundings, no matter where he was. He focused his attention with equal enthusiasm on the visual cacophony of midtown Manhattan, the muddle of the waterfront of Gloucester, Massachusetts, and the intimacy of the streets of working class Paris. His still lifes celebrate packaging, labels, kitchen gadgets, and objects culled from the hardware store. He is reported to have kept a television set constantly on in his studio, tuned to sports programs with the sound off, but the sounds of modern life, from street noises to radio broadcasts to his beloved jazz, seem to have found their visual equivalents in his work, all of it translated into a highly individual, disciplined language of form and hue that he called "Color-Space Realism."

"Realism" is the key word. Davis was insistent that no matter how much his art departed from naturalistic appearances, he was not an abstract painter. He was scornful of "non-objective" artists who sought "to make the subject matter of art art itself" by embracing what he termed "Pure Art, Universal Plastic Values, Significant Form,"[2] in ironic upper case. For Davis, the "non-objective" was synonymous with reductive, arbitrary geometry, which he believed could never be the source of expressive painting. This conviction separated him from artists who were in other respects his allies, his friend Ad Reinhardt among them: the slightly younger painters and sculptors who exhibited together as the "American Abstract Artists," and who were so highminded that Piet Mondrian joined them on his arrival in New York.

Davis's own art was always "objective," based on direct encounters with the world

around him and the feelings they provoked. He insisted that only by confronting the actual, with all its irregularity and unpredictability, could an artist discover eloquent, unnameable shapes and unexpected imagery. No matter how "abstract" the finished picture, Davis's Color-Space Realism was a distillation of the specific; witness the lovingly scrutinized fire-escapes and elevated trains, gas stations and ships' rigging, lampposts and café tables that populate his sketchbooks, their profiles and patterns vividly evocative of particular places, even when they are stripped down to the bold, simplified drawings that he called "configurations." A configuration translated all of Davis's responses, perceptual and emotional alike, into an autonomous linear structure that could then become the basis for improvisation and further transformation; a powerful configuration could ultimately become the scaffolding of a fully-developed painting or even a series of paintings, with color added to establish and vary its spatial dynamics.

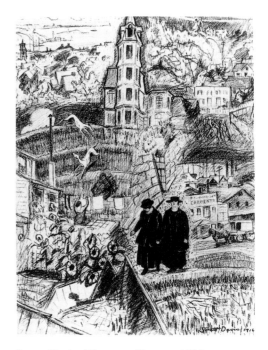

Stuart Davis, *Gloucester Terraces*, 1916
Crayon, ink and pencil on paper
Collection Earl Davis.
Courtesy of Salander-O'Reilly Galleries,
New York

Davis deeply mistrusted ungrounded invention, but anything, he maintained, could serve as subject matter; anything could provide impetus to paint. Yet newly embarked on a direction that he would follow for the rest of his life, he wrote, "The real question is not HOW TO PAINT but WHAT TO PAINT."[3] He seems to have quickly resolved the problem. A frequently quoted declaration of "things which have made me want to paint, outside of other paintings," written in 1943, leaves no doubt about what had stimulated this idiosyncratic artist from the beginning of his career: "American wood and iron work of the past; Civil War and skyscraper architecture; the brilliant colors on gasoline stations, chainstore fronts, and taxi-cabs; the music of Bach; synthetic chemistry; the poetry of Rimbaud; fast travel by train, auto, and aeroplane which brought new and multiple perspectives; electric signs; the landscape and boats of Gloucester, Mass.; 5 & 10 cent store kitchen utensils; movies and radio; Earl Hines hot piano and Negro jazz music in general."[4] The easy fusion of high and low art sources in this list seems both strikingly contemporary and strikingly American. Davis's references include not only jazz, but such New World specialties as the 5 & 10 and the skyscraper, and the distinctly non-European phenomenon of brightly-colored taxis. Yet in addition to the great jazz pianist, Earl Hines, the list includes Rimbaud and Bach, reinforcing something that is plain despite the irreducible Americanness of Davis's paintings: that this fan of what would now be called American popular culture was also a knowledgeable admirer of the most advanced European art of his time. Davis's paintings are as deeply informed by Picasso and Braque's reinvention of spatial possibilities as they are by the architecture of American cities and the expanses of the North American continent; as responsive to Matisse's explorations of color structure as they are to the billboards of American highways and the nuances of North American light.

Davis boasted of his Americanness; he was proud of his family's long history in the United States and often pointed out that he had been born, raised, and trained as an artist entirely in the U.S.A. These sentiments were undoubtedly genuine—and useful to an aspiring New York painter of Davis's generation, given the narrow vision of the American art establishment in the early days of his career—but the "ace of American modernists,"[5] as an enthusiastic critic called him, was no chauvinist. His ambition was to make the most expressive, potent art he was capable of, to paint pictures that could hold their own in any context, not pictures that served some nationalist purpose; his quest had been to learn from the most exciting art he encountered, no matter what its origin, and to put those lessons into the service of his own, indigenously American, impulses.

Davis was outspoken about his belief that the best art, including his own, was deeply indebted to European prototypes. When a mainstream critic who generally liked Davis's work faulted him as too influenced by Picasso, he complained that he had been described as "a swell painter whose value to American art was nullified...

because I had a French style."[6] This was nonsense, Davis said, since there was no such thing as an American art without European influence, differences in American styles were simply the result of differences in the European influences chosen, but this in no way compromised the national identity of American painters and sculptors, if their reach was large enough.

Davis heartily disliked the popular American Scene painters of the 1930s and 40s, such as Thomas Hart Benton and Grant Wood, whose illustration-like images of a rock-ribbed, idealized American heartland he denounced as sentimental in content and reactionary in form. He was equally dismissive of the Social Realists of the period, such as Ben Shahn and the Soyer brothers, whose wistful, politically engaged images appealed, strangely, to both the conservative museum establishment and the Left. While the American Scene and Social Realist painters were praised for having rejected pernicious foreign innovations in order to express profound truths about their country, Davis found their work to be merely provincial. He would, he said grumpily, "welcome the sight of some kinds of American art being menaced by alien trends."[7] The only issue worth considering, he believed, was excellence. "If Picasso were a practicing artist in Akron, Ohio, I would have admired his work just the same," Davis quipped.[8]

Davis's evolution as an artist was a continuing dialogue with advanced French art. While his point of departure, throughout his long career, remained the specifics of his quotidian existence as an urban American with a taste for the vernacular, the visual language with which he inscribed his images was learned from his European colleagues. As a young painter, he looked to such innovators as Paul Cézanne and Vincent van Gogh as models; as a mature artist, he both measured himself against the painters he admired most, such as Pablo Picasso and Henri Matisse, and looked to them for confirmation of his direction. Some of his closest friendships, during crucial years in his development, were with the European-born New York artists, John Graham and Arshile Gorky. (Together they were known as "the Three Musketeers.") In the 1920s and 30s, Graham, a minor aristocrat who fled revolutionary Russia for Paris before coming to the U.S. (and changing his name), was an important source of information about avant-garde art for a circle of young artists

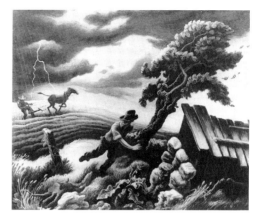

Thomas Hart Benton,
The Hailstorm, 1940
Tempera on canvas mounted on panel
Joslyn Art Museum, Omaha, Nebraska. Gift of the James A. Douglas Foundation

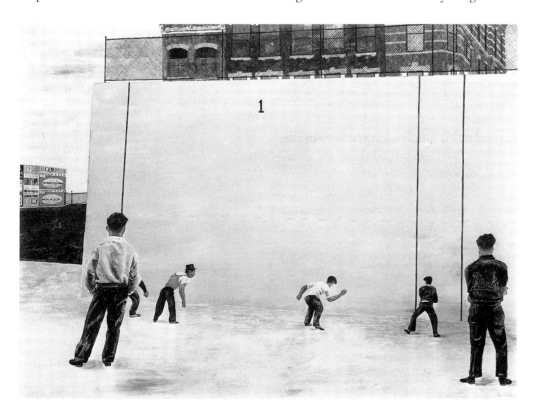

Ben Shahn, *Handball*, 1939
Tempera on paper over composition board
The Museum of Modern Art, New York. Abby Aldrich Rockefeller Fund

that included, in addition to Davis and Gorky, David Smith, Willem de Kooning, and Adolph Gottlieb. Whenever Graham returned from one of his frequent trips to Europe, where he apparently knew everyone from Picasso to the Surrealists, he reported on what he had seen and provided his New York friends with the latest issues of the influential magazine *Cahiers d'art*, with its invaluable photographs of new art.

Yet to describe Davis as a gifted follower is obviously inaccurate and inadequate. Even to categorize him as an inspired translator of Old World concepts into a distinctively American colloquial idiom, while closer to the truth, still fails to come to terms with his real achievement, since it implies that he was primarily an interpreter, not an originator. The evidence of Davis's work may leave no doubt about his debt to his chosen ancestors, but it makes just as plain his inventiveness and his independence of mind. If Davis's pictures are conceptually different (as well as just plain better) from the work of most of his American contemporaries, the rambunctious shapes, the vibrant, assonant color harmonies, and the refusal to be elegant or ingratiating that distinguish his work differ no less from the more refined efforts of his colleagues on the other side of the Atlantic.

In many ways, Davis's closest aesthetic links are not with his coevals, but with older painters such as John Marin, or Gertrude Stein's friends, Marsden Hartley and Alfred Maurer, who were among the first Americans to embrace the ideas of the European avant-garde. Although he was almost a generation younger than these pioneer modernists, Davis's aesthetic beliefs and his formation as an artist largely parallel theirs. There are notable differences, of course. The first wave of American modernists were often expatriates who gained their knowledge of advanced European painting directly, among the Fauvists, Cubists, and Expressionists in France and Germany. Davis first saw what he called Modern Art—with respectful capitals—in the great "International Exhibition of Modern Art of 1913," known as the Armory Show, an assembly of almost sixteen hundred paintings, drawings, sculptures, and prints that introduced a generation of astonished Americans, Davis among them, to adventurous European art from Romanticism to Cubism. Davis always described this initial encounter as an epiphany, and while he may have exaggerated his lack of knowledge prior to the Armory Show, the impact of seeing so much daring work firsthand, under one roof, cannot be overemphasized.

In 1913, Davis was twenty, the star pupil of the progressive art school founded by the "Ashcan School" realist painter, Robert Henri, whose teachings, Davis later recalled, stressed "expression of ideas and emotions about the life of the time"[9]—especially its seamier side. Five of the young painter's loose, Ashcan School–type watercolors had been hung in the juried American section of the vast exhibition at the Armory, a sign of approval that could have made a young artist complacent; but seeing his work in proximity to the show's startling European pictures made Davis realize how old-fashioned were his own efforts. He was instantly converted to the cause of modernism. "I was enormously excited by the show," he wrote, "and... sensed an objective order in these works which I felt was lacking in my own. It gave me the same kind of excitement I got from the numerical precisions of the Negro piano players in the Negro saloons, and I resolved that I would quite definitely have to become a 'Modern' artist."[10]

Davis spent the next ten years doing just that, looking hard and assimilating the inventions of the artists he had come to admire; the task of being a Modern artist occupied him for the rest of his life. The single-mindedness of this response is unusual. Most of Davis's contemporaries seem to have been less affected by their first encounter with radical European art or, after an initial infatuation with modernist ideas, later rejected what they saw as foreign novelty. American art, they claimed, could grow only if it drew upon the particulars of the American experience and rejected European abstractness. (The American Scene painters were the most extreme

manifestation of this point of view.) Davis's art refutes this assertion.

It is relatively easy to trace the young painter's enthusiasms in the years immediately following 1913, as he explored the diverse implications of the work that had impressed him most in the Armory Show or that he saw afterwards, in the rare New York exhibitions of adventurous art that followed in the Armory Show's wake. Davis's economical landscapes and townscapes of the 'teens, constructed with thickly applied expanses of saturated color, attest to his initial attraction to Gauguin and Van Gogh—inevitably, he later declared, because Henri's teaching had prepared him to respond: "Broad generalization of form and non-imitative use of color were already practices within my experience."[11] Fauvist prototypes engaged him for similar reasons. At times, he seemed to seek real-life rationalizations for formal innovations, finding justification for Van Gogh-inspired strokes of blazing yellows in the cornfields of Pennsylvania or for Fauvist-derived clashes of hue and shape in a New England fishing town.

The young artist was restless; Davis's path seems so circuitous that at times he promises to turn into an entirely different kind of painter than the one he became. Yet as early as 1917, pictures such as *Garage* (cat. no. 7) were prescient of the mature Davis whom we know. While the relatively subdued palette and vernacular imagery of this modest, forthright painting seem haunted by the memory of the Ashcan School, a new foursquare, frontal abstractness of composition and a new boldness and clarity of structure—to say nothing of the way Davis used lettering—point not only to his mastery of a modernist idiom, but to his discovery of formal themes that would become wholly his own.

Davis's work, in these early years, can generally be described as a kind of home-brewed Fauvism or Expressionism: the landscape and townscape of the Northeastern United States interpreted in terms of generously scaled, angular planes in a palette of thickly brushed hot colors. After about 1920, however, his pictures were characterized by more restrained structure, cooler color, and generally more intimate subject matter: the garden instead of the town square, the table top instead of the waterfront. Perhaps Davis equated the "objective order" that he ardently wished to achieve with a less emotional, less painterly way of making pictures; perhaps, having digested Fauvist ideas, he then felt ready to explore other modernist notions of how perceptions could be embodied on canvas. Whatever the motivation, it is clear that by the beginning of the 1920s, Davis was deeply engaged by the possibilities offered by Cubism. As early as 1916, he had flirted with Cubist notions, "discovering" overlapping planes in the tombstones of a Gloucester graveyard, but the results suggest that he was aping the appearance of Cubism without fully understanding its rationale or spatial conceptions. He also experimented, with similar lack of success, with a kind of conceptual Cubism, jamming together naturalistic vignettes to create fragmented, discontinuous space. Yet in the early 1920s, a series of remarkable landscapes and still lifes announces not only what was to be Davis's lifelong allegiance to Cubism, but his sure grasp of its pictorial language; indeed, these pictures signal the beginning of his maturity as a painter.

The most striking are a group of large tabletop still lifes that includes *Still Life with Dial* (cat. no. 15), 1922. These generous, imaginatively colored *guéridons* leave little doubt that Davis was well aware of what Picasso, Gris, and especially, Braque were doing at the moment, yet they are impressive for having been painted when they were, in the relative isolation of the United States, by a painter still in his twenties. Arguably the most original of Davis's pictures of this period are a series of "Tobacco Still Lifes": frontal, overscaled conflations of labels and packaging that seem to ring changes on both Cubist collage and traditional trompe l'oeil. The large *guéridons* are more ambitious and spatially complex than the "Tobacco Still Lifes," but in their spareness and economy, their confrontational scale, and their steamrollered space, pictures such as

Stuart Davis, *Graveyard, Gloucester No. 2*, 1916
Oil on canvas
Collection Earl Davis.
Courtesy of Salander-O'Reilly Galleries, New York

21

Cigarette Papers (cat. no. 14), 1921, anticipate Davis's principal concerns in some of his most achieved pictures of the 1950s and 60s. They are also significant for their subject matter; a lifelong heavy smoker, Davis frequently included the accoutrements of his habit in his pictures, even leaving suggestive evidence that smoking materials and the cigar store were signs for maleness in his private iconography—a brand of loose tobacco, provocatively named "Stud," with a rearing stallion on its label, appears often.

By the end of 1927, "The 'abstract' kick was on,"[12] as Davis put it, in the form of his "Egg Beater" series (cat. nos. 21 and 22), a group of Cubist pictures that not only fulfill the implications of the *guéridons* and the "Tobacco Still Lifes," but carry them to new levels of originality for the young painter. The pastel palette of the "Egg Beaters" is typical of Davis only in these early years, but the uncanny way their interlocking shapes appear both effortlessly improvised and absolutely immoveable would become a hallmark of his mature work. While they are still indebted to Picasso, the "Egg Beaters" offer unequivocal evidence that Davis was no longer emulating a style, but using a new language to say original things. He would speak this language fluently and idiomatically for the rest of his life.

This makes Davis's development sound straightforward and uninterrupted when it would be more accurately described as a series of advances, sidesteps, and retreats. Drastically simplified compositions are followed by anecdotal ones, severe abstractions by modified naturalism, generously scaled, economical structures by intricate ones verging on the overwrought. Yet despite these oscillations, Davis's alliance with Cubism was quickly formed, wholehearted, and long lasting. Before he was thirty-five, he had found his direction.

Nevertheless, when Davis spent slightly more than a year in Paris, in 1928 and 1929—funded by a sale to what would become the Whitney Museum of American Art—he appeared to retreat from the abstraction of the "Egg Beaters." While the pictures Davis made before he left New York for Europe were notably independent of natural appearances, once in Paris, he produced streetscapes embellished with specific details of railings, rooftops, shutters, awnings, and lampposts—anything, in short, that struck him as essentially French and unlike what he had known at home. (A notebook drawing records a Turkish-style toilet.) But Davis had not lost faith in modernism. His Paris streetscapes, in fact, prove to be more adventurous than they seem at first. Rather, as a connoisseur of urban life, he had capitulated immediately to a seductive city and as an American in Europe for the first time, he was enthralled by the evidence of long habitation, of an old culture, around him. Davis was not ignorant of what French modernist painters were doing. The writer Elliot Paul, a friend from his Gloucester days, an established member of the American expatriate community and co-founder, with Eugene Jolas, of the experimental magazine *transition*, provided the young painter with instant access to the legendary Paris art world of the 1920s. A promised introduction to Picasso never materialized, but as an intimate of Gertrude Stein's, Paul easily arranged for Davis to visit the celebrated apartment on rue de Fleurus several times. Stein herself came to Davis's atelier on the rue Vercingétorix, although she failed to make the hoped-for purchase. An exchange of studio visits with Fernand Léger was a high point. Davis reported in a letter home that he had found Léger's newest work "very strong." Even though the "internationally famous modern painter" found his Paris streetscapes "too realistic, ... he liked the 'Egg Beaters' very much and said they showed a concept of space similar to his latest development and it was interesting that 2 people who did not know each other should arrive at similar ideas."[13]

Davis returned to New York in the summer of 1929, a few months before the October stock market crash that precipitated the economic disaster of the 1930s. The Depression quickly turned the painter into a frontline organizer for social reform, to

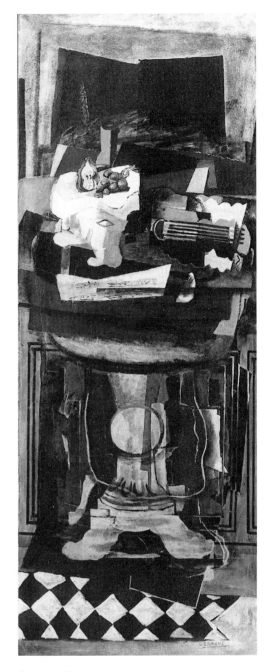

Georges Braque,
Le Guéridon, 1921–22
Oil and sand on canvas
The Metropolitan Museum of Art,
New York. Gift of Louise Reinhardt
Smith, in honor of William
S. Lieberman, 1979

the point where he had little time to be a studio artist. Davis was a passionate advocate of social activism, a tireless editor, writer, and illustrator of engagé publications, and a hard-working officer of organizations—some of which he helped found—dedicated to improving the lot of his fellow artists. Davis's long-standing friendship with Gorky dissolved at this time because the painter, Davis said, "still wanted to play,"[14] meaning that Gorky was unwilling to abandon the studio to work for social reform. But if Davis was contemptuous of artists who were politically apathetic, he had an equally low opinion of those who turned their art into propaganda. No matter how progressive his views, no matter how much energy he expended on socially responsible causes, Davis separated his art-making from his other efforts. In contrast to the work of many of his fellow artists in the program, the prints and murals that he executed as a member of the Works Progress Administration Federal Art Project explored themes and formal propositions indistinguishable from his usual concerns. "An art of real order in the material of paint doesn't say 'Workers of the World Unite,' it doesn't say 'Pasteur's theory had many beneficial results for the human race,' and it doesn't say 'Buy Camel cigarettes'"; Davis wrote, "It merely says 'Look, here is a unique configuration in color-space.'"[15]

"Art is not politics nor is it the servant of politics," he declared. "It is a valid, independent category of human activity."[16] But he struggled to define his position for himself, often within orthodox dialectical terms. (Davis knew his Marx.) His notebooks of the 1930s are filled with efforts to reconcile his political conscience with his aesthetic judgement. Aesthetic judgement always wins. Davis may have believed in principle that "a reactionary social viewpoint" could not produce "a vital art"[17] but his empirical experience forced him to admit that good art, even great art, could be disassociated from what he called "good social thought." Cézanne, one of his heroes, had a "scientific attitude toward painting and at the same time socially reactionary ideas."[18] Davis might have preferred Cézanne to have been more progressive in his political beliefs, but he could not argue with his own perception of excellence. Neither could he support the artists officially approved by the Left, in spite of his sympathy for their views. He tried hard to like what he called "Mexican muralism, the fetish of fresco,"[19] but he was unable to persuade himself of its aesthetic significance, its excellent intentions notwithstanding. "A people's art," Davis wrote, "is not to be achieved by turning art into illustration."[20] The Mexican mural movement was "culturally reactionary in the international sense because its art forms are historically obsolete."[21] Davis was particularly hard on Diego Rivera, arguing that the former Cubist should have known better.[22]

Perhaps because his studio time was often interrupted by his activism during the Depression years, the work Davis produced in the 1930s is marked by even greater diversity than usual. It encompasses stylized naturalism, near-abstraction, and just about everything in between. Davis's output, in these years, ranged from severe black and white drawings and prints to the dazzling murals he executed for the W.P.A., from simplified still lifes to conflations of disparate exterior spaces. It seems to have been a period of experimentation and consolidation, a coming to terms with the effects of his stay abroad. Especially in the first years of the 1930s, Davis seemed to be testing the limits of the modernist vocabulary he had so painstakingly assembled and to be measuring his French experience against his acute sense of his own Americanness. Some pictures from the 1930s are surprisingly literal, but in others Davis's awareness of Picasso, Léger, and Miró is more conspicuous than it is in anything he painted in Europe. It is as if he had been liberated by his return to his native ground and felt himself free to confront once again his European ancestors on his own terms.

Davis's obligations to the Federal Art Project and his duties as an organizer came to an end in the late 1930s, generally to the benefit of his art. Although he was never especially prolific—quite the contrary, he often lamented how slow his process was—

after about 1940, his pictures are notably more consistent and increasingly audacious, as though he had at last come to terms with the multiple implications of his earlier pictures and was able to work with a heightened sense of authority. Davis's paintings of the 1940s and 50s are not only among his most achieved, but among his most personal; they are deservedly among his best known. In "signature" works such as *Arboretum by Flashbulb* (cat. no. 37), 1942, *The Mellow Pad* (cat. no. 38), 1945–51, *Rapt at Rappaport's* (cat. no. 45), 1952, or *Premiere* (cat. no. 55), 1957, his familiar themes are present, but they are addressed less literally than ever before and with a new intensity; they explore new extremes both of density and of economy. Unpredictable color harmonies, freewheeling planes, syncopated patterns, and floating calligraphic flourishes take the place of the coherent spaces and recognizable imagery of earlier works. To make a jazz analogy, which is always tempting given Davis's declared passion for hep music and hip talk, his approach is like that of a brilliant scat singer. Faithfully recorded details—the visual equivalent of lyrics—are replaced by ecstatic improvisation.

Yet Davis had lost none of his sensitivity to the particulars of place. Glimpses of things familiar from more overtly naturalistic pictures flicker through even the most apparently abstract. The barber poles and gas pumps that were the protagonists of Davis's earlier urban dramas return as schematized shapes; patterns evoke urban accretions and dockyard litter, swirls of line suggest ironwork and the calligraphy of signage. Yet these highspeed allusions are no more important than any other aspect of the complex piling of shapes and patches that constructs these pictures. It is as if Davis conflated observed snatches of the natural and the man-made environment with invented elements that stand for the intangible parts of daily life, as if he dislocated shapes and lines from a great variety of sources and recombined them to make an entirely new kind of structure.

In the last decades of his career, Davis seemed to strive for greater economy in his pictures, intensifying the concentration of his distillate of modern experience. The unstable density of his paintings of the 1940s, with their layers of shifting, multicolored shapes, like dissonant chords, gave way to the relative simplicity and clarity of his works of the 1950s, a disciplined reduction of means enhanced by the larger scale both of Davis's canvases and of the elements within them. In the 1950s, the virtuoso orchestration of an astonishing range of vibrant hues typical of paintings of the 40s, such as *The Mellow Pad*, became the more rarefied (but no less complex) harmony of pictures like *Premiere*. In the last four years of Davis's life, in the 1960s, this process of simplification culminated in his most pared-down paintings in a half century of serious art-making. These late works depend on the interplay of a few eloquently-shaped planes and the clash of a sharply reduced range of colors—orangey-red, clear green, and New York taxicab yellow—fully saturated for maximum drama and sparked with black and white.

The assurance and individuality of the post-40s pictures are unmistakable. Yet for all their accomplishment and originality, they also bear witness to the persistence of Davis's engagement with artists whose work interested him. The nature of this engagement had changed. By the 1940s, Davis was a mature artist, secure in his idiomatic language of Color-Space Realism, and increasingly recognized and acclaimed. In 1945, the Museum of Modern Art organized a Davis retrospective; three years later, he was listed as one of the "ten best painters in America today" in a national poll of museum directors and critics. Davis no longer looked to the European artists he admired for guidance, as he had thirty years earlier, but rather, he examined them critically, as equals. He took Mondrian very seriously, but he was suspicious of the Dutch painter's insistence on the primacy of the right angle and his disdain for the unexpected irregularities of actuality. When the two men met in New York in the 1940s, their strongest bond was their common affection for jazz; aesthetically, their

Stuart Davis, *G & W*, 1944
Oil on canvas
Hirshhorn Museum and Sculpture Garden, Smithsonian Institution, Washington, D.C. Gift of the Marion L. Ring Estate, 1987

chief shared sentiment, according to Davis's recollections, was the "mutually unstated agreement that Nature was a great thing provided you didn't get mixed up with it."[23] In the mid-40s Davis produced two canvases based on a Mondrian composition, turning the grid into a scaffolding, an organizing support for densely packed clusters of patterns and small-scale floating shape—visual equivalents, perhaps, of jazz riffs. It is as if Davis were demonstrating how Mondrian *should* have put his picture together by burying the original "pure" geometric composition under a constellation of eccentric images encapsulating the workaday world.

Picasso intimidated the mature Davis no more than Mondrian. A playful canvas of 1954, *Colonial Cubism* (cat. no. 49), owes a good deal to Picasso's *Musiciens aux masques* (1921, Museum of Modern Art, New York), as well as to Picassos of the same period in general; but Davis's picture is both homage and challenge. Something of the palette and the hooked, angular shapes of *Musiciens aux masques* survive in *Colonial Cubism*, but they are treated without particular reverence, as Davis would treat any source of imagery in his experience: detached, dislocated, improvised upon, and freely reassembled without special regard for their original context. A floating guitar shape asserts its presence, upper right, in *Colonial Cubism*, like the reversed negative of the instrument held by Picasso's harlequin, while the spiky ears of the crouching dog in *Musiciens aux masques* may be echoed by a jagged red-brown shape, upper left—or maybe not. The ironic title reinforces the connection by signalling both the painting's debt to a European prototype and Davis's role in transplanting the Cubist idiom to America.

Davis's relation to Matisse, in the 1950s, is more subtle. Clear affinities (of appearance, not of technique) exist between Davis's later work and Matisse's late cutouts, especially the 1943–44 series, "Jazz." Davis had ample opportunity to see Matisse's work, including some of the cutouts, in a number of large American exhibitions in the late 1940s and early 50s. *Jazz,* in particular, was featured at the Pierre Matisse Gallery, in New York, in 1948, and while there is no documentary evidence that Davis visited the exhibition, it is hard to imagine someone with his tastes in art and music not paying close attention to a cycle of Matisse's work with that title. Yet it is difficult to prove its effect on Davis's work. The thickened loopy calligraphy and floating shapes in Davis's later paintings seem, on the surface, indebted to Matisse's example; but Davis had deployed detached written elements and insistent patterns since the 1920s. The

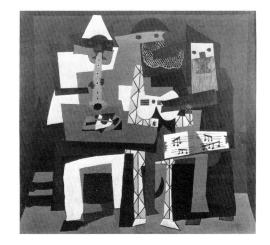

Pablo Picasso, *Musiciens aux masques*, Fontainebleau, Summer 1921
Oil on canvas
The Museum of Modern Art, New York. Mrs. Simon Guggenheim Fund

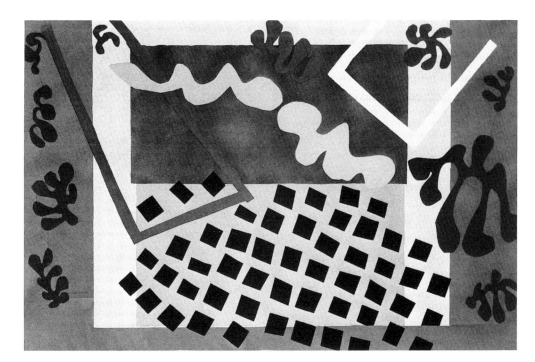

Henri Matisse, *Jazz-Les Codomas*, (pl. XI), 1947
Painted and cut-paper collage, executed in pochoir
Paris, Tériade Editeur, 1947

similarities are undeniable, but it seems probable that Davis, as a fully formed, clear-sighted painter in his fifties, saw Matisse's radiant, exuberant compositions as reassurance of the validity of his own path, rather than as signposts to a new direction.

"I can work from Nature, from old sketches and paintings of my own, from photographs, and from other works of art," Davis wrote in a notebook of 1942. "In each case the process consists of transposition of the forms of the subject into a coherent, objective color-space continuum, which evokes a direct sensate response to structure."[24] Perhaps the most revealing part of this statement is the phrase "from old sketches and paintings of my own," since one of the most striking aspects of Davis's later work is its hermetic dependence on his earlier images. A thrifty re-use of configurations that seemed to him particularly resonant or provocative had long been part of his practice, but from the early 1940s on Davis increasingly turned inward for "what to paint." Small studies from the 1920s resurface as ambitious paintings of the 1950s and 60s; Davis's last painting, left on his easel when he died—after having painted the word "fin" in the upper left hand corner—owes much of its initial configuration to a Cubist landscape of 1921. Sometimes Davis seems motivated by self-criticism, treating his own work as he did Mondrian's geometric abstraction, but more often he appears simply to have found fresh stimulus in an existing image. Davis often alerted us to these reprises with the words he incorporated as pictorial elements in his later pictures. "Else" or "new" can signal derivation from an earlier configuration, while numbers can refer to the dates of both the original and current versions. The phrase "the Amazing Continuity," inscribed on a canvas whose permutations absorbed Davis at intervals from 1950 to 1962, sums up the phenomenon. Davis's working method added further complications. His agonizingly slow process involved testing alternative color structures—spatial variants—of sections of works in progress; these "detail studies," in turn, frequently became the bases of independent works. The most extreme manifestation of Davis's recycling of images is a group of late black and white "reprised" paintings, like overscaled line drawings. They prove to be the last, not the first, stages of the process, as if the original configuration proved so potent that the artist was forced to re-excavate it, to let it stand alone.

"The Amazing Continuity" of Davis's work is neither self-quotation nor mere repetition, but creative reinterpretation, informed by new knowledge and new experience. A truly reverberant configuration was not exhausted by a single use. As if imitating the jazz musicians he loved, Davis treated his stock of distilled images like a repertory of familiar tunes, recognizeable every time he played them but varied by new harmonies, new rhythms, new colors. The original theme could be embellished, simplified, inverted, or dissected, transformed until it was all but unrecognizeable, or "corrected" according to whatever issues currently absorbed him. "The new," Davis wrote in 1956, "is a Recovery not a discovery."[25]

In the course of his long career, Davis's brand of "made in U.S.A." modernism won him the respect of both his peers and, eventually, a larger audience. Yet in spite of this success and recognition, he remained something of an outsider, an "exile," as he put it, "forced by birth and circumstance to live in the American Art Desert." Davis was born, in 1892, into a society for which art-making was something dangerously foreign, faintly unseemly, and probably unmanly. As the son of two artists, he met no family opposition to his chosen career—quite the contrary, he was allowed to leave high school at sixteen to study at Henri's school—but he was certainly aware of the general American climate. Throughout most of his life, the majority of his countrymen ignored the existence of any kind of art or were more conservative in their taste than the most conservative critic or curator. Davis's early espousal of modernism did little to make him more secure. When he first hit his stride, in the decade after World War I, the issue concerning much of the American art world was whether or not abstract art *was* art; by the 1930s, when he had begun to explore fully his own version of

Cubist abstraction, non-figurative art was deemed dangerously un-American by some of the most respected art experts in the country. In prosperous, post-World War II America, Davis watched, with horror, the rise of McCarthyism and found himself—along with the cream of American thinkers, artists, writers, and performers—under attack for both his politics and his aesthetic principles.

In his last decades, when he was finally honored as a doyen of American modernism, Davis found himself out of touch. He had been a significant role model for the New York painters and sculptors associated with Abstract Expressionism, who admired his unwavering committment to High Modernism, even though Picasso and Miró remained their ultimate heroes. Davis's year in Paris conferred a certain cachet, particularly among artists too poor to travel, but more important, he offered living proof that it was possible to make serious, advanced art on the North American continent. In the view of the most progressive dealers, curators, and critics, however, during the 1940s, the youthful Abstract Expressionists had gradually supplanted Davis in his role as standard-bearer of the avant-garde. By the 1950s, the New York School's notoriety had made them visible to a wide and increasingly receptive audience and, in spite of his position as a senior American painter, Davis found himself eclipsed by artists younger than himself, many of whom he had championed at the beginning of their careers. This might have been less painful had he been enthusiastic about their current work, but he was unable to accept the aims (or forms) of developed Abstract Expressionism. Its basis in Cubism had initially given Davis and his younger colleagues some common ground, but Abstract Expressionism's fascination with Surrealist theory—the mining of one's inner world as a source of art—alienated him. "Surrealism denies the objective world and is escapist," Davis wrote. "It denies the classic function of art—bold assimilation of the environment."[26]

For the still younger abstract painters of the early 1960s who reacted against the layered gestures and unbridled emotion of Abstract Expressionism, Davis might have served as a welcome precursor of a cooler, more restrained approach. But as with his own generation, European forebears still had more authority, and it was Matisse's example that was paramount for the emerging color-field painters. Of their American predecessors, Jackson Pollock was the most significant influence, and beside his intuitive skeins of paint, Davis's carefully planned and composed pictures looked almost traditional.

Davis's fiercely individual art acquired a new context with the burgeoning of the American Pop movement of the 1960s. His quirky paintings suddenly seemed prophetic. His lifelong delight in packaging and labels, in signs and storefronts, provided ancestry for the work of artists such as James Rosenquist, Jim Dine, and Andy Warhol. Davis's belief that *any* subject could generate good art and his celebration of the unglamorous and the ordinary seemed not only to anticipate the work of Roy Lichtenstein and Jasper Johns, but Robert Rauschenberg's combines and Claes Oldenberg's soft sculptures. But for all these similarities, Davis ultimately stands apart from these artists, as he does from so many others. The resemblances to his work—the choice of subject matter, the brashness, brightness, and clarity of Pop Art—prove to be only superficial likenesses.

Davis's pleasure in labels, billboards, and signs suggests that he and the Pop painters shared an iconography, but they used it very differently. Where the Pop artists glorified their banal subjects, deliberately mimicking the look of advertising art, Davis took liberties with his fragments of actuality, transforming them, according to what he called "color-space logic," into his usual Cubist-derived construction with colored planes. Davis described his colloquial themes in the language of High Modernism; his younger colleagues used the language of the media. In the end, Davis remains unique. He forged his version of Cubism almost single-handedly, without direct American ancestors; he left no direct disciples. Often misunderstood,

in his early years, as being too difficult and too radical, by the time of his death in 1964, his work was well regarded but somehow consigned to the past. Davis seems to slip between the two conventional points of focus in the history of twentieth century American art. Too young to have been part of the expatriate generation who helped introduce modernism to the United States, he was considerably older than the New York artists who made postwar America a center of innovative art, and he was overshadowed by them. Among his contemporaries he seems even more isolated. But if Davis's art is difficult to categorize, it should make us admire his independence of mind all the more. It is not an overstatement to call him the best American painter of his generation.

[1] Stuart Davis, letter to Edith Halpert, August 11, 1953. Edith Halpert Papers, Archives of American Art, Smithsonian Institution, Washington, D.C.

[2] Stuart Davis Papers, Harvard University Art Museums, on deposit at Houghton Rare Book Library, Harvard University. Reel 1, 1936. Some pages are dated, others are dated and numbered; the papers have been indexed by John R. Lane. Reel numbers refer to microfilm copies of the papers; there are no frame numbers. All Davis Papers at the Harvard University Art Museums are copyright 1987 by the President and Fellows of Harvard College.

[3] Stuart Davis notebook, 1923. Quoted in K. Wilkin, *Stuart Davis*, Abbeville Press, New York 1987, p. 36.

[4] S. Davis, "The Cube Root," in *Artnews*, no. 4, February 1, 1943, pp. 33–34.

[5] H. McBride, "Stuart Davis...Downtown Gallery," in *New York Sun*, March 21, 1932, p. 6.

[6] S. Davis, "Letter to Henry McBride," in *Creative Art*, no. 6, February 1930, supp. pp. 34–35.

[7] Davis Papers, reel 3, January 16, 1940.

[8] D. Kelder (ed.), *Stuart Davis*, Praeger Publishers, New York, Washington and London 1971, p. 11.

[9] *Ibid.*, p. 20.

[10] *Ibid.*, p. 24.

[11] *Ibidem.*

[12] *Ibid.*, p. 26.

[13] Davis, unpublished letter to his father, September 17, 1928.

[14] S. Davis, "Arshile Gorky in the 1930s: A Personal Recollection," in *American Magazine of Art*, no. 44, February 1951, p. 58.

[15] Davis Papers, reel 2, c. 1940.

[16] Davis Papers, reel 1, 1936.

[17] *Ibidem.*

[18] *Ibidem.*

[19] D. Kelder (ed.), *op. cit.*, p. 117.

[20] Davis Papers, reel 2, March 9, 1938.

[21] Davis Papers, reel 1, September 1937.

[22] Davis Papers, reel 1, March 24, 1937.

[23] D. Kelder (ed.), *op. cit.*, p. 186.

[24] Davis Papers, reel 4, November 21, 1942.

[25] Davis Papers, reel 14, June 30, 1956.

[26] Davis Papers, reel 4, January 8, 1942.

Stuart Davis's Word-Pictures

Lewis Kachur

During the latter phase of Stuart Davis's career, the formalist school of art criticism was ascendant, and its exponents saw each of the arts tending to self-definition, toward "the irreducible working essence of art and of the separate arts," in Clement Greenberg's view. For these critics and their supporters, the essential issue in pictorial art proved to be "flatness and the delimitation of flatness."[1] Thus, theatrical or literary concerns were considered extraneous to the rigorous essence of painting.

Stuart Davis, however, had already worked through these issues as a young artist in the 1920s. Contrary to the practice of formalist artists, Davis increasingly incorporated words and linguistic associations in his works from 1949 on. Not surprisingly, therefore, as the hegemony of formalist criticism consolidated, Davis's reputation waned, and his ambition to combine language and image in art has remained largely unrecognized. With hindsight, we now realize that Davis's word-pictures are unique among his generation of American artists, separating him first from his Ashcan School contemporaries, then from the Stieglitz group of American modernists, and, finally, from the emergent New York School of the postwar era. This was neither a monolithic development nor a consistent one on his part, yet it became a vital basis for the unique quality of his ultimate artistic achievement. Since John R. Lane published his pioneering study on Davis in 1978, we know that the dialogue of word and image in Davis's oeuvre was buttressed by a massive quantity of theoretical writings—perhaps the aspect of Davis's artistic legacy that is of greatest relevance and interest to the growing ranks of art-and-language artists today.

Davis's "art-theory papers" are integrally tied to the peregrinations of words in his pictures. Indeed, his earliest preserved writings date from just before his first important word-pictures: the "Tobacco" paintings of 1921. In the earliest preserved notebook, Davis bravely asserted, "As in Apollinaire poetry encroaches on painting, so let painting encroach on poetry… The hint of 'Journal' in Cubism should be carried on."[2] This forward-looking ambition was one that, initially, Davis was able to live up to only sporadically. He also recognized that to "use literature as well as visualization" would fall outside the boundaries of traditional fine art, yet he deliberately decided not to limit himself to the "problems of painting as such." Instead, he vowed, "where words or a word is necessary, they will be used."[3] Thus began five decades of melding word and image. Writing, or calligraphy, bridged the sister arts, and suggested that painting and language functioned analogously as systems: "Script in writing, the free sequence of written letters is the equivalent of the visualization and drawing of a shape."[4]

Davis's landmark "Tobacco" pictures boldly explored a variety of contemporary typographies. A comparison with the cigarette packaging and advertising of the time indicates how far Davis's art was from true trompe l'oeil. As a smoker, he was keenly aware of the sleekness of the new, mass-market advertising graphics and, for instance, of the richness of the Lucky Strike package's deep red-and-green hues.

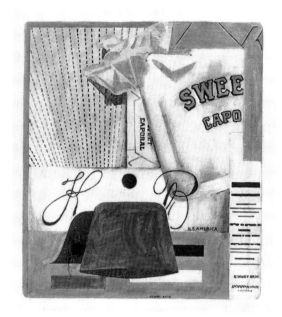

Stuart Davis, *Sweet Caporal*, 1922
Oil and watercolor on canvas board
Fundación Colección Thyssen-
Bornemisza, Madrid

Sweet Caporal cigarette packs
The Metropopolitan Museum of Art,
New York. Burdick Collection

Sweet Caporal of 1922 is a prime example of how Davis suggested current graphics while abstracting their specific images. In terms of lettering, the elegantly scripted *K* and *B* are prominent elements in the picture, but only when we examine contemporary cigarette packs do we realize that Davis distilled the typography quite directly from the manufacturer's name, Kinney Bros., as it appears on the wrappers. So, too, the multicolored, stitched pattern at the upper left of *Sweet Caporal* is a stylized setting sun, while the red, bell-like shape in the foreground derives from the fez on the actual pack. In a similar way, the blue bands—one with a "false" 1910 date—in *Lucky Strike* (cat. no. 12) are adaptations of the tobacco-tax stamps, bearing the year of the relevant legislation, affixed to cigarette packs.

Davis thought of smoking in a historical context, writing of the advance of individual packaging over the bulk barrels of tobacco of the previous century as "the nature of the present days." This new, urban "nature" included "photographs and advertisements, Tobacco cans and bags and tomatoe [*sic*] can labels."[5] Besides anticipating Andy Warhol's Campbell's soup paintings, this attitude also led Davis to an important blending of low culture and fine art—a self-avowed consolidation of "the popular picture."[6] Too close to advertising and design sources to be "pure" fine art, but too fragmentary and abstracted for commercial posters or trompe l'oeil—yet with elements of each—these hybrid pictures resist easy categorization.

Although Davis produced only a handful of "Tobacco" pictures, the advertising logo became part of his visual vocabulary, which he would continue to exploit. Later works that include trademarks, such as the iconic *Odol* of 1924 (cat. no. 19) or the compositions containing the word *Champion*—from a brand of spark plugs Davis saw advertised on a matchbook as late as 1949—are among some of the artist's most impressive images. Thus, he far surpassed his Ashcan School origins, for in those earlier works words and signs functioned merely as an aspect of the urban streetscape rather than as independent elements in the composition.

One notable exception is *Garage* of 1917 (cat. no. 7), essentially an Ashcan word-picture and therefore, as Karen Wilkin notes, particularly prophetic.[7] Spatially, it is quite shallow, as if Davis wished to suggest the flatness and clarity of the printed page. This canvas would prove to be especially significant for, the following year, Davis appropriated part of *Garage* as the major typographic element in *Multiple Views.*

Concurrent with the "Tobacco" paintings, Davis produced a large-scale wall decoration for the Nut Shop in Newark owned by his friend the artist Gar Sparks.

Stuart Davis, *Multiple Views*, 1918
Oil on canvas
Collection Earl Davis.
Courtesy of Salander-O'Reilly Galleries,
New York

Although the final result is more aptly regarded as advertising rather than fine art, this environmental "mural" was a new experience for the painter. No imagery appears on the store's four walls, only "letters of every color, letters of every shape and size, looking at first like a pied form in a lunatic's print shop." Oversaturated by innovative typography as we now are, it is difficult to appreciate just how radical this "weirdness of alphabet," as it was described in one journalist's report, seemed at the time.[8]

The effect of the Newark wall-painting experience gradually filtered into Davis's work. In an early notebook, he planned his first true word-picture: the capital letters GAR isolated on "a beautiful background of cream-colored stucco. Some handsome clap-boards painted yellow..."[9] The first three letters of "garage" make a nice pun on the unusual name of Davis's patron-friend. Yet, in the sketch as executed, the word is shortened to GA, evoking still a third possible interpretation: the initials of the French poet Guillaume Apollinaire, whose *Calligrammes* are referred to in the same notebook in which this drawing appears. If the allusion to Apollinaire is valid, it would be appropriate, since his innovative image-poems were regarded by Davis as exemplars of a new, hybrid form of expression somewhere between art and language. Although apparently never realized, the "GAR" project heralds the full-blown development of the word-picture in Davis's oeuvre in the late 1940s.

In pursuit of Gallic culture, Davis first immersed himself in the French language during his trip to Paris, Apollinaire's city, in 1928. In his Paris paintings, Davis in many ways reverted to the Ashcan approach to the urban scene, only now grafted onto an unreal, planar space. The words in the Paris works are in basic French and, in some cases—particularly, in *Rue Lipp* (cat. no. 26)—begin to take on a life of their own. This title, too, is more literary than literal, for no such street exists; it refers, instead, to the well-known Brasserie Lipp, on the Left Bank, frequented by artists and writers. In *Rue Lipp,* Davis also incorporated into the streetscape a personal, biographical allusion, via the poster on the right, to the poems of his friend the writer Bob Brown, who would soon visit Paris. Brown's "optical poems," published in his *1450–1950,* were lighthearted extensions of Apollinaire's *Calligrammes,*

Stuart Davis, *"GAR,"* 1922
Ink on paper
Stuart Davis Notebook: 1920–22.
Private collection

Stuart Davis, *The Barber Shop*, 1930
Oil on canvas
Collection of Neuberger Museum,
State University of New York at
Purchase. Gift of Roy R. Neuberger

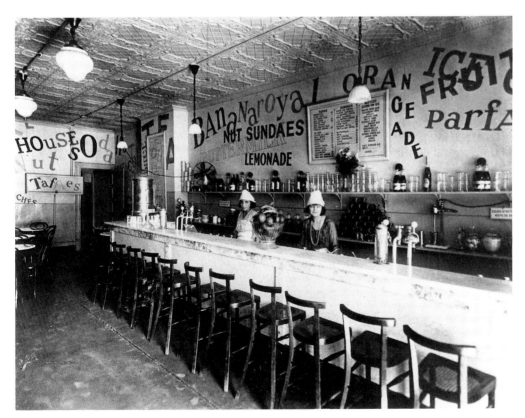

Soda fountain in Gar Sparks's Nut
Shop, Newark, New Jersey, showing
Stuart Davis's first public wall
decoration (1921; now destroyed).
Photograph courtesy of Earl Davis

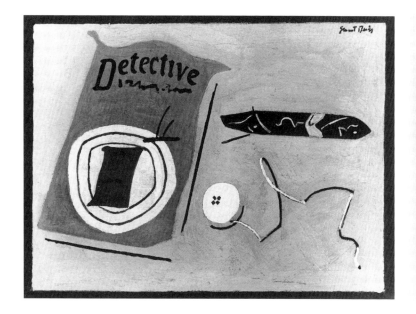

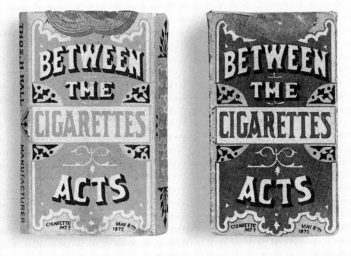

Stuart Davis, *Magazine and Cigar*, 1931
Oil on canvas
Richard York Gallery, New York

Between the Acts cigarette packs
The Metropolitan Museum of Art,
New York. Burdick Collection

and re-ignited Davis's interest in the verbal-visual nexus. Davis unleashed his first visual pun in *Rue Lipp*—the top hat within the beer mug on the table that he labeled *biere hatt* [*sic*] lest the viewer miss the double image.[10] Davis would eliminate the words and express this pun solely in terms of color in the 1959 variant on this painting entitled *The Paris Bit* (cat. no. 60). This odd juxtaposition of images is primarily significant as a type: an attempt to transpose a purely literary device (the pun) into visual form.

After his return to New York, Davis would allude to Paris in his correspondence with Brown, recalling their beer-drinking bouts at the Brasserie Lipp,[11] and his New York paintings, such as *The Barber Shop*, would take on something of the quality of Parisian streetscapes, the Parisian *tabac* even transformed into a cigar store, replete with several varieties, including LeRoy and Garcia Grande. The cropped poster on the right in *The Barber Shop,* captioned BETWEEN THE ACTS, at first glance seems to be an internal reference to the composition's empty, stage-like space, but is, in fact, the brand name of cigarettes and cigars as well. When Davis painted a second version of *The Barber Shop* in 1941, *New York under Gaslight* (cat. no. 36), the inclusion of words was meant to heighten the conceptualized unreality of the image. Thus, Davis went beyond what could be viewed as recognizable street typography, although his wit has worn rather thin here. Most interestingly, in *New York under Gaslight* he eliminated the words BETWEEN THE ACTS, perhaps because they had recently gained quite a different association as the title of Virginia Woolf's last novel, and replaced them with a self-referential sign underscoring the fact that the image is an illusion. The use of non-referential language, even if strained, here attains a new level, and the poster alluding to gin and jazz interjects other personal enthusiasms of the artist into a densely "inscribed" image.

If Davis was intrigued by the poetry of Apollinaire, or even "the thing that Whitman felt," the vernacular, too, became a recurrent strain in his literary preoccupations. The painting *Magazine and Cigar*, like Davis's mural for the Radio City Music Hall men's lounge (1932)—which also focused on masculine pastimes—introduces the detective story into his range of subjects. Such pulp fiction was becoming a popular staple at the time, and was also turned out by another of Davis's writer-friends, Elliot Paul. Perhaps in connection with the controversy in the art world over what constituted the "American Scene," Davis turned increasingly to his version of Americana, including popular culture. It is likely that no other painting is more polemical in this regard than the suggestively titled *American Painting* of 1932–51.

American Painting was a major effort for Davis, created specifically for a historic occasion—the first biennial exhibition of contemporary American painting at the newly opened Whitney Museum of American Art in New York. The work practically jumps out of the pages of the plates section of the Whitney catalogue, which is clogged with conservative, Realist art. This clean-lined and schematic composition was a conscious attempt to telegraph what American painting could or should be in 1932—hence its title. Davis was not alone in this aim: consider, for instance, Charles Sheeler's *Americana* (1931, Edith and Milton Lowenthal Collection, New York), an even cleaner-lined, photographic version of modernism, exhibited in the same premier Whitney Biennial. For Sheerer, Shaker furniture was emblematic of a quintessentially pure American cultural product, as jazz was for Davis. Thomas Hart Benton's *America Today* murals (1930–31, formerly The New School for Social Research, New York) were another contemporary bid for the distillation of native experience, as was the coloration of Georgia O'Keeffe's *Cow Skull: Red, White and Blue* (1931, The Metropolitan Museum of Art, New York).

In this context, one would expect a work entitled *American Painting* to manifest a similar definition of native art. Indeed, the couplet on the left edge of the canvas, *"It dont mean a thing/If it aint got that swing,"* does so. This Duke Ellington lyric is clearly analogized to the fine-art realm, which should "swing" with the bounce and rhythm of popular music. Specifically, Davis had a lifelong regard for jazz, considering it an authentic American art form that could appropriately grant a parallel authenticity to painting. "Real jazz, that is to say Jazz as an Art, is characterized by complete freedom in its expression."[12] A post-Lindbergh, Prohibition America plagued by gangsterism may also be the source of the outlined, inconsistently scaled airplane and the hand with a pistol in the composition, but this does not account for the atypical presence of figures in a Davis painting. Perhaps the artist aimed for ambiguity and a rather surreal sense of juxtaposition."[13]

The phrase LITTLE JOE on the fuselage of the airplane does provide a visual and conceptual center for a number of the disparate elements in the picture. In American slang, the expression refers to the number four in the game of dice.[14] Thus, the four dots next to the phrase become one face of a die—another optical pun recalling the beer/hat of *Rue Lipp.* "Fourness" extends as well to the unusual group of standing males behind the airplane. Could they be schematic allusions to those Davis felt would lead American painting forward?

Certainly, the men have never been identified, yet the images could still refer to a loose artistic alliance of Davis, John Graham, and Arshile Gorky, who were known as "The Three Musketeers."[15] One artist who recalled this group, Willem de Kooning, may himself be the fourth "Musketeer"; Jan Matulka is another possibility.[16] Such an alliance would be analogous to the three musketeers in the Alexandre Dumas novel who are joined by a fourth swashbuckler. Two sketchbook drawings of 1932, identifiable as heads seen in front of city-scapes, tend to support this interpretation.[17] More portrait-like than the gang of four in *American Painting,* one can be identified as Gorky and the other as a self-portrait. These drawings were not published until after the artist's death; Davis undoubtedly turned away from their specificity in the final canvas, which was earmarked as a more public work.

An indication of the import of *American Painting* in Davis's oeuvre is its later overpainting. Davis often redid compositions—indeed, theme and variation are the core of the late paintings—but *American Painting* is the unique canvas that was taken up again and reworked after being finished and publicly exhibited. As such, it is an unequaled palimpsest of Davis's shifting concerns, from the 1930s to the 1950s. Davis's notes on art theory reveal that he was very busy in the fall of 1948 revising the composition of *American Painting.* He does not write directly of his intentions, but he did make an exceptional number of studies for the picture—seventeen within the three-

Stuart Davis, *American Painting,*
1932–51
Oil on canvas
Joslyn Art Museum,
Omaha, Nebraska

Stuart Davis, *American Painting,*
1932 (original state)
Oil on canvas
Photograph, Collection Earl Davis

week period from September 10 to 30, 1948—followed by a few sporadic sketches in subsequent months, into 1949. It is clear from these studies that September 1948 was the major period in Davis's rethinking and reworking of the earlier canvas. The writings accompanying these sketches speak of the neutralization of the "subject cliché": "The C[olor]-Art concept makes all subject matter immediately available by neutralizing it."[18] Nonetheless, there remains a "continuity of subject meaning," even after changes are made: "Such ideological sequences contain repudiations and erasures of themselves as part of their continuity."[19] Just what aspect of the subject is "erased" by Davis's addition of the word *Eraser* in the center has not been posited. The death of his old friend Arshile Gorky on July 21, 1948, surely prodded Davis to think about what American painting had been in the thirties, and soon after (in September) sent him back to *American Painting,* his sixteen-year-old canvas. The exceptional decision to overpaint it was therefore particularly motivated by the desire to update the four-figure group.

Most suggestive in this regard is Davis's compositional sketch of September 21, 1948, executed exactly two months after Gorky's suicide. The second figure from the right encloses a linear doodle within its outline—a tangled script that is more legible in other sketches as the word *Eraser.* It begins with a horizontal capital *E* at the bottom, and proceeds up to a thickened *r* before becoming unreadable, As the word is entirely within the outline of the figure, it is clear that he is the one "consigned to the dimension of memory."[20] Davis thus achieves a public "neutralization" of a highly charged recollection that, nonetheless, is buried within the "continuity" of the canvas's meaning. Furthermore, the process of reworking *American Painting* led to the development of the concept of "the Amazing Continuity"—one of the theoretical bulwarks underlying Davis's late 1940s transition to his monumental, final style.

Three years later, Davis began yet another campaign of repainting, interspersed with the beginning of work on the new canvases *Visa* and *Owh! in San Pao* (cat. nos. 43 and 44). His art-theory sketches of September 24–27, 1951, introduce the alliterative title ENGROSSED AT GROSSINGERS for the reworked *American Painting.* Although striking primarily for its pure alliteration, this phrase brings to mind both Grossinger's bakery on Columbus Avenue in Upper Manhattan, as well as the renowned Catskills resort hotel. Over the heads of the four men, he also inserted the word ELSE, as in "somethin' else." Davis further posited, "Else is the 4th dimensional Eraser"—in other words, *Eraser* in another dimension, somewhere else. At this point, *Eraser* itself had shifted from the "dimension of memory" (implying Gorky) to that of "obsolescence."(Davis never felt he had to be consistent about his homespun definitions, and their meanings often evolved over time.) A few days later, on September 29, Davis leapt beyond the fourth dimension, when he defined "the Amazing Continuity" as "a Shape of 5 dimensions." This meta-concept encapsulates the constants in the artist's experience of this canvas over two decades.

In *American Painting,* as it was left in 1951 and appears today, ELSE has become a black bar over the head of the third, "*Eraser*" figure. The other words added to the composition neutralize or cancel out the old subject on a conceptual level, while still leaving large parts of the original linear structure visible. Thus, NO stands for "the Idea of No Idea," and *Any* for "any subject matter."[21]

Davis continued to toy with this motif in his art-theory papers: imagining the top-hatted man and the woman from the 1932 version of *American Painting* in front of a television with rabbit-ear antennas (February 21, 1952), writing about the subject of the 1932 *American Painting* (March 1, 1952), making an "Eraser" sketch (May 21, 1952), changing the word *Eraser* to *Every* (February 18, 1952ff.). On April 20, 1953, he drew the composition two more times. Then, almost a year later (April 13, 1954), he drew a jewelry-like design, labeled *Ornaments,* extracted from the configuration of the woman's eyes and nose. Finally, a new, yellow-ground version of *American*

Stuart Davis, Study for *American Painting,* September 21, 1948
Ink on paper
Harvard University Art Museums,
Fogg Art Museum,
Cambridge, Massachusetts.
Gift of Mrs. Stuart Davis

Stuart Davis, Study for *American Painting,* September 24–26, 1951
Ink on paper
Harvard University Art Museums,
Fogg Art Museum,
Cambridge, Massachusetts.
Gift of Mrs. Stuart Davis

Painting (Tropes de Teens of 1956) seemingly brought the theme to a conclusion. Yet, as late as mid-1962, Davis told an interviewer that he was still considering repainting the original *American Painting,* which he had placed on his easel. Although he termed it "not resolved," he apparently did not further alter this palimpsest of three decades of his life and career.

The Late Works

With the inclusion of the Champion matchbook cover in *Little Giant Still Life* (cat. no. 40*),* followed by *Visa* (cat. no. 43), Davis returned to the smoking-related subjects of his early career—particularly to the "Tobacco" series of 1921, as well as to works such as *Matches* of 1927 (cat. no. 20). The last painting, while identical in subject to those later pictures, contains no lettering, and thus relates to strictly planar Cubist compositions like the contemporaneous "Egg Beater" series. In his theoretical writings on art, Davis typically emphasizes his formalist approach, which downplays content, citing the "book of matches with printing on it" as notable only for its "lack of interest."[22] At the same time that he views the content of *Visa* as "my Unconcern with the Meaning of this Subject,"[23] Davis is nonetheless cognizant that such lowly, commercial subject matter has its own agenda, which he "champions": "The Cunning of the Commercial Designer of Match Box Covers, Cigar Box labels... must be loved."[24] In this way, he was implicitly opposing the "high culture" of the new American painting and its grand and weighty subjects, the "tragic and timeless." With *Champion,* as he first called *Visa,* Davis ironically crowned himself the proponent of the lowly, humble, and quotidian.

Visa is a further emboldening of Davis's word-pictures. The letters of CHAMPION are entirely flat, and the pictorial space becomes that of the printed page. Davis stakes the entire composition on letter images, or what he speaks of as "the manufacture of the Word-Shape."[25] Once established, the "Word-Shape" continued to develop as a major innovation in Davis's late works.

An important forerunner of Davis's word-pictures was the work commissioned by the Container Corporation of America, which chose a group of artists to depict each of the forty-eight states in their "United States" series of advertisements beginning in 1946. Unlike the others who were commissioned, Davis incorporated the name of the state—his native Pennsylvania—in his design, along a zigzag vertical axis. The banderole containing the word *Pennsylvania* echoes the configuration of the familiar crack in the Liberty Bell, shown on the lower left. Between the banderole and the bell is a tricorne—a less familiar symbol, and therefore discretely labeled W. PENN after William Penn, the Quaker founder of Pennsylvania, for whom the state was named. (A monumental statue of Penn, sculpted by Alexander Milne Calder [1846–1923], stands atop Philadelphia's City Hall, his three-cornered hat until recently the highest point in the city.) The role of the word *Pennsylvania* in the gouache is not as dominant or dramatic as that of CHAMPION in such paintings as *Little Giant Still Life,* although it is a vital, calligraphic component of the composition; its inclusion, however, is quite unusual in the context of the rest of the series of advertisements, which generally features typical scenes of each state, also done by a native artist. Few of the artists commissioned used typographic elements in their designs. An interesting exception is fellow Downtown Gallery artist Jacob Lawrence, who lettered the names of the cities to identify his various scenes of New Jersey. These Container Corporation advertisements were published monthly in *Fortune*; Davis's design appeared in October 1946, and Lawrence's that December. *Fortune* itself commissioned and published Davis's apotheosis of commercially based word-pictures, *Package Deal* (1956, Private collection), exactly a decade later.[26] Davis took such commissions seriously, and his approach demonstrates that he did not subscribe to an exclusivist notion of fine art. For him, not only were the

Stuart Davis, *Pennsylvania,* 1946
Gouache and pencil on paperboard
National Museum of American Art,
Smithsonian Institution, Washington,
D.C. Gift of Container Corporation
of America

lines between "high" and "low" art blurred, as with so many other modernist artists, but he believed that the ordinary "topical subject" is actively prized by the "real" or "hip" artist for its raw freshness and unpretentious directness: "The Most Artist... accepts the Banal and gives it a Bust in the Nose."[27] This "punchy" banality undermines the traditional conception of the fine-art subject. Davis's notes clearly indicate that he was fully aware of the implications of such choices: "I like popular Art, Topical Ideas, and not High Culture or Modernistic Formalism."[28] Thus, over a decade before the emergence of Pop Art in America, Davis foresaw that popular culture was a way out of the dead end of "modernistic formalism."

The terse title *Visa* gives another inflection to the CHAMPION motif, implying the crossing of borders and relating to Davis's ambition to paint canvases of international import. Two years earlier, Davis had written of his "Neutral Subject-Logic concept" as a "passport of finesse."[29] Now he confidently asserted, "The Amazing Pads are Absolute Universal Expression... They are an International Currency."[30] Then, in a surprising prediction of the transformation of art into a multi-national commodity, he explained that such pictures were "an Internationally accepted market security. This Stock is called Pad, Inc. The Artist-Broker is not emotionally attached to his shares."[31] In critiquing the Action Painters, Davis comes out sounding clear-eyed and contemporary: "A Great Picture is not a special revelation of transcendental mood... It is a product of routine work in realistic logic which includes its Social Use and Distribution through Retailers."[32] Thus, for Davis this "Amazing" canvas was cleared for international travel, as well as for the global art market.

The proliferation of large, international exhibitions of contemporary art in the 1950s seems to have contributed to Davis's cosmopolitan outlook. These included the Venice Biennale, revived after World War II—Davis's work was shown there in 1952—as well as the São Paulo Bienal, founded in 1951. The initial American representation in the latter comprised a sizable group of works selected by a jury of museum curators and overseen by René d'Harnoncourt of The Museum of Modern Art in New York. *Visa* was, appropriately, one of Davis's three "envoys." Notes in his desk calendar reveal that he was working against a deadline of August 15, 1951. *Visa* was finished and picked up on August 13, but *Motel,* another painting in progress, was still being worked on as of mid-August.[33] It was apparently not completed in time for the Bienal, and Davis incorporated his likely disappointment in his choice of a new title for the picture: *Owh! in San Pao.*

The Amazing Continu-ity., which appears on the far right in *Visa,* is an oft-repeated phrase in Davis's theoretical writings at the time that went through many permutations, from the personal to the social. With sly humor, the last word is, in fact, not continuous, but hyphenated onto a second line. On one level, the phrase obviously refers to the consistency within the artist's development and, in particular, to his conceptualization of art—for instance, in "its contradictions, the inexorable casualness of its idiom."[34] As we have seen, Davis's sense of "continuity" was undoubtedly heightened by his contemporaneous retouching of *American Painting*—a canvas begun in 1932 but overpainted in the 1940s and again in the early 1950s. As Davis reassured himself, "Art is Nows [*sic*] in the Dimension of Continuity which makes all Nows Equal."[35] Or, "The Amazing Continuity is the New Idea that a New Idea is Any Idea which is Complete."[36] He also takes the phrase beyond art into the social sphere: "The Amazing Continuity is the Hip Phrase which Erases the Square Phrase 'Freedom',"[37] and he goes further, devising one of his best-turned definitions, "Society is the Amazing Continuity between the Subjective Individual and the Display Window of History."[38]

Nonetheless, in keeping with Davis's developed sense of paradox, this concept can also be seen as its opposite—discontinuity—where the only constant is "the experience of Change" itself.[39] Similarly, somewhat later he writes, "The Amazing

Continuity is not an Order of Likeness but a system of Unlikeness"[40]—or, as contemporary theorists would put it, of difference.

In explaining the new title of *Motel* (the painting contemporary with *Visa), Owh! in San Pao,* Davis claimed that he modified *ouch*—a reflection of painful "reality"—so it would rhyme with the name of the locale for which the work was originally intended.[41] The "pain" may have been the disappointment of not being able to exhibit this new canvas after all in the Bienal.

This uniquely named composition also includes the unusual phrase We *used to be*—NOW. Now is linked to *Owh* phonetically, but also conceptually: "The Plentitude of Now,-Ouch! Alliteration changes the 'Ouch' to 'Owh'."[42] This also may be a reflection of how "now" or up-to-date Davis felt in the art world. Although this canvas was soon shown at the Whitney Annual of 1951, Davis had not been represented there the previous two years, when the younger Abstract Expressionists were first presented in force. Davis was well aware of this development, but while he critiqued Robert Motherwell's paintings, he nevertheless made simplified sketches after works by Mark Rothko and William Baziotes. Did Davis sense that the New York School was pushing the older generation of modernists out of the limelight?

The vertically aligned ELSE on the left side of *Owh! in San Pao* links that painting to *Visa,* in which the same word appears at the lower center. In some early sketches for the latter composition, this place had been reserved for *visa,* but the word eventually migrated to the title instead. Thus, there is a certain interchangeability in the pictures of this period between the words on the canvases and the titles. We have already seen ELSE in studies for the revised *American Painting,* over the head of the "Eraser" figure. In many ways, then, these works of the early 1950s form a cluster— sharing interrelated and reciprocal themes—that can only be understood when the individual pictures are analyzed as a group.

Davis considered the title *Engrossed at Grossingers* in connection with sketches for the revision of *American Painting,* as well as for the composition that became *Rapt at Rappaport's* (cat. no. 45), a similarly alliterative appellation. This last picture is also based on a 1920s motif—an example of the "Amazing Continuity" phenomenon again—a landscape with a building alongside a body of water.[43] In the studies for *Rapt at Rappaport's,* Davis also developed the "International Surface" concept —a further reference to the global market for paintings. He also writes of "pairs of colors" and the "switch" or "diad quanta," which appears to be a term for a binary system. The "diads" seem to be the pairs of new versions of old compositions.

The 1952 painting *Rapt at Rappaport's* has a pendant, *Semé* (cat. no. 46), from the following year. *Semé* is a French word defined in Davis's notes as "scattered, dotted, powdered."[44] The status of these two canvases as a "color pair"—or a so-called "diad quanta"[45]—is underscored by the inclusion in the upper left corners of a plus sign and a minus sign, respectively. With these symbols Davis signals a binary opposition, like positive and negative electrical charges, even though the dominant background color in both pictures is green (albeit different shades).

These works may be regarded as strictly dialectical pendants—"Opposites in total sequence continuity is properly called the Theory of Pairs"[46]—but, nonetheless, they sometimes represent less of an opposition than theme and variation. In fact, almost all Davis's works of the early 1950s are pendants, such as *Something on the 8 Ball* (cat. no. 47) and *Medium Still Life* (The William H. Lane Collection, Boston), and *Colonial Cubism* (cat. no. 49) and *Memo No. 2* (1956, Southwestern Bell Corporation, St. Louis), among others. These "diads" are all based on 1920s motifs, and thus are, appropriately, examples of the "Amazing Continuity": "The principle of Continuity is recognized by this concept of comparative Pairs..., Continuity of Pairs in Space-Time."[47] In one case Davis even combines a pair of views on a symmetrically divided canvas whose title, *Deuce* (1951–54, San Francisco Museum of

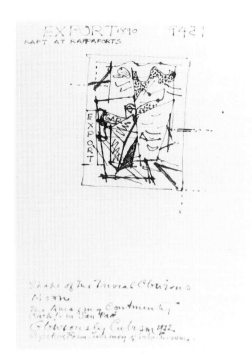

Stuart Davis, Study for
Rapt at Rappaport's,
September 4, 1951
Ink on paper
Harvard University Art Museums,
Fogg Art Museum,
Cambridge, Massachusetts.
Gift of Mrs. Stuart Davis

Modern Art. Gift of Mrs. E.S. Heller), emphasizes its diptych-like quality.

As the designation *Deuce* suggests, beginning with the wonderfully alliterative *Report from Rockport,* Davis bestowed on his pictures some of the most inventive appellations in American art of the 1940s and 1950s. During this time, against a flood of numerically titled or even untitled works by the New York School, Davis gave his considerable thought, and began to blend English with French in increasingly complex plays on language. As he affirmed, "The idea of an interesting Name for a painting is an important part of the Shape of Art Content."[48] Later, discussing the centrality of titles, he explained, "Titles in art are important because they are integral with the visual image and enrich it."[49] Some of his most interesting, such as *Tropes de Teens* (Hirshhorn Museum and Sculpture Garden, Washington, D.C.) or *Letter and His Ecol,* have remained undeciphered; others, such as *Contranuities* (1963, Private collection), seem to coin new English words.

Among American modernist artists, perhaps Davis, above all, had "something on the ball," yet, historically, he found himself "behind the Eight ball" when it came to the growing recognition of American art. Davis combined these two expressions in the catchy title *Something on the 8 Ball*—a 1953–54 revision of *Matches* of 1927. The artist introduced a new word-concept: "Facilities is the control power of the Delegated Power of Free Decision."[50] In *Something on the 8 Ball,* Davis split up the word *Facilities* on two lines, creating an elaborate pun, "Facile-it-is," that also referred to the "ease" of "free choice." In part, this means the artist is free to use any subject matter, or *any* IT, as he wrote in his notebooks and across the upper left part of the painting itself,[51] including "any" one of his own old motifs. The title *Something on the 8 Ball* was first recorded on July 25, 1953, but sketches for the actual composition were not made until a month later. The word *Facilities* first appears in a sketch of August 26, 1953, which Davis accompanied by studies for splitting it up. Like his earlier "Eye-ideas" pun, it is doubtful that "Facile-it-is" was understood by much of the public during the painter's lifetime.

A similar pun, the title *Contranuities,* has resisted decoding until now. With "Contra-new-it-is," Davis originated a title manifesto for his own recidivist compositions, implicitly denouncing the cult of the "new" that was beginning to overtake the art world. The forms in the 1963 *Contranuities* follow quite closely those in the 1931 canvas *Summer Twilight*—a painting Davis no longer owned—turned upside down. Oriented thus, the central bird becomes a black-and-white abstract shape. In this case, Davis may have appropriated the image from Eugene C. Goossen's 1959 monograph on Davis, or from a photo of the earlier, 1931 work. The "Contra-new" is literally a demonstration of Davis's belief in the viability of his old configurations, as well as a critique of novelty for its own sake.

Tropes de Teens (1956)—yet another unique and puzzling title that seems to come from Davis's special bilingual dictionary—is a play on the words *Teen-Tropes.* Davis zoomed in on the central portion of the original composition of *American Painting* in this variant. There are also a number of changes in detail: the Duke Ellington lyric is rendered as illegible calligraphy; the artist's signature appears toward the middle of the canvas, below the first *r* of the word *Eraser*; and, on the lower left, a blue *X* was added. On the most obvious level, the title appears to refer to teenagers' figures of speech, or to their slang expressions, however Davis's notes of 1956 reveal another, more obscure personal association: the "Voices used like Trumpets/Real Crazy Syncopation" of the medieval music of Guillaume Dufay.[52] Thus, *Teens* alludes to this "jazzy" counterpoint of the fif*teen*th century, while *Tropes* not only signifies "figures of speech" but also, according to Webster's dictionary, "phrase[s] or verse[s] added as an embellishment or interpolation to the sung parts of the mass... during the medieval period." That Davis may have intended to convey a third meaning is possible when one recalls that the title *Tropes de Teens* superseded *Teen-Tropes,* and that

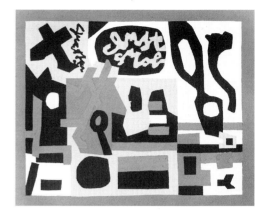

Stuart Davis, *Letter and His Ecol,*
1962
Oil on canvas
The Pennsylvania Academy
of the Fine Arts,
Philadelphia, Pennsylvania.
John Lambert Fund

among the literal tropes in our century are Guillaume Apollinaire's imagistic *Calligrammes,* or poems, dating from the *19teens* (1918).

Titles of this type represent a split in the public and private spheres of Davis's artistic persona. More often, he culled the most up-to-date references from contemporary life: from the space age and unidentified flying objects (*UFO,* Private collection), fashions (*Ready-to-Wear,* cat. no. 51), and the new computer technology (*Punch Card Flutter No. 3,* cat. no. 62)—the only interests the unpretentious Davis acknowledged publicly, in his gruff style. Therefore, in the past, few viewers of Davis's works would have been aware of the allusions in the titles to historic figures such as Dufay or Apollinaire.

In his notes about art from the last few years of his life, Davis wrote increasingly cryptically about "the Letter"; for instance,"the Letter is 2/front and back," or "the Letter and his Read-Ecol."[53] "The Letter" seems to emerge as a distilled symbol of the pictorial aspect of language. *Letter and His Ecol,* the title of a small canvas of 1962 as well as of two black-and-white versions identical in size, is an overlooked word-picture whose bilingual title, like *Tropes de Teens,* has remained mystifying. Included prominently at the top of the composition are *Inst* and *Ecol* in nearly illegible calligraphy, both words cut off at the right by the rounded edge of their black field. If French, the first word could be an abbreviation of *Institut [de France],* the subject of an earlier gouache Davis painted in Paris, and the seat of the Academic des Beaux-Arts. If English, an entry among Davis's art-theory papers gives the most likely explanation: "Letter is Ident[ity] of Instant Formula"[54]—suggesting the first word is short for *Instant.* This is Davis's self-defined term for the all-at-once impact of a picture, similar to the "punch-card" concept. With the title *Letter and His Ecol,* Davis seems to have wanted to affiliate himself with a "school" (or *école*) of Lettrism—with those who would use language in pictures for its visual impact as well as for its verbal associations. At the time, he continued to make the important claim—reinforced by the multicolored ANY on the lower right of *Letter and His Ecol*—that "words & phrases, and their Meaning, are part of the Form-Shape of Drawing even if they appear only in the title. They are integral with the unanalyzed Given Any content."[55]

Such letter-paintings as *Lesson I* of 1956 (Private collection) suggest the kind of "lesson" given in Davis's *Ecol.* A large, white *X* cancels out the right side of a simplified Gloucester landscape, with boats painted in red, black, and green—the "Given Any content." At the lower right, the word *Speech* in red asserts the strongest visual suggestion that, for Davis, language parallels painting as a system of signification; letters (like the *X)* are the basic units of words and of speech, just as colored shapes are the building blocks of images.

With the wit of Davis's alliterative titles and puns, it is possible to lose sight of the deeply serious side of his plays on words. The artist staked his later career on continuing the *peinture-poesie* tradition, which placed him in opposition to Abstract Expressionist action painting. Indeed, by the fall of 1954, Davis would define art as, "the Shape of Language"[56] (not an arena in which to act). Later, he told an interviewer, "Physically words are also shapes."[57] His commitment to the physicality of the word in the thousands of pages of his own theoretical writings on art was not a separate activity, but an integral part of the process of creating form.

Thus, words and letters for Davis were not embellishments, but rather a touchstone —a system parallel to visual art or, at times, the subject itself of that art: "The Alphabet Syntax and Language of Color-Space Method become the Object... as they take the place of Subject as Given."[58] Davis has always been touted as an all-American precursor of the Pop Artists, but, however improbable it may seem, his work can also be seen as a harbinger of the profusion of language-involved art forms that have evolved since the late 1960s.

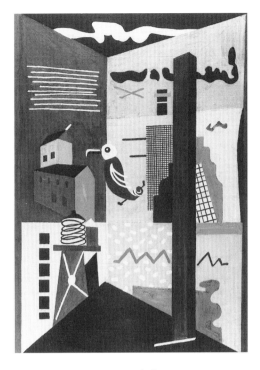

Stuart Davis, *Summer Twilight,* 1931
Oil on canvas
Collection of the Montgomery
Museum of Fine Arts, Montgomery,
Alabama. The Blount Collection

* Lewis Kachur's "Stuart Davis's Word-Pictures" was originally published in *Stuart Davis, An American Painter* by The Metropolitan Museum of Art, New York. Copyright © 1991 by The Metropolitan Museum of Art. Reprinted by permission.

Research for this essay was completed with the support of a Chester Dale post-doctoral fellowship at The Metropolitan Museum of Art, New York, during the 1989–90 academic year. I would like to thank William C. Agee, Earl Davis, John R. Lane, and Lowery S. Sims for their assistance and helpful suggestions.

[1] C. Greenberg, "After Abstract Expressionism," in *Art International*, no. 6, October 1962, p. 30.

[2] Stuart Davis, Notebook: 1920–22, March 12, 1921, p. 19. Private collection.

[3] *Ibid.*, May 1921, p. 35; May 29, 1921, p. 38.

[4] Stuart Davis Papers, September 5, 1952, Harvard University Art Museums, Fogg Art Museum, Cambridge, Massachusetts.

[5] Stuart Davis, Notebook: 1921–23, March 11, 1921, no. 40. See also J.R. Lane, *Stuart Davis: Art and Art Theory*, exhibition catalogue, The Brooklyn Museum, New York 1978, no. 7.

[6] Stuart Davis, Notebook: 1920–22, June 1, 1921, no. 41. Private collection.

[7] K. Wilkin, *Stuart Davis*, Abbeville Press, New York 1987, p. 70.

[8] Unsigned, "Even in Grinnich There's Nothing as Odd as Emblazoned Walls of 'Nut Shop' Here," in *Newark Evening News*, May 16, 1921; clipping preserved in Stuart Davis, Notebook: 1920–22, p. 33. Private collection.

[9] Stuart Davis, Notebook: 1920–22 [after September 22, 1922], p. 55. Private collection. A similar sketch and plan for another mixed-media work, "8th AVE," appears above on the same sheet.

[10] This picture is discussed at length in L. Kachur, "Stuart Davis and Bob Brown: The Masses to The Paris Bit," in *Arts Magazine*, 57, 2, October 1982, pp. 70–73.

[11] Letter from Stuart Davis to his friend the image-poet Bob Brown. September 25, 1929. Robert Carlton Brown Papers, Special Collections, Morris Library, Southern Illinois University at Carbondale. Davis gives the formula "8 McSorleys Ales = 5 or 6 Demi Lipps."

[12] Stuart Davis Papers, March 5, 1949, *op. cit.* In his notes of March 8, Davis refers specifically to American jazz.

[13] Contemporary reviewers of the Whitney Biennial do not discuss the painting's imagery, but several classify it as "Surrealist." See, for instance, R. Flint, "Whitney Museum Opens Its First Biennial Show," in *Artnews*, 31, 9, November 26, 1932, p. 4.

[14] Unsigned, *American Notes and Queries*, 1, April 1941, p. 7. In an important parallel, Davis's friend Bob Brown also used the phrase "Little Joe" as a reference to dice in his slightly earlier and equally American story "National Festival: G.W., 1732–1932," in *American Mercury*, December 24, 1931, p. 405: "Roll them bones, Little Joe!"

[15] John Graham alludes to the group in a letter to Duncan Phillips of December 28 [n.d.], pp. 2–3, in the Phillips Collection Archives, Washington, D.C.: "Stuart Davis, Gorky and myself have formed a group and something original, purely American is coming out from under our brushes. It is not the subject matter that makes painting American or French, but the quality, certain quality which makes paintings assume one or the other nationality." Thus, even the Russian-born Graham associates this confederation with uniquely American art.

[16] J.T. Valliere, "De Kooning on Pollock," in *Partisan Review*, 34, Fall 1967, p. 603. P. Sims (in *Jan Matulka 1890–1972*, exhibition catalogue, National Collection of Fine Arts, Smithsonian Institution, Washington, D.C. 1980, pp. 27–28) presents some evidence that, Davis organized an exhibition at the Art Students League of New York in 1930 or 1931–32 that included works by these three artists plus Matulka.

[17] Stuart Davis, Sketchbook: 9–21, illustrated in D. Kelder (ed.), *Stuart Davis: A Documentary Monograph in Modern Art*, Praeger Publishers, New York, Washington and London 1971, p. 62 lower right.

[18] Stuart Davis Papers, September 14. 1948, *op. cit.*

[19] *Ibid.*, September 16, 1948.

[20] Lane, *op. cit.*, no. 80, p. 155.

[21] *Ibidem.*

[22] Stuart Davis Papers, October 20, 1949, p. 3, *op. cit.*

[23] *Ibid.*, December 26, 1950, p. 7.

[24] *Ibid.*, October 9, 1951.

[25] *Ibid.*, November 1, 1951. Davis soon would define the "Word-Shape as Subject" and stress its calligraphy, "drawn freely in an invented shape which carries the mood of the doing" (November 20, 1951ff.).

[26] Unsigned, "Still Life from the Supermarkets," in *Fortune*, 54, 3, September 1956, p. 140. The "United States" series is documented in *Art, Design, and the Modern Corporation: The Collection of the Container Corporation of America*, exhibition catalogue, National Museum of American Art, Smithsonian Institution, Washington, D.C.,1985, p. 58.

[27] Stuart Davis Papers, October 21, 1951, *op. cit.*

[28] *Ibid.*, December 17, 1950. On December 25, Davis elaborated on this in relation to *Lucky Strike* (cat. no. 12).

[29] *Ibid.*, September 28, 1948.

[30] *Ibid.*, August 14, 1950.

[31] *Ibid.*, August 22, 1950.

[32] *Ibid.*, July 14, 1951.

[33] Stuart Davis Calendars, July 17 and 23, and August 13–16, 1951. Copies kindly supplied by Earl Davis.

[34] Stuart Davis Papers, November 19, 1951, *op. cit.*

[35] *Ibid.*, August 2, 1952.

[36] *Ibid.*, November 17, 1951.

[37] *Ibid.*, October 19, 1951.

[38] *Ibid.*, September 4, 1951.

[39] *Ibid.*, October 14, 1951.

[40] *Ibid.*, November 1, 1951.

[41] Lane, *op. cit.*, p. 168. According to entries in Davis's calendars, the work was originally titled *Motel Cadillac* or *Motel Pad* (July 11, 1951), just *Motel* (August 17, 1951), *Motel Detroit* (August 26), and finally, in an unusual full-page note, "Title for Motel/Owh! In San Powh [*sic*]" (August 31). Davis's notations for Tuesday, July 17, 1951, indicate he was to phone Andrew C. Ritchie of The Museum of Modern Art "next Monday [to ask] whether Motel can be available." As mentioned above, *Visa* was collected by the shippers on August 13, while Davis continued to work on *Motel* after that date.

[42] Stuart Davis Papers, January 19, 1952, p. 2, *op. cit.*

[43] This painting is incorrectly titled *[Landscape with Saw]* in *Stuart Davis (1892–1964): Motifs and Versions*, exhibition catalogue). Foreword by William C. Agee; introduction by Lawrence B. Salander. New York: Salander-O'Reilly Galleries, 1988, colorplate 7.

[44] Stuart Davis Papers, January 1951, *op. cit.*

[45] *Ibid.*, August 31, 1952, and September 3, 1952.

[46] *Ibid.*, December 3, 1953.

[47] *Ibid.*, March 25, 1954ff., and April 7, 1954.

[48] *Ibid.*, September 27, 1951.

[49] *Ibid.*, October 27, 1960.

[50] *Ibid.*, January 1, 1953ff. "Free Decision" is further described there as "the gift of free choice."

[51] *Ibid.*, August 10 or 25, 1953: "ANY IT is Constantly Given. E[nvironment] itself is seen as an IT."

[52] *Ibid.*, December 7, 1956 [?]. This sheet comes after July 1956, but not in the sequence of the December 1956 papers. The complete edition of the works of Guillaume Dufay (1400–1474), who is noted for composing the first cyclical Masses, was published beginning in 1947. Dufay may have been brought to Davis's attention by his friend Meyer Schapiro, the art historian and medievalist. Davis goes on to relate Dufay's "syncopations" to "Earl Hines['s] 'Trumpet Style' idea."

[53] *Ibid.*, n.d. [following February 1963 and March 22, 1963, respectively].

[54] *Ibid.*, following January 5, 1963. The title *The Letter & his Ecole* [*sic*] appears with a sketch on the next page.

[55] *Ibid.*, n.d. [1963–64]; undated group of pages at the beginning.

[56] *Ibid.*, September 27, 1954.

[57] K. Kuh, *The Artist's Voice: Talks with Seventeen Artists*, Harper & Row, New York and Evanston 1960, p. 52.

[58] Stuart Davis Papers, June 6, 1960, *op. cit.*

Stuart Davis (A European Memoir)

Rudi Fuchs

Somehow, when I began to take proper notice of American art, Stuart Davis was always around. I knew about his paintings before I ever saw one. He figured rather prominently in Barbara Rose's book *American Art since 1900*[1] (1967), probably the first book on the subject that I read all the way through. She assigned Davis an important role as a former student of the Ashcan School-painter Robert Henri, and credited him with being the first American artist "to appropriate successfully the means of French art toward the end of making distinctively American pictures." She also established a lineage in the American tradition by noting Arshile Gorky's admiration for Davis.

So there he was: a historical figure of distinction but hardly known in Europe. Apart from his show at the Venice Biennale in 1952, he has never had a proper European exhibition; he is largely absent in European public collections. I also recall (and I have checked that my memory serves me well) that Clement Greenberg, a powerful advocate of American art (I avidly read his *Art and Culture*[2] anthology years before I saw the book by Barbara Rose), had a somewhat mixed opinion. He found the work too decorative. "Great taste but little force," he once noted about Davis—and he expressed the same reserve about Calder, with whom he often paired Davis.

The European public became aware of American art only in the fifties. It was the painting of the Abstract Expressionists that caught our attention and it was that art, large-scale and provocative, that by and large informed the European public of what American art was really about. The great, influential New York critics of the time, men like Clement Greenberg and Harold Rosenberg, defined Abstract Expressionism as the first *real* American art. There had been art in America before that time, of course, but in the old days most artists had struggled with powerful European influences (as, presumably, Stuart Davis had struggled with Léger and Miró). Whatever was American about American painting resided in the subject-matter: John Sloan doing street scenes and domestic life, George Bellows painting boxing-matches and American landscapes as did, after a stint with modernism in Paris and Berlin, Marsden Hartley. Georgia O'Keeffe painted the Southwest, Charles Demuth and Charles Sheeler the urban and industrial landscape. There was the popular Reginald Marsh, the realist Thomas Hart Benton, Pollock's teacher, and of course Edward Hopper. Important as this slowly growing inventory of American subject-matter may have been (mostly in some variant of a realist style: what the artists saw at home, rather than their imaginings in pastoral dreams), it did not lead to dramatic stylistic inventions. Eventually, as in Davis's work, Cubism had its impact and with it came the possibility of an abstracting stylization of shapes and of flat, bright colors—the kind of semi-abstract style that Greenberg called decorative.

If we see the establishing of Abstract Expressionism as the first great American art, and as the most advanced art around, as a *campaign* ("New York taking the lead"), it was in the interest of the organizers to play down previous art in America. To what

extent this happened in America itself I cannot judge. The European public (and European museums) were content however. They were convinced that Abstract Expressionism was indeed very good, and better, more expansive and imaginative, than most contemporary European art, with the exception of course of some of the great masters then still alive like Matisse, Picasso or Miró. Whenever new art such as Abstract Expressionism has such an impact (as was to happen again with Pop Art and Minimal Art in the sixties and seventies), it is bound to obscure the work of previous artists, possibly minor yet distinctive—and eventually one begins to realize the historical unjustness of it all.

The situation is classic. Most Europeans were largely unaware of artists like Stuart Davis (and of the others I mentioned above) because they could not see them in the European Museums that had been seduced (and why not?) by Abstract Expressionism. When instead Europeans went to New York they could not see much of the pre-war American artists either, because American museums were engaged in defining the new modernist canon that placed the new American art in front, right next to the classic modernists from Europe. Perhaps we should reproach ourselves for allowing such a categorical view of modern art to come into existence. Likewise, Americans may reproach American critics, collectors and museums for sometimes ignoring contemporary, post-war European art—even such painters as Asger Jorn, Karel Appel, Emilio Vedova or Antoni Tápies who are of an Abstract-Expressionist persuasion.

I repeat, such instances of mutual ignorance are classic. (I must be a little careful. There was some interest in European art in New York in the sixties, especially at the Guggenheim Museum, and not only for Dubuffet who was always, I do not know why, the most popular. The relative neglect came later. It was there, at any rate, when I became interested in these matters—and it was all the more marked as, by that time, around 1970, all European museums were deeply engaged in showing and collecting contemporary American art.)

Yet, Stuart Davis was somehow around, in the wings, if only because he reminded me of certain European painters such as Léger, whom I liked. I cannot remember when I first saw his work in the original, but I do remember that I loved his clarity, his crispness. European art of a similar kind tends to be more complicated, overly ambitious —and I liked Davis's simplicity. Then my friend Donald Judd started to talk about him. He considered him a great painter. I think I understood why. It was the time, the early eighties, when Judd started to make those multicolored pieces that many people did not like because they considered them frivolous and therefore not properly minimal, not austere enough. If he had defended himself (which he wasn't much inclined to do, aloof and independent as he was), Judd might have said that all his art, from the very beginning, when he made some bright red pieces, was really about color. The shapes he used for his objects were always geometrically simple and matter-of-fact. Then they became *colored* objects; the color gave them a large part of their magic.

Maybe one should look at Stuart Davis's painting in a similar way. When he began he was, as some early paintings in this exhibition like *Consumer Coal Company* or *Ebb Tide, Provincetown* (cat. nos. 2 and 6) show us, an anecdotal painter, or a realist who had a great talent for finding a good "frame" in which he then ordered details in an arresting or surprising composition. Basically this remained his method throughout his career. *Summer Landscape* (cat. no. 28) was painted in 1930, after he had spent some time in Paris. It is an abstracted version of a real view. In this painting as in later work, bolder and more abstract though his shapes were, they were recognizable: one continues to find the same anecdotal vision. *Consumer Coal Company* is interesting because of the street lamp in front. That is the detail that gives the picture a quality beyond ordinary realism. It is Davis's invention, so to speak. His eye was tuned like that, and one sees this kind of observation in all his work until the end. This is the

continuous formal structure of the paintings, and it did not change or even much develop. There was no need to do so, as his real interest lay probably elsewhere—*with color*. In the early, realist paintings color had to conform to the atmosphere of the painting's lighting. In *Summer Landscape*, however, the objects are not modeled in light and shadow; they are drawn as flat, abstracted shapes. That he learned this from Léger and Miró is immaterial. He had discovered that in such a construction he could use colors brightly.

The formal structure of his paintings is always inventive and in general more lively and energetic than in most other painting, American or European, with the exception of Miró. The reason for this is, I think, that he (again like Miró) never became a real abstract painter. Most abstraction tends to formal balance and quiet order; Davis continued however to view his motifs with the lively eye of a realist, a storyteller. Shapes are dashing about, and so are colors. Davis became the master of the bright, multi-colored picture. He did not allow color to be adapted to formal rigor. He gave color a marvelous freedom. That is what Judd liked so much about Davis and that is why he considered him a great painter. I entirely agree.

[1] B. Rose, *American Art since 1900: A Critical History*, Frederick A. Praeger, New York 1967.

[2] C. Greenberg, *Art and Culture: Critical Essays*, Beacon Press, Boston 1961.

An American in Venice
Stuart Davis at the XXVIth Biennale

Federica Pirani

During the years of oppression under Fascism and during the Second World War, cultural relations between Italy and other countries of the West came virtually to a standstill. After the war, artists and intellectuals offered themselves as the prime movers of renewal, as bearers of liberty and instruments of moral pressure. In the post-war period more than in almost any previous epoch, the illusion that cultural intervention could bring about appreciable change in social dynamics was widely regarded as axiomatic.

This conviction, mixed with the hopes and enthusiasm of the Italians in the wake of the successful struggle to liberate the country from Fascism, was reflected clearly in artistic movements. On the one hand, art associated with the previous regime, from Sironi to Piacentini via Futurism, was rejected out of hand, without pausing to reflect on its figurative values; recent events were still too close to see such things in perspective.[1] On the other hand, an attempt was made to find a unifying, even if ephemeral style; Picasso was regarded as the unquestioned apostle of the true faith, and the syntax of Cubism was perceived as the language best suited to communicate the drama of the moment.

The temporary equilibrium established by the Fronte Nuovo delle Arti (Guttuso, Birolli, Vedova, Pizzinato, Corpora, Turcato, Santomaso and others),[2] paralleled by the movement in France known as Jeunes peintres de tradition française (Fougeron, Manessier, Estève, Bazaine, Pignon and Tal Coat),[3] was soon shaken, between 1947 and 1948, thus exposing the willed artificiality of the recently-forged union. If art could not but be political, then it had to follow the directives of the party; if instead it was not to be conditioned from the outside, then it must live exclusively through its own formal research.

While the notion of realism as an indispensable moral requirement, and of the national-popular language as a unifying idiom, found its ideal visual expression in the cinema of Rossellini, De Sica and Visconti, the self-same preoccupations caused lasting and insurmountable barriers within the figurative arts: between the advocates of realism and their abstract opponents (as yet decidedly in the minority). The opposing camps closed ranks and nowhere were the internal divisions so apparent as in the Italian Communist Party, which at that time occupied the cultural high ground and was practically the sole point of reference for Italy's intelligentsia. In the pages of *Rinascita,* party secretary Palmiro Togliatti went so far as to define the tame Neo-Cubist experimentation as "a collection of monstrosities... displaying horrors and idiocies."[4] There ensued a storm of anathemas, abjurations and bitter polemics: certain artists proclaimed themselves "Formalists and Marxists,"[5] while other left wing intellectuals moved away from the party, refusing to be "the pied pipers of the revolution."[6]

It was against this cultural background and in this atmosphere of hostility that the Venice Biennale opened its doors again after the war-time interruption. The task which its president Giovanni Ponti and its secretary general Rodolfo Pallucchini, had

set themselves was to parade the history of twentieth century Italian and international art, and above all the avant-garde movements: the art which had been obliterated, or at least veiled, under Mussolini. To this end, the Biennale organized a series of special exhibitions: of Impressionism, Fauvism, the Blaue Reiter, Futurism and, in 1952, Italian Divisionism and German Expressionism (thus doing justice to "degenerate" artists such as Otto Dix and Max Pechstein).

Equal, if not greater importance was attached to the increasingly extensive and influential presence of foreign countries; the participation of several North and South American countries at the 1952 Biennale was hailed as manifest confirmation of this tendency.[7]

The United States returned to the Biennale as early as 1948, and in the same year Peggy Guggenheim, at the invitation of Count Zorzi, exhibited her outstanding collection of avant-garde art in a pavilion specially designed by Carlo Scarpa. Two years later it was the turn of John Marin, together with a number of young abstract and figurative expressionists, to represent America. They were coolly received by the critics.[8]

Official recognition came in 1952 when Alexander Calder received the Grand Prix of the Presidency of the Council of Ministers for Sculpture.[9] The Commissioner for the Pavilion of the United States of America at the XXVIth Biennale was David E. Finley, director of the National Gallery of Art and president of the National Commission of Fine Arts. It was his decision to delegate to the American Federation of Arts, with its coast-to-coast organization, the task of selecting the artists. The Selection Committee was made up of directors and curators of major U.S. galleries and museums: the Brooklyn Museum, the Metropolitan, the Addison Gallery, the Whitney, the Art Institute of Chicago, the National Gallery of Art, and the Museum of Modern Art, New York. Rather than attempt an overview of contemporary U.S. production or a historical perspective, the selectors chose four artists only, an unprecedentedly restrictive number, in order to give a relatively complete picture of their individual careers.[10] The artists were Alexander Calder, Stuart Davis, Edward Hopper and Yasuo Kuniyoshi.

The choice was intended to present the two main trends in contemporary American art: on the one hand realism, typified by Hopper and Kuniyoshi, albeit with their respective originality and primacy of style; on the other the more abstracting tendencies of modernism.

Non-figurative art had come in for such heavy criticism from McCarthyism in the early 1950s that the directors of the Boston Institute of Contemporary Art and New York's Museum of Modern Art and Whitney Art Gallery had felt the need to issue a joint public defence of abstract artists accused of "un-American behavior."[11] Davis and Calder represented a kind of modernism already to some extent accepted by the cultural establishment; suffice it to mention that in 1948 Davis was recognized as one of America's ten best artists by a jury of museum directors and critics.[12] Conceivably the intention of the organizers in 1952 was to lend definitive credit on the international scene to modern abstract tendencies.

The Biennale was certainly one of the most prestigious showcases in the world for contemporary art.[13] This was not the first appearance of Davis's paintings there, but one can assume that they went virtually unnoticed in the crowded and heterogeneous pavilion installations customary through 1948. The entire gallery given to his work in 1952 amounted to his debut on the international scene, together with his participation in the first Bienal of São Paulo in Brazil the previous year. Expectations were high, and an impressive range of work was chosen in order to represent fully the whole
career of the artist. At the same time, in tune with his new-found stature, Davis began to include international words in his pictures—Visa for instance—and wrote in his diary: "Art is International Currency," July 27, 1951.[14]

The U.S. pavilion as a whole was planned by James Johnson Sweeney, director of the Solomon R. Guggenheim Museum, who had already organized Davis's solo exhibition at the Museum of Modern Art in October 1945. The selection of the individual works was entrusted to Andrew Carnduff Ritchie, curator at the Museum of Modern Art. Davis's contribution to the Biennale consisted of thirteen major pictures painted between 1916 and 1951, arguably the landmarks in his development to date. Many of the works selected for Venice had been among those cited, discussed and illustrated in Sweeney's 1945 monograph on the artist, or had appeared in Davis's autobiography written the same year.[15]

The works shown included a realistic landscape of 1916, as well as *Egg Beater No. 4*, 1928, a painting from the "Egg Beater" series which marked Davis's definitive move away from naturalistic forms, and which has been considered one of "the first truly abstract paintings to be made in this country [U.S.A.]."[16] Davis himself reiterated the significance of the series as a milestone in his career, stating that "everything I have done since has been based on that eggbeater idea."[17] In the same way *Salt Shaker* (1931, cat. no. 29), although it may be read as a personal elaboration of synthetic Cubism—for instance in the use of horizontal lines to render the background—also has fresh elements in its visual language, not just in the insertion of signs and letters in the composition, but also in the anthropomorphy of the object. *Bass Rocks No. 1* had been exhibited as part of the 1942 "Artists for Victory" event in support of American artists, organized by the Metropolitan Museum. The painting—as Davis commented—"represents the color and space harmonies which I observed in a landscape subject. Casual observation of the scene from which they were taken would not reveal the elements from which my picture is made. These harmonies only became apparent after study and contemplation of it."[18] *For Internal Use Only*, 1945, appears to constitute a homage to Mondrian; in particular, it shares the incessant rhythm of his late works, the juxtaposition of black lines, bars, squiggles, signs similar to imaginary letters which combine in a kind of musical improvisation. *Ursine Park*, 1943, another of the pictures on show (which was reproduced in the Biennale catalogue), had won for Davis the Pennsylvania Academy's Scheidt Prize in 1945. *Little Giant Still Life*, 1950, was to become, together with *Owh! in San Pao*, 1951, symbolic of Davis's work in the 1950s (cat. nos. 40 and 44). In the *Little Giant Still Life* a single word was used for the first time as the prevalent subject of the entire composition. Turning away from the bustling density of his earlier work, Davis now turned everyday household objects into heraldic emblems, a matchbook for example, rendered with vivid color and essential economy in its formal components.

In order to understand the impact that these paintings made on the Italian artists who saw the Venice show, however, we have to take a number of factors into consideration. Post-war Italy fell very much under the spell of the United States and of American urban culture. New York was gradually taking over from Paris as the world capital of culture and had become, during the war years, synonymous with liberty itself.[19] The young artists of the Italian avant-garde who attended the art history lectures given at Rome University by Lionello Venturi, recently returned from exile, were treated to enticing descriptions of the U.S. metropolis: "New York is beautiful, despite what people say. From Central Park, above the trees and the water, you can see the skyscrapers looking from a distance just like the towers of San Gimignano... The light in New York is colder and clearer than in Rome: and yet it's beautiful by virtue of its incitement to action. There's so much more to New York than all the material advantages it offers and for which it is justly famous; there's incredible courage, the courage of the absurd, to conquer the air, seeing as how the ground is too cramped for its population and all its energy."[20] The United States exerted a magnetic attraction, even though it was still relatively difficult, or at least rare, for European artists to be able to exhibit their work on the other side of the Atlantic.[21]

There were painters, such as Afro, who achieved a certain success in the U.S. as early as the early 1950s. On the other hand, various young American artists such as Rothko, Rauschenberg and Twombly visited and stayed in Italy and thus came into contact with Italian painters. The resulting friendships, exchanges of information and the mutual interest involved were such as to create a complex web of reciprocal influence whose exact pattern and timing are still the subject of discussion today.[22]

The liveliest interest in what was going on in the British and American art worlds was shown by the artists grouped around the magazine *Arti visive* (Dorazio, Perilli, Colla, Villa and others).[23] Already some years before, when they had been involved in the activities of the small bookshop/gallery called the Age d'Or, Perilli and Dorazio had been able to count on the support of Baroness Hilla Rebay, director and founder of Solomon R. Guggenheim's Museum of Non-Objective Painting. Baroness Rebay not only helped to make their work better known, circulating photographs, catalogues and books around the United States, but also secured a study scholarship worth ten dollars a month for the young Italian artists.[24]

The 1952 Biennale as a whole was marked by the opposition between the pictorial neo-realism of Guttuso, Zigania, Pizzinato and Treccani on the one hand, and on the other the experiments of the Gruppo degli Otto—Afro, Birolli, Corpora, Moreni, Morlotti, Santomaso, Turcato, Vedova—a movement ambiguously labelled by Lionello Venturi as abstract-concrete. This tense juxtaposition of the opposing political and ideological stances was further strained by the undisguised partiality of the Italian Communist Party,[25] which was vigorously opposed to abstractionism, even in the diluted forms proposed by the Gruppo degli Otto. As a result, critics' reviews in newspapers and magazines clearly took sides along the same lines of battle.

In *Commentari* of 1952, Lionello Venturi, himself a high profile contributor to the debate, made no mention at all of the U.S. pavilion in his review of the Biennale, except to mention in passing "the imaginative Calder" as winner of the sculpture prize.[26]

Despite the suffocating atmosphere that marked this embattled Biennale, some artists were quick to appreciate Davis, in particular those from the newly-founded Fondazione Origine,[27] present at the Biennale only in the somewhat marginal setting of the Black and White room, together with Burri (who was showing in Venice for the first time). These artists already knew Davis's work through their own active participation in the research on international abstract art for the magazine *Spazio*,

in which Davis was identified as the initiator of American abstract art.[28]

The path followed by Davis, at first assimilating the fragmentation of composition he learned from Cubism, then the dynamic surface decoration of Matisse and the loss of center of Miró, found significant parallels in the experiments developed by the "Forma" group, and by Perilli and Dorazio in particular. This attention to the continuity of the chromatic surface as a whole, without, that is, any center or focus, was close in conception to the young Italian artists' experiments in chromatic modulation of the plane. Another similar feature was the readiness to admit a "narrative" value in the painting, sometimes expressed and reinforced in the title of the work, albeit well aware that, as Davis himself put it, "if the composition tells a story, this can have only a pictorial existence through the artist's conception of form."[29]

In its choice of adjectives to describe Davis's work, Ritchie's introduction to the Biennale catalogue revealed a surprising affinity with Futurist terminology, and in particular with the Futurist movement's theoretical writings.[30] The theory and practice of Futurism, well known in the United States, also contributed significantly to his art:[31] the messages on road signs and their communicative potential, the interest in means of communication, from trains to airplanes, from radio to the telephone, and his oft-stated opinion that anybody, after impacting with the new media, would no longer be able to think of form and space in the traditional manner: all these aspects clearly echo the writings of Boccioni, Marinetti and Depero.[32] We cannot therefore exclude that this may have been a side of Davis's work which attracted the artists of the Fondazione Origine: it was just at that time that they were reappraising Futurism, indeed, they can in retrospect be credited with the rediscovery of that avant-garde movement.[33]

Art critics were so concerned with the bitter polemic raging around the Italian art at the Biennale that their reviews of the U.S. pavilion, and of the foreign contribution in general, tended to be myopic and superficial. Even so, the total incomprehension of the international dimension of the debate that accompanied the post-war advent of the modern movement and of non-objective art is surprising.

Art News dedicated an editorial to the Biennale which neatly summed up this critical reaction: "The tides of European critical opinion of Venice's twenty-sixth biennial exhibition of art from twenty-seven countries eddied between the poles of approval or disapproval of abstraction and 'the new realism.' The American quartet—Calder, Davis, Kuniyoshi and Hopper—was deposited gently but firmly on the periphery, although the styles of the four variously mediate between these extremes. Their solutions were regarded as personal and, occasionally, 'provincial.'"[34] The commentator found the virtual indifference of the critics particularly surprising so far as Stuart Davis was concerned: "Stuart Davis's near abstract city-scapes provoked less reaction than might have been expected, though several Italian papers recognized his 'ingenuity' and 'accomplishment.'"[35]

Time magazine picked out precisely Davis from the hundreds of artists present, for an entertaining and flattering special mention,[36] but Jerome Mellquist in *Art Digest* and John D. Morse[37] in *American Artist* judged his paintings, like those of Hopper and Kuniyoshi, to be inextricably linked to a provincial dimension. "Their cocktail wit and suggestiveness [i.e. of Davis, Hopper and Kuniyoshi, author's note]," wrote Mellquist, "though perfectly adapted to New York, require a more lenient light than Venice's."[38] On the other hand, the judgement of Eloise Spaeth went in exactly the opposite direction: she viewed the strong American connotation positively as a guiding criterion in the selection of works and artists: "Above all in his most recent work [Davis] manages to capture dynamic aspects of our lives. To the unbridled rhythms of jazz, he breaks up neon signs and billboards and then courageously puts them together again... The unquiet spirit and flaming vitality of a growing nation are brought together in these pictures by Davis."[39]

Another wide-ranging piece on the U.S. pavilion was that written by Marcello

Venturoli. Declaring himself particularly pleased by the new direction taken up by Calder, he found the American contribution to be more interesting and balanced than that of previous years, but he nonetheless fell more or less in line with the general view when he judged the only noteworthy picture of Davis to be the sole example of realism in the selection, namely *Gloucester Beach*. The works from the 1930s, which were compared with those by Severini from the same period—which Davis had seen in Paris—were rather coldly received, while not so much as a word was spent on the recent work from the fifties. One article which struck a discordant note in the overall chorus of the reviews was that by Corrado Corazza in *L'Avvenire d'Italia*. Corazza emphasized that American art had its own distinct history, and that this lent it greater interest: "Frankly, the U.S. pavilion is more interesting than many of the others, for one chief reason: the energy and sincerity with which the exhibiting American artists follow their chosen path."[40] With regard to Davis, too, Corazza avoided the playful and decorative labels attached by most critics, writing instead that the artist "intends to interpret aspects of contemporary life, mastering facts in a statistical and geometrical sense, but only in order to turn them into zestful decorative compositions. And make no mistake: by decorative I mean artistically realized and autonomous." There were, in fact, many critics who saw his paintings as being merely decorative, like tapestries or carpets, or else as best suited to advertising posters.[41]

Corrado Maltese, art critic with the communist daily *L'Unità* and the paper's special reporter in Venice, verged on sarcasm in his dismissive summary. If Calder was "a juggler" and Kuniyoshi "a semi-surrealist", Davis became "a merry paper-cutter." The only artist to emerge unscathed from this hostile critical attention was Hopper, recognized as being the only one of the four to "tell us something about North America."[42]

Thus the official line of criticism seems to have been devoid of farsightedness or prophetic intuition, as if obligated to filter any independently formed opinion through a screen which blinded it to the path which art was taking. A few isolated commentators succeeded in looking impartially at American art,[43] but it was the poets, unorthodox critics, artists and writers who alone were able to grasp what was rapidly fermenting, and who bore witness to the rapid change which in a matter of years would transform the art scene and indeed the very materials and language of artistic expression, in Italy and abroad. With Action Painting, New Dada and Pop Art, the initiative in modern art was in the process of crossing the Atlantic for the first time.

* I would like to thank Monica Ambrosini and Franco Miracco for their help in locating source material for this essay. Special thanks are also due to Philip Rylands for his assistance and much useful advice.

[1] Only in recent decades have certain such artists at last received adequate critical appraisal. Mario Sironi, for example, was long considered a spokesman and interpreter of Fascist ideology. This critical boycott also barred Futurism, which has only regained its prestige as an international avant-garde thanks to the pioneering studies of Maurizio Calvesi and Giulio Carlo Argan, together with the reassessment carried out by young abstract painters in the early 1950s.

[2] The diverse group of artists who came together under the name and program invented by Guttuso, the Fronte Nuovo delle Arti, had its first show in 1947 at the Galleria La Spiga in Milan. The members of the group were Birolli, Cassinari, Guttuso, Levi, Leoncillo, Morlotti, Pizzinato, Santomaso, Turcato, Vedova, Viani, Fazzini, Corpora and Franchina. The group's manifesto was republished in P. Barocchi, *Storia moderna dell'arte in Italia*, vol. III, *Tra Neorealismo e anni Novanta*, Turin 1992, p. 53.

[3] The Jeunes peintres made their debut in Paris in 1942 during the German occupation.

[4] These were the words with which Togliatti, writing under the pseudonym of Roderigo di Castiglia, reviewed the "Prima mostra nazionale di arte contemporanea," held at

the Alleanza per la Cultura di Bologna in the fall of 1948. The exhibition included works by almost all of the artists in the Fronte nuovo. The review, from the November issue of *Rinascita*, together with the artists' replies, was republished in P. Barocchi, *op. cit.*, pp. 77–78.

[5] The artists of the Forma 1 group defined themselves as Formalists and Marxists. Polemically opposed to realist poetry, they claimed there was no contradiction between the two terms. The Forma 1 manifesto was signed in 1947 by Accardi, Attardi, Consagra, Dorazio, Guerrini, Perilli, Sanfilippo and Turcato. It was republished in P. Barocchi, *op. cit.*, pp. 65–67.

[6] The phrase was used by the writer Elio Vittorini, editor of the review *Politecnico*, in a reply to Togliatti. He asked the rhetorical question whether the task of artists and intellectuals was to "suonare il piffero per la rivoluzione." On the debate, see N. Recupero, F. Leonetti, E. Fiorani, *La polemica Vittorini-Togliatti e la linea del P.C.I. nel 1945–1947*, Milan 1976.

[7] Fourteen nations took part in the 1948 Biennale, twenty-two in 1950 and twenty-six in 1952. Pallucchini was not slow to appreciate this trend, seeing it as a phenomenon of evolving taste and political freedom. See the introduction to the catalogue of the XXVIth Biennale, Venice 1952, especially pp. xvii and xxviii.

[8] The other artists were Hyman Bloom, Willem de Kooning, Lee Gatch, Arshile Gorky, Rico Lebrun, and Jackson Pollock. See M. Calvesi, "Un'arte prima adulta e poi giovane," in *American Art in Italian Private Collections*, exhibition catalogue, M. Boyden, (ed.), American Academy in Rome, Rome 1994, pp. 16–26. On United States participation at the Venice Biennale, see P. Rylands, E. Di Martino, *Flying the Flag for Art. The United States and the Venice Biennale*, Richmond, Virginia, 1993, esp. chapters 6 and 7, and pp. 279–280.

[9] For a report on the prize-giving ceremony, see the article by Irene Brin in *La Biennale di Venezia*, 9, July 1952, with a photo of Italian President Luigi Einaudi in the American Pavilion.

[10] The official announcement of the selection was made in a press release on May 3, 1952. See the Archive of the Galleria Nazionale d'Arte Moderna, Rome, folder for the 1952 Biennale; the same document is preserved in the Archivio Storico delle Arti Contemporanee, Venice.

[11] See M. Gendel, "Abstract Art in America," in *Spazio*, 4, II, February 1951, pp. 40–42.

[12] See L. Kachur, "Stuart Davis. A Classicist Eclipsed," in *Art International*, Fall 1988, pp. 17–22.

[13] That the Venice Biennale was the biggest and most important international art exhibition was also recognized by the American press. See, for example, J.D. Morse, "The Artful Traveler," in *American Artist*, 16, 6, June 1952, p. 30.

[14] See L. Kachur, *op. cit.*, p. 18.

[15] Davis showed the following works at the XXVIth Biennale, listed here with their ownership at the time: *Gloucester Beach (Rockport Beach?)*, 1916, The Downtown Gallery, New York; *Egg Beater No. 4*, 1928, Phillips Collection, Washington D.C.; *Salt Shaker*, 1931, collection Mrs. Edith Gregor Halpert (cat. no. 29); *New York – Paris I*, 1931, collection Mr. and Mrs. Joseph Gersten, Brockton, Massachusetts; *Composition with Winch*, 1931, collection Mrs. Edith Gregor Halpert; *New York Waterfront*, 1938, Albright-Knox Art Gallery, Buffalo; *Bass Rocks No. 1*, 1939, Wichita Art Museum, Wichita; *Hot Still Scape for Six Colors – 7th Avenue Style*, 1940, The Downtown Gallery, New York; *New York under Gaslight*, 1941, collection Herman Shulman, New York (cat. no. 36); *Ursine Park*, 1942, Fine Arts Department of the International Business Machines Corporation, New York; *For Internal Use Only*, 1945, collection Miller Co., Meriden, Connecticut; *Little Giant Still Life*, 1950, Virginia Museum of Fine Arts, Richmond, Virginia (cat. no. 42); *Owh! in San Pao*, 1951, Whitney Museum of American Art, New York (cat. no. 44). Davis's other paintings at the Venice Biennale have been as follows: *Rue des Rats, No. 2* (cat. no. 27) in 1930; *Place Pasdeloup* (cat. no. 25) and a watercolor in 1934; *Ursine Park* in 1948; *Something on the 8 Ball* (cat. no. 47) in 1954, as part of the exhibition "American Artists Paint the City," organized by the Art Institute of Chicago; 2 *Studies for Radio City Music Hall mural* and *Environment Situation Space* (documentation) for the "Ambient/Art" exhibition in 1976: and finally *Study for Mural with Undulating Landscape* in the "Art/Nature" exhibition in 1978.

[16] J. Ashbery, "Our Forgotten Modernism," in *Newsweek*, 104, July 1984, p. 84.

[17] E.C. Goossen, *Stuart Davis*, New York 1959, p. 21.

[18] "Pictures of this kind," continued Davis "indeed all genuine art... keep the eye of the beholder alive, force him to make observations, and give value to, aspects of nature which everyday preoccupations too often leave unnoticed." See S. Davis, "Bass Rocks," in D. Kelder, *Stuart Davis*, New York 1971, pp. 99–100.

[19] See, for example, the article by E. Bonfante, "Il Museo d'Arte Moderna di New York," in *Comunità*, 10, January–February 1951, in which the MoMA collection is described as a "simbolo di libertà d'espressione" with reference to the "valore umano e sociale dell'Istituzione."

[20] L. Venturi, "L'America oggi," in *La nuova Europa*, 18, March 1945, p. 9.

[21] See L. Venturi, "The New Italy Arrives in America," in *Art News*, 60, Summer 1949, pp. 27–29.

[22] One example is the relationship between Burri and Rauschenberg. Critics continue to disagree over which of these two artists first tried out certain innovative means of expression. On the whole issue of artistic relations between New York and Italy, see G. Celant, *Roma – New York 1948–1964*, Milan and New York 1993. For relations between Afro and the United States, see above all the exhaustive essay by Fabrizio D'Amico: "Afro e New York: la sua pittura degli anni Cinquanta dalla memoria della vita alla vita della forma," in L. Caramel, *Afro. L'itinerario astratto*, exhibition catalogue, Milan 1989, pp. 23–55.

[23] The review of the Fondazione Origine, *Arti Visive*, began to appear in the summer of 1952. The scope of the magazine was international, with contributors from the United States.

[24] On the subject, see A. Perilli, *L'Age d'or di Forma 1*, Mantua 1994, p. 119 and pp. 137–141.

[25] See for example the issues on the Biennale of the review *Realismo*, edited by Raffaele De Grada.

[26] L. Venturi, "La Biennale," in *Commentari*, 1952, pp. 252–254.

[27] "An international collection and archive center for the study and knowledge of abstract art," the Fondazione Origine took over when the group of the same name broke up. As well as organizing important exhibitions such as "Giacomo Balla," "Omaggio a Leonardo da Vinci" and "Pittori americani non-oggettivi," the Foundation published a review whose contributors included, to mention only some, Villa, Colla, Dorazio, Perilli, Prampolini, Canevari, Pandolfi and the literary critic Angelo Maria Ripellino. On the Fondazione Origine and its member artists, see the article in the catalogue to the exhibition *Trovare le Origini. Ballocco, Burri, Capogrossi, Colla, Mannucci, Villa, Dorazio, Perilli, Scialoja*, Mariano Apa (ed.), Rome 1993.

[28] See M. Gendel, "Abstract Art in America," in *Spazio*, 4, II, February 1951, pp. 40–41.

[29] See J.J. Sweeney, *Stuart Davis*, Museum of Modern Art, New York, 1945, p.27.

[30] Ritchie wrote: "...the most frantic Jazz, the gas pumps, the loudest advertising billboards, the fantastic architecture, the hysterical atmosphere of the night clubs, the heat and dazzling light of the American sun, he has felt all of these things and, by an alchemy all his own, transferred them to canvases which, better than many others, will tell the fabulous story of the last three decades in the United States." See "Stuart Davis," in *Catalogo della XXVI Biennale di Venezia*, Venice 1952, p. 363.

[31] Balla, Boccioni, Carrà, Russolo and Severini exhibited for the first time in the United States in 1915 at the Pacific International in San Francisco. In 1917, Alfred Stieglitz organized a one-man show for Severini at his famous Gallery 291 in New York. On the relations between Davis and the American Futurists, see also the interview with Piero Dorazio in this catalogue.

[32] Among Davis's numerous writings, see on this subject "The Cube Root," published in *Art News*, February 1, 1943. On the other hand, it is also true that New York was the city where the future had become reality, where the ideology of modernism and the utopia of Futuristic progress could appear to have come true. The fantastic architecture of Sant'Elia, the neon advertising signs whose praises were sung by Depero, Boccioni's dynamic deformation of perspective, as also Balla's myth of speed: only in New York could all these things be said to have taken concrete form.

[33] The first retrospective of Balla's Futurist works to be held after 1930 was organized in the Spring of 1951 at the Fondazione Origine. In September 1952, *Arti Visive* featured an

article by Colla on the Futurist master, while studies by Calvesi and Argan on Boccioni appeared in 1953. Not long after, in 1954, two important Futurist exhibitions were held in the United States: the first was "Balla and Severini" at the Rose Fried Gallery, while the second, held at the Sidney Janis Gallery, was "Futurism: Balla, Boccioni, Carrà, Russolo, Severini." On the reappraisal of Futurism, and of Balla in particular, see also Federica Pirani, "La riscoperta di Balla," in *La donazione Balla e altre opere dell'artista*, exhibition catalogue, G. De Feo, P. Rosazza Ferraris, L. Velani (eds.), Mondadori, De Luca, Milan 1988, pp. 82–88.

[34] Unsigned article, "Venice: This Year's Biennale," in *Art News*, 51, 5, September 1952, pp. 32–33, 52–53.

[35] *Ibidem*.

[36] The text in *Time* magazine ran as follows: "Among the hundreds of contemporary abstractionists showing at Venice, there are a handful of clever artists. Stuart Davis, for one, soups up the American pavilion with designs as piercing and brassy as a Louis Armstrong high note. Unsigned article, "Ruts & Peaks," in *Time*, LX, 4, July 28, 1952, pp. 48–49.

[37] J. D. Morse, "The Artful Traveler," in *American Artist*, 16, 6, June 1952, p. 30.

[38] J. Mellquist, "Venice Biennale, 1952: Seeing a United Nations of Art," in *The Art Digest*, 26, 19, August 1952, pp. 6–8.

[39] E. Spaeth, "Americani alla XXVI Biennale," in *La Biennale di Venezia*, 9, July 1952, pp. 30–34, esp. p. 34.

[40] C. Corazza, "Battono la via della sincerità i pittori americani a Venezia," in *L'Avvenire d'Italia*, VII, 10, 1952.

[41] This, for example, was the view of Piero Girace in the Naples daily *Roma*: "These paintings fall between the humorous and the serious, as may be noted in his *Ursine Park*, which has the liveliness of a carpet or a tapestry." "Giro del mondo da fermo nei saloni della Biennale," *Roma*, July 24, 1952. Silvio Branzi voiced a similar opinion: "Davis is an agile, incisive abstractionist, well suited to composing poster designs," in "Altri stranieri," in *Il Gazzettino di Venezia*, October 16, 1952.

[42] C. Maltese, "I padiglioni stranieri," in *L'Unità*, June 19, 1952.

[43] See for example the article by G. Falzoni on Calder which appeared in *La Fiera letteraria* of June 22, 1952, or by L. Sinisgalli, "Calder scultore ingegnoso," in *Civiltà delle Macchine*, January 1953.

Piero Dorazio Interviewed by Federica Pirani, 1997

Federica Pirani (FP): Do you remember when you first became aware of Stuart Davis's painting?

Piero Dorazio (PD): When I went to the United States in 1953, I already knew something about American painting, as much as one could know living in Italy. I had seen Davis's works at the Venice Biennale in 1952, and the year before I had worked on a special issue of the magazine *Spazio* which was dedicated entirely to international abstract art. I remember that, in payment for doing an article, for which Perilli and I even supplied the photographs, we received five thousand lire. Davis was discussed in that article.[1]

Along with Hilla Rebay[2] we also organized a show of abstract art from America, at the Fondazione Origine, in which we exhibited pictures from the Solomon Guggenheim Museum in New York. Davis was not included in the selection because he was not, strictly speaking, an abstract painter. He was a Cubist painter. Hilla only wanted non-objective art; in other words, abstract art that drew its subject matter from reality did not interest her.

FP: But did you like that kind of painting?

PD: If the painters were as good as Stuart Davis, I certainly did. I have never had a dogmatic approach to the abstract movement. But Soldati for example refused to show Corpora's paintings at the "Prima Mostra Nazionale di Arte Astratta" in Rome in 1948. We organized that show together with the Milanese, with Ettore Sottsass and others, and Soldati sifted through the artists and rejected all those who left any trace of atmosphere or air in their paintings.

FP: When did you meet Davis for the first time?

PD: I was already a great admirer of Davis because Davis was a Cubist, but he was absolutely original; he used the most beautiful colors, American colors. There were no grays in his pictures, but instead dissonant chromatic scales and colors such as one never saw in the Cubists. And his drawing was original, curious, much more baroque than that of the French Cubists. And when he painted objects—I'm thinking of his packet of Lucky Strike—he was really marvelous. He didn't disguise the object, as Braque or Picasso would have done; he painted it just as it was.

At that time I lived on West Fifteenth Street, behind the Fourteenth Street Armory. In the evening I used to go to Seventh Avenue to buy the newspaper in a stall run by a music buff, a music maniac even. It was a place to meet people, a hangout where people would gather to talk. One evening a man about sixty years of age, somewhat stout, *simpatico*, asked me what I was doing in America. I said to him, "I'm a painter," and he said, "But I am Stuart Davis." At that time I was a friend of Fritz Glarner, a Swiss artist who used to live in Naples, a great painter, and we used to see Davis often. Glarner was a close friend of Mondrian when he was in America, and he and Reinhardt and others, belonged to the American Abstract Artists.

Davis was a very reserved man, intelligent; he talked a lot about painting; he read the

Daily Worker, the Communist party daily; he was left wing, a man of the Labor Party. We often went to the Village Vanguard to listen to music together; we listened to Charlie Parker, and he was a particular fan of Thelonious Monk.

FP: What was your impression of America in the 1950s?

PD: To travel from Italy to America in 1953 was an extraordinary experience for me, like taking a trip to the moon. Crossing the Atlantic on the *Queen Mary* made me realize just how far away the New World was. I remember that the evening before we docked we saw in the distance a myriad of twinkling lights. It was like entering the harbor of Naples. You could even hear Neapolitan shouts and cries. They were immigrants fishing for clams in their small sailboats, in June. America in those days was not yet a modern country. When I arrived I took a bus that took me directly from the port to Boston and to Cambridge. Crossing the city I passed through Harlem. I was astounded by all the blacks, in their undershirts, and by the atmosphere of poverty everywhere. I realized that America was still pre-Capitalist, still peopled by the poor laboring masses and by the jobless. For our part, back in Italy, we were reading avantgarde writers like Dos Passos, William Saroyan, Steinbeck and Hemingway, and it was a literature of society in the raw, of crisis and denunciation.

Davis the painter was aware of all this. He was the artist of an America that was struggling with its desire to become modern, clean and efficient. New York had been "cleaned up" by Robert Moses, Mayor La Guardia's adviser for town planning. He was the one who demolished thousands of wooden shacks and built up the area between Third Avenue and Seventh Street, around Cooper Square as far as the East Village towards First Avenue.

FP: How did you see America in the fifties? Had it replaced France as the land of liberty?

PD: America was a model of libertarian individualism, which France was not. In France there was socialism; in 1947 there was even a near Communist revolution of an anti-American kind. The left wing intelligentsia was furthermore deeply split between orthodox Communists and Trotskyite sympathizers. France was a very free country where the refugees of the Spanish Civil War came. I knew *il Campesino* and *la Pasionaria*.[3] But America embodied absolute individual liberty: we used to say, go to America and tear up your passport, change your identity, vanish. America was the country where you could just be yourself, free of any influence. And then the United States had defeated Nazism, had sacrificed its soldiers to conquer the infernal, near-invincible machine of the German army. They were the ones who freed us from Nazi Fascism.

FP: Let us go back to the 1952 Biennale: Italian critics were shortsighted with respect to the American pavilion. Reviews in the papers generally skated over Davis's work, considering it somewhere between the playful and the decorative.

PD: They were obedient to the party, and faithfully followed Togliatti's anathema against abstract art.[4] For them Stuart Davis, who was America's most up-to-date painter, was worthless. They were blind to the international quality of his work, and at the same time to its profoundly American spirit in his choice of subject matter. His work was not intimist, but extrovert; even publicity billboards supplied him with ideas. He was an outgoing painter, whose attention was addressed to the wide world, to the city, to the community.

FP: Do you think Futurist painting and poetry had any influence on Davis's art?

PD: Certainly, Davis was passionate about Futurism and knew the manifesto of poetry, and then again he was a friend of Joseph Stella, the Italo-American Futurist, and also of Edgard Varèse the composer. The latter, the teacher of John Cage, was a Futurist from Turin who emigrated to America, and a pupil of Russolo. He played the drums, a sort of *intonarumori*. For him the interval had the same value as the note. Frederick Kiesler, who had worked with Josef Hoffmann, was in the same circle.

FP: What was the connection between Davis and the younger generation of Gorky, Pollock and de Kooning who, as it happened, had been shown at the 1950 Biennale?

PD: I think Davis had a very subtle influence on those painters, as he did on Motherwell. He was America's most modern painter and was one of the few who had lived in Paris, where he had become friends with Léger, whom he saw again in New York. They were bound by their political commitment, Trotskyism, the International Socialist. I believe the young ones admired him greatly, perhaps secretly.

You have to realize that there were very few modern artists. They would all see each other around the Village, at the Club. They talked mainly about projects to encourage artists, and Davis sometimes came to our meetings. No one could stay alive just by selling paintings—you would have starved. Those who could would teach, like Reinhardt at Brooklyn College. Artists then were very dependent on Europe and there's no doubt that Davis was important in constructing an American identity which the younger generation could make their own.

FP: Often the critics, even in America, speak of Davis as a precursor of Pop Art because of his habit of using words in his paintings, and everyday things as subject matter. What's your view?

PD: He detested Pop Art when he saw it; it was vulgar, not popular, while Davis was a classic, refined painter.

FP: In the final analysis his art was less of a model for Pop Art than it was for painters like Kenneth Noland and Morris Louis.

PD: They admired Davis, his use of color. Greenberg, when I went to see him in 1992 at the time of the Stuart Davis exhibition at the Metropolitan, even though he considered the late paintings a little weak, told me he admired Davis's painting immensely and that he considered him the first American Abstract painter.

FP: How was the art market in America in those years? Who were the collectors?

PD: It didn't exist, except for a few collectors who were mainly interested in European art...Cézanne, Miró, the Impressionists. Otherwise the most important collectors lived outside New York, in Baltimore and Philadelphia. Even the Museum of Non-Objective Painting was not a museum but a house on Fifth Avenue with three rooms where Kandinsky's paintings were shown. Rothko couldn't sell anything, nor could Kline and de Kooning. In 1954 Kline was given an exhibition, a fantastic show, with marvelous works, but he sold nothing. Then there was the exhibition Janis gave Pollock in 1954 and it was a couple of years later that Ben Heller bought *Blue Poles* for $32,000. When Pollock heard about it he fled, hid in the Cedar Tavern, got drunk, and punched someone in the face. He was furious. Pollock was a genial painter but a bit off his head. He was passionate about James Joyce and *Finnegan's Wake* especially. All his painting was inspired by Joyce, by his automatism. I used to pull his leg in a good natured way for his gentle but outlandish character. I even made a film about him, *A Day in the Life of a Painter*, in which a cowboy comes to New York, wearing cowboy boots and jeans, and decides to become a painter. To get started he throws eggs against the canvas and drops everything on the floor. He used to be teased because his paintings were so strange and he used such unconventional techniques, walking on the canvas.

This was the generation that detached itself from Davis, even though Davis was always the alternative to the influence of Picasso which was everywhere. I remember Hans Hofmann told me that it was Picasso he was fleeing from, when he went to America.

Rome, Caffè Greco, March 12, 1997

[1] Dorazio refers to an article in the fourth issue of *Spazio*, edited by the architect Luigi Moretti. The article, by Milton Gendel, was called "Abstract Art in America," and stated amongst other things that "the best known American painters who have clung long and close to abstraction are Stuart Davis and George L.K. Morris. Both artists generally stop short of the non-figurative, retaining realistic suggestions within an abstract framework." Dorazio, Perilli, Guerrini and Severini helped with the section on Italian abstract art. See M. Gendel, "Abstract Art in America," in *Spazio*, no.4, II, February 1951, pp. 40–42.

[2] Hilla Rebay supported the young Italian abstractionists from the time of the Age d'Or onwards, sending them printed materials—books, essays, photographs and magazines—documenting what was going on in America, and also obtaining Guggenheim fellowships for Perilli and Dorazio. See A. Perilli, *L'Age d'Or di Forma I*, Mantua 1994, especially pp. 137, 141ff.

[3] *Il Campesino* was the name of the commander of the people's militia on the Republican side against Franco. *La Pasionaria* was the *nom de guerre* of Dolores Ibarurri, one of the leaders of the Spanish Communist Party during the Civil War.

[4] Togliatti, speaking of abstract paintings, said they resembled paintings made by a donkey flicking its tail.

Underwriting the "Amazing Continuity"
The Journals of Stuart Davis

Wayne L. Roosa

In keeping with his habit of jotting down the day's main events on a small appointment calendar, Stuart Davis summarized October 28, 1951 by writing: "Made the Greatest Analysis of the Shape of the Amazing Continuity which is the additive Real change in the Act of Perceiving in written form. Did some powerful drawings of *Rapt at Rappaport's*."[1]

Compressed into this terse memo, and written in his almost private vocabulary and syntax, are the hot ingredients of Davis's mature aesthetic: his idea of "the Amazing Continuity"; his conviction that the real subject and content of art is "the act of perceiving" and that perception occurs as "Shape"; his relentless use of "Analysis" to test the shape of his perceptions, and his inventive, hip melding of two grammars—the geometric construction of color-space logic and the calligraphic syntax of word-shapes—as a way of being true to the fact that all perceptions are simultaneously visual and linguistic.

But this humble calendar entry contains something else fundamental to Davis's art. It eludes to his process of working, a process that involved a rich symbiotic relationship between the acts of writing, drawing and painting. This entry's hint at the give and take between "analysis... in written form" and the making of "powerful drawings" offers a glimpse of the inventive process driving Davis's art. Of course, what mattered most to Davis were his finished paintings. But beneath those paintings are the records of his mode of invention in the form of some twelve thousand pages of private writings produced over a period of five decades. In them, Davis followed a complex and interwoven rhythm of writing, drawing, and analysis which made the paintings possible. And it was the energy of this process that produced the continual "additive Real change" so evident in the evolution of Davis's style.

It has long been recognized that Davis contributed a crucial body of paintings, constituting one of the most extensive investigations of modern American art by any American working in the twentieth century. But only more recently have we begun to understand the profound contribution made by the vast body of Davis's theoretical papers, which underwrote his vibrant paintings with such lively intelligence. These writings consist of both public and private explorations. For the public, Davis published over fifty essays, statements, or lectures between 1912 and 1961.[2] The published writings contain crucial insights into his work, theory and socio-political views. Yet the vast bulk of his writings were private, serving as his means of working through the ideas and problems encountered once he had decided, as he put it, "that I would quite definitely have to become a modern artist."[3] They cover some twelve thousand pages of journals, daybooks, sketchbooks and calendars. They stand as the record of Davis's extraordinary energy, sustained intellectual discipline, and sheer inventiveness of eye, mind, image and language.

These writings are neither diaries nor personal memoirs. They are instead a sustained investigation into the nature of art and modernity, and especially into his search

for how a modern style might house the consciousness ("percept," to use his term) of a modern person's experience. They are an investigation into how someone who enthusiastically embraced the contemporary American scene and experience, but who also welcomed influences from Europe, might create a uniquely American modernist painting. And above all, from Davis's mid-career until his death, his writings are an investigation of what would become his central "subject matter": that is, as he so eloquently stated it, they are about how "a work of art is not a description of the objective world [but] is an objective record of the total awareness of that world by a man."[4]

Given all this, it is tempting for the reader when first approaching Davis's writings to look for a "key," as a means for decoding his complex paintings and their semiotic/color-space configurations, which are such a richly woven fabric of references to nature, urban settings, signage, typography, abstract art theory, and dynamic geometric constructions all at once. A reader will find hundreds of insights into the meanings of Davis's signs, but his writings are in no way a system or an explanation of his art. Rather, what the reader will find most vivid in them is a sensibility, a manner of thinking, and a process of inventing. Reading them in relationship to his finished paintings is more like reading the koans of Zen in relationship to life, than it is to reading a theoretical explanation of a man's art.

Diane Kelder has rightly claimed that Davis developed "an idiomatic Cubism that translated the dynamics of the contemporary American environment into abstract color and shape," and that his success in doing so went further than that of his American peers, who used Cubism more imitatively.[5] It is Kelder's contention that Davis "was the only painter of his generation to penetrate the surface of its style and seek its underlying logic" with full insight. She rightly notes that his "painting is bolder, his handling of color and paint more provocative, and his pictorial syntax more distinctively vernacular" than in the art of any other American influenced by the combination of American experience and European modernism at the time. The reason for Davis's greater vigor, she observes, is that he was deeply "rooted in theory and tested by experience, manifesting a rare understanding of the ideational character of painting, as well as a broad streak of native pragmatism."

It is precisely this depth of understanding, gained through the process of written theory and tested by analysis and drawings which is so evident in page after page of Davis's writings. His writings were the calligraphic scene in which he "penetrated the surface of style" in search of an "underlying logic" that enabled him to reinvent "the ideational character of painting" in his own modernist American vernacular terms. It is that process of penetration and reinvention that one encounters in his journals. There, Davis repeatedly posed fundamental questions about art, subject, content, meanings, and the essential nature of his medium, working and reworking those questions from a myriad of angles and possibilities. Initially this makes Davis's writings seem repetitive. But if followed patiently, this repetition soon reveals a gradual evolution of thought that is extraordinary.

Since 1960, scholars have increasingly recognized the richness of Davis's writings both as a great achievement in American art theory and as the means of Davis's invention of an original style. From Rudi Blesh's essay on Davis (1960), to Diane Kelder's anthology of his writings (1971), John R. Lane's treatise on his art and theory (1978), or more recently the work of Lowery Sims, William Agee, Karen Wilkin, Lewis Kachur (1991), and others, scholars have begun to excavate Davis's papers for the wealth of insights and pleasures they contain.[6] These scholars reveal the integral role that writing in association with drawing played in his invention of an American modernism. And in that context, Davis is now seen as one of the major pioneers of modern American painting.

However, as important as Davis was in his American context, it is now time to think about him within a larger context. Davis's achievement has long deserved its place in

the widest context of International Modernism, as one of the great contributions to the early twentieth century, even granting what he humorously called his distinctive "New York dialect." In recent decades it has been increasingly understood what an indispensable role artists' theoretical writings have played in the invention of modernism in general. Today it is inconceivable that the radical paradigm shifts which art underwent from nineteenth century Realism to twentieth century expressionism, non-objective abstraction and Cubism could have happened solely through the making of paintings.

So radical were those changes that many of the pioneers of modernist art consistently employed extensive writing as a secondary means of thought in the process of coming to terms with what their visual intuitions were urging upon them. Gauguin's writings enabled him to grapple with a shift from Impressionism to Synthetism; Van Gogh's letters allowed him to articulate the traumatically beautiful seismic quakes occurring in his color, brushwork and space; the voluminous writings of Kandinsky and Mondrian made possible their overthrow of realism and their invention of non-objective abstraction based in theosophical mysticism and the advances of modern science; and Gleizes, Metzinger, Léger and others wrote about the nature and invention of Cubism's revolt against the Renaissance paradigm of perspectival space and modeling in light and shadow.

From an international perspective, this is the context in which Davis too was working, although he began somewhat later than his European counterparts, just as his American context became receptive to modernism more gradually than theirs. But as with the European artists, Davis's writings were similarly extensive and enabling. They too served as a means for working through a vast paradigm shift from a nineteenth century mindset to a twentieth century modernism. In Davis's case, this shift required the resolution of distinctively American or, as Kelder put it, "vernacular" variations of modernist aesthetic problems. For his youthful American culture was in the midst of its own efforts to come of age, of changing from an agrarian towards an urban society, and from a highly provincial to a reluctantly cosmopolite attitude. Indeed, Davis thought of himself historically as someone building upon the European contribution, but in American terms. And in so doing he dared to think that he was even going beyond European contributions by extending their ideas into the raw environment of the American scene.

He wrote about his sense of his own historical continuity with his European counterparts in 1951, by describing his admiration for European innovations. Yet he also spoke of his ambitions to press beyond them. What he admired was, "The discoveries of the past in Democratization of subject matter (Courbet) thus making it available to the individual; and the freeing of color (Van Gogh) from an imitative role; and the freeing of Form in Cubism-Fauvism (Picasso-Matisse)."[7]

He felt that he belonged to the lineage of these breakthroughs, but was also confident enough to travel farther. These discoveries of the past, he continued, "are all part of my Idea which goes beyond them in a single concept of the Shape of Purpose as the common denominator for Art."

Ultimately it was this notion of "the Shape of Purpose" (a variant of his mature "Shape of the Amazing Continuity") that Davis regarded as his important contribution to this history. If one were to extract the single most important thread from the complex labyrinth of Davis's written theory, it would be his evolution of this concept. The first hint of this is evident in what he naively understood in 1918 as: "Ultra-modern expression takes the whole scope of many [consciousnesses] as its field and in the plastic arts has as its object the expression of the mental scope in plastic form."[8] Thirty-three years later the full implication of this early intuition that modern art is "the expression of one's mental scope in plastic form" had grown into his sophisticated understanding that modern art is the expression of one's entire consciousness

of reality (one's "Total Percept") in plastic terms. Thus by 1951, he would write: "The Total Percept is a consciousness... It is a self-evident complete satisfaction. To ask the question what should I draw is answered by Drawing the Shape of the Amazing Continuity, and what is that? It is consciousness of the meaning of the act of drawing as the Objective Realization, contemplation, and psychological satisfaction, in the physical areas of Visual-Kinesthetic Color-Space Logic."[9]

This almost rapturous statement is so loaded and condensed that it both begs and defies decoding. But when understood within the context of Davis's body of mature paintings, the ideas expressed here rightly locate him in the company of modernism's great innovators. Thus, while Gauguin's writings helped articulate the richness of Synthetism, Kandinsky's essays aided a definition of the Spiritual in Art, and Mondrian's refined his idea of Neo-Plasticism, Davis's writings, enabled him to articulate a body of ideas characterized by the hip phrase, "The Amazing Continuity." Looking back through his paintings and the extensive written/drawn journals which underwrote those paintings, we discover his writings as a path by which he invented and explored the "Shape" of that "Amazing Continuity."

Davis's use of private jargon and technical terms can make those writings highly personal and obtuse. But his invention of his own theoretical language (which he assumed was only for private use) was proof of his desire to "penetrate the surface of style" and get inside "the ideational character of painting" in his own way. At the risk of oversimplifying, it can be said (with the advantage of hindsight) that two central tenets lie at the heart of Davis's written theory. One is that the real subject of art is one's consciousness of the world, one's "percept" (to use his favorite term) of reality. The second is that one's "percept" is experienced, felt or known, *as shape*; and therefore the visual artist must comprehend all aspects of consciousness within the dimensional, color-space logic of the medium of painting. As he said of this in 1951, "Percept is mental object; Percept is Consciousness which is a Total Shape" and "Real Art is the Shape of this [as a] Perceptual Satisfaction."[10]

By the 1950s, Davis had come to think of his perceptions as a rich continuum of many factors. These factors originated from a multitude of sources: the features of his loved American scene (gas pumps, architecture, electric signs, taxi-cabs); the genres of his cultural experience (Bach, Earl Hines's piano and jazz, the comic strips, the poetry of Rimbaud and Walt Whitman); the experiences of modernity (traveling at top speed in an automobile or airplane, using a telephone, radio, or the motion pictures); and the intellectually abstract knowledge of modern concepts (Cubism and simultaneity, synthetic chemistry and modern science, and four-dimensional conceptions of time, space and memory).

Such were the components that constituted what Davis meant by one's "Total Percept." They were acquired over a lifetime of experience, and existed as a "continuity of consciousness." At the peak of his awareness of the complexity of that consciousness (especially from 1951 to 1964), Davis assimilated the essential color-space features derived from all these components into configurations of abstract color-space shapes integrated with calligraphic word-shapes. These are the vibrant paintings of his peak years. *Visa, Owh! in San Pao,* or *Rapt at Rappaport's,* for example, hold together abstract references to the American scene, mundane objects and crucial, meaning-laden "Word-Shapes," in rhythmic configurations analogous to the structure of jazz. In such paintings there is a remarkable fluidity between all these factors and the two-dimensional language of painting.

In his writings of the same years, so fluid was his synthesis of these highly loaded elements and terms that his prose almost sounds mystical in its sense of unity. In December of 1951, for example, he wrote, "Reality is Completeness as the Percept of One. The content of Reality is One. One is the Amazing Continuity of the Percept... The Percept is All; All is Any; Any is All Truth; Any is Infinity."[11]

Each of these terms is loaded with Davis's theory and experience. But each has become for him an abstract sign (both as word-shape and color-form) experienced *as Shape.* Thus, the "shape of his consciousness" is clearly visible. *Rapt at Rappaport's,* (cat. no. 45), the product of those "powerful drawings," is a great example of Davis's celebration of the continuity of consciousness *as Shape.* It is itself a vibrant manifestation of the Shape of the Amazing Continuity, not only in its overall geometric configuration, but in its rhythmic synthesis of pure color-space form, word-forms (as in "ANY," "IT," "Stuart Davis" and the title), and symbol signs for "infinity," "plus," and (a private Davis invention) the purple squiggle to the right side which he links in his journals to a sense of "wonder."[12] This ecstatic vernacular perception, so evident in this painting's total quality, is further played out in the syncopated rhythms of sound implied by his visual analog in typography, color syllable divisions, and alliteration in the title's "Name-Shape," *Rapt at Rappaport's.*

What is fascinating about the evolution of Davis's writings (and paintings) is that this remarkable sense of the Shape of Continuity as subject matter was only latent, at best, in his beginnings. In fact his earliest influences were sharply discontinuous. Those influences, as he recalled in 1941, were "the teachings of Robert Henri [1901–12]... and the Armory Show of modern European art in 1913."[13] Although he knew then that "both were revolutionary in character," the disjunction between Henri's life-saturated realism and the abstract order of European modernism posed opposite paths of action. But Davis felt their connection on an intuitive level. He determined then to maintain the vibrancy of Henri's life-oriented "art spirit," but to discover how to grasp it in the pure terms of two-dimensional color form. Mastering the felt continuity between these matters would become his aesthetic adventure for the next fifty years.

One crucial touchstone which enabled Davis to discover that continuity was the knowledge of an analogous continuity already within his aesthetic experience: early American jazz. Although jazz was deeply rooted in life experience, its musical abstraction into ordered yet improvised form seemed to him connected to what he felt in Gauguin, Van Gogh, and Matisse: "I sensed an objective order in [their broad generalizations of form and non-imitative use of color which] gave me the same kind of excitement I got in the numerical precisions of the Negro piano players in Newark saloons."[14] Once again we see how Davis's mindset belonged to the larger context of International Modernism and its pioneers. For Gauguin and Matisse, as well as Kandinsky, Mondrian and the Cubists, the paradigm of music as an abstract and direct form of expression, with no need of naturalistic subject matter to carry, it played a crucial role in their inventions of abstract modes of painting.

Davis was supremely aware of the difficulty of resolving his disjointed early influences. Recalling his youthful decision to do so, he wrote, "The abstract kick was on ... I would become a modern artist. So easy. Except for one small matter. How? I was nineteen then."[15] That deceptively simple question of "How?" is the leitmotif of Davis's writings until his death in 1964. In my view, the single most important thread which leads the reader through the labyrinth of those twelve thousand pages is the ever-evolving concept of *how* the unity between his love of life in the American scene and the objective abstract order of painting's two-dimensional language of colors and forms became an Amazing Continuity by way of that excitement he felt in Negro piano music.

Tracking that development one moves from his first realization in 1918, that "Cubism is the bridge from Percept to Concept," allowing for the "expression of the mental scope in plastic form," to his working through a series of increasingly sophisticated notions of exactly *how* that "plastic expression of mental scope" is accomplished. By the early 1930s, he had invented a way of analyzing his perceptions in abstract terms through his Angle Theory. Through this notion, he translated his

sensations before nature into the objective order of angles, spatial planar units, and the dynamics between them. By the late thirties, his Angle Theory had been enriched by his thinking through the spatial qualities of color, such that he recast his ideas in terms of his Unit Area theory and his Color-Space Theory.[16] In 1938, he began to sense something of "Continuity," but in a still-disjointed way, as he wrote, "Art, then, is a triple unity of geometric forms, objective forms, and ideological forms."[17] During the 1940s, his understanding evolved into his richer, more subtle "Configuration Theory." In 1943, he wrote about "Total Quality" as an analog to "the total awareness of the world" conveyed through the "Total Shape" of one's consciousness of reality."[18]

Although these stages in Davis's developing theory enabled him to produce wonderfully rich and increasingly integrated paintings, the writings were still traveling, so to speak, in parallel to those paintings. But by 1951 his sense of Continuity had become so rich and so fluid that a remarkable melding developed. It was in the early fifties that the word "Continuity" became a constant. Pursuing that "Shape of Total Reality," the notion of "the Amazing Continuity" became his term for best encapsulating his awareness. As he wrote on October 20, 1951, "the sense of Continuity as physical Configuration-Ratios is most appropriate to Drawing. All great Art has its Meaning in the realization and satisfaction of the sense of unity as Continuity in these terms of Coherent structure."[19]

Leo Steinberg once pointed out that when we write words, we are just writing," but when we write our signatures, we "draw them" because they are both words and signs with complex referents to meaning and language. Davis, of course, had long "drawn" his signature in paintings as a compositional form loaded with both shape- and life-meanings. As he wrote on November 8, 1951, "My large signature is a level of Realization accomplished after twenty-five years in which the specific and usual Meaning of the Name-shape is changed to another plane, not denied in its content and as a subject, but made into a greater subject, a Public subject, Democracy of Society of Individuals."[20]

But by 1951 this "signature," and how it had meanings on various planes, moved beyond the shape of his name. It now encompassed the entire continuity within his writings, and more profoundly, within the entire processes *between* writing, drawing, and painting. In a sense, by 1951 we can no longer speak of Davis's writings, drawings, and paintings as separate activities. For by that year, it is more true to him to say that he is "drawing his writings" and "painting his drawings," and that the Continuity which is between these activities has become his chief subject matter and form. Even a quick look at the phrases he uses in his writings during the fifties reveals how full and rich this continuity was for him. A brief catalogue of phrases from the late writings, for example, suggests the fluidity he now felt between writing and drawing, between thinking verbally and visually. In 1960 he wrote, "The Alphabet Syntax and Language of Color-Space Method become the Object... as they take the place of Subject."[21] Within that "syntax" of alphabet and color-space, Davis wrote of "the Shape of Language," noting that "physically words are also shapes."[22] But he also wrote on sketches without words or lettered alphabets, speaking of their pure forms in terms of "spatial semantics," of "The Given spacial semantic phrase," and of how "ANY subject" has within its color-space configuration "the Semantic Direction of the Time Sequence as GIVEN in [one's] Percept."[23]

Perhaps Davis's made his most succinct summary of these explorations on October 28, 1951, when he wrote: "Reality is characterized by, and in Art has the shape of, the Amazing Continuity which is the Constant Percept of a Five Dimensional figure...
3 dimensions of space
1 dimension of time
1 dimension of Indetermination
Only this 5 dimensional shape is Art because its content corresponds to the Totality

of common perceptual experience. Art Drawing is the completion of consciousness in Objective Action on 3 dimensional Color-Space Logic in the Likeness of the Total Constant Percept... The Total Percept is a consciousness... It is a self evident complete Satisfaction."

It is this kind of complex consciousness that Davis so tersely abbreviated when summarizing the events of that day on his small appointment calendar page: "Made the Greatest Analysis of the Shape of the Amazing Continuity which is the additive Real change in the Act of Perceiving in written form. Did some powerful drawings of *Rapt at Rappaport's.*"

Of course, most important is how this complex consciousness was consummated by Davis in painting, for example, in *Rapt at Rappaport's.* Yet without the extended underwriting of his journals, there would have been no guarantee to back Davis's bold claim that, "What my paintings are, of course, should be seen and not heard."[24]

[1] Stuart Davis's appointment calendar, courtesy of Earl Davis. I want to thank Earl Davis for his continued generosity and helpfulness in making material available for research

[2] For a bibliography of his published writings, see D. Kelder (ed.), *Stuart Davis: A Documentary Monograph in Modern Art*, Praeger Publishers, New York, Washington and London 1971, pp. 201–203.

[3] Stuart Davis, *Stuart Davis*, American Artists Group, New York 1945, n. p.

[4] Stuart Davis Papers, Reel 6, March 8, 1943, Fogg Art Museum, Harvard University Art Museums. Gift of Mrs. Stuart Davis. All rights reserved by the President and Fellows of Harvard College. All quotations are from the Davis Paper unless otherwise indicated.

[5] D. Kelder, "Stuart Davis: Pragmatist of American Modernism," in *Art Journal*, Vol. 38–39, Fall 1979, pp. 29–36.

[6] R. Blesh, *Stuart Davis*, Grove Press, Inc., New York 1960; D. Kelder (ed.), *op. cit.*; J.R. Lane, *Stuart Davis. Art and Art Theory*, (The Brooklyn Museum, Brooklyn, New York 1978); L.S. Sims, W. Agee, K. Wilkin, L. Kachur, see respective essays in *Stuart Davis, American Painter*, The Metropolitan Museum of Art, distributed by Harry N. Abrams, Inc., New York 1991; K. Wilkin, L. Kachur, *The Drawings of Stuart Davis, The Amazing Continuity*, The American Federation of Arts in association with Harry N. Abrams, Inc., New York 1992.

[7] Reel 11, October 27, 1951.

[8] "Man on an Ice Floe, Gloucester, 1918," quoted in D. Kelder (ed.), *op. cit.*, p. 93.

[9] Reel 10, October 10, 1951.

[10] Reel 11, November 20 and 21, 1951.

[11] Reel 11, December 27, 1951.

[12] Reel 11, December 7, 1951.

[13] "How to Construct a Modern Easel Picture," a lecture by Davis at the New School for Social Research, December 17, 1941.

[14] Stuart Davis, *Stuart Davis*, Monograph No. 6, American Artists Group, New York 1945, n.p.

[15] Quoted by R. Blesh, *Stuart Davis*, Grove Press, Inc., New York 1960, p. 13.

[16] For further discussion of these ideas see John R. Lane, chapters 4–8. For a comparative study of Davis's theory with other thinkers of his generation, see my doctoral dissertation, "American Art Theory During the 1930s: Thomas Craven, George L.K. Morris, Stuart Davis," University Microfilms, Ann Arbor, Michigan, 1989.

[17] Reel 2, July 6, 1938.

[18] Reel 6, March 8, 1943.

[19] Reel 11, October 20, 1951.

[20] Reel 11, November 8, 1951.

[21] Reel 14, June 6, 1960.

[22] Reel 14, September 27, 1954 and K. Kuh, "Stuart Davis," in *The Artist's Voice: Talks with Seventeen Artists*, Harper & Row, New York and Evanston 1960, p. 52. Also see Lewis Kachur's essay of Davis's use of word-image for further discussion.

[23] Davis sketchbooks 21-6-54, 21-7-54. Courtesy of Earl Davis.

[24] Davis, "The Cube Root," in *Art News*, February 1, 1943, reported in D. Kelder, *op. cit.*, p. 130.

Writings of Stuart Davis

Selected by Diane Kelder

From the Notebooks of Stuart Davis

Man on an Ice Floe, Gloucester, 1918
Cubism is the bridge from percept to concept. A cubist picture is a concept in light and weight of a specific object in nature. It is from that only a step to the expression of a concept of diverse phenomena, sound, touch, light, etc., in a single plastic unit. 14th century demanded plot relationship of subject. 1870 to 1918 demanded plastic relationship of subject. 1918—demands plastic expression of mental scope.

Art, December 30, 1922
A work of art should have the following qualities.
It should be first of all impersonal in execution, that is to say it should not be a seismographic chart of the nervous system at the time of execution. It may be as simple as you please but the elements that go to make it up must be positive and direct... The work must be well built, in other words. The subject may be what you please. It may express any of the qualities that man is capable of perceiving or inventing. It can be a statement of character or a statement of pure abstract qualities but in all cases the medium itself must have its own logic...

THE INTENTION OF THE ARTIST IS THE THING THAT MAKES THE PICTURE.
ONE PICTURE IN A ROOM IS BETTER THAN TWO.
THINGS THAT WON'T MAKE A WORK OF ART ARE MONEY, HARD WORK, SYSTEMS OF PRO-
CEDURE, PRECONCEIVED TEXTURES, IMITATION OF NATURAL OBJECTS.
THE THING THAT WILL MAKE A WORK OF ART IS THE INTENTION ON THE PART OF THE
ARTIST TO MAKE A WORK OF ART AND NOT SOMETHING ELSE.
ART IS THE THING THAT IS NEEDED AS A LIFE FACTOR AND THE MORE OF IT WE HAVE THE
BETTER IT WILL BE...

The Subject, March 2, 1923
...The elements that go to make the picture on your panel are—SHAPE, COLOR, and the SIZE of the colored shapes in relationship to one another and to the size of the panel...
I want the picture to be simple.
I do not want any illusions of light in the accepted symbolism to creep into the painting as I desire the light to be the actual light of the color itself. I want to recover the primary sense of vision...
A work of art is an orderly construction in a given material.
Nature is an orderly construction in millions of materials.
Little order and big order.
The one is not the other. It is only a parallel system...

1923

...To begin with the object of doing the painting in the first place is not to construct an abstract figure but to get on to the canvas in a direct and positive style the actual shapes and colors of the objects that inspire it. Therefore while it is necessary to have a dominant simple planal combination as a base just as there is a simple and dominant color the planes should be carried on into minor variations which brings the picture closer to nature. In a word a true realism...

From the Daybooks

1932

The artist goes to nature to draw. In nature he sees a series of accidental combinations from which he selects. He is selecting accidents just as though he selects from a series of random lines on a piece of paper which have been drawn by himself.

This is the *subject* of painting. The mode of expression is by means of angular variation. From any given point the line moves in a two-dimensional space and is continually creating space relative to all existing points which is either expansive or contractive according to the point of observation. Relativity, knowledge of this fact, and the ability to visualize the logical correlatives of a given angle allows the artist to *see* the *real* angular value of his drawing as opposed to associative value...

Definitely understood are the ideas relating to drawing as follows: that anybody can *see* an interesting subject in nature. That none can draw it effectively. That a drawing is a real thing equal to but *not* a replica of the subject in nature. That the anatomy of the drawing is *two dimensional*. That the *only* possible [thing] to be achieved in drawing is a numerical variety in the two-dimensional elements. The indivisible second unit is the triangle...

A drawing is never nature. Therefore it is necessary to arbitrarily define space in terms of a standard and its variants, the 90° angle. The object of drawing is to build up measurable angular variations. Through these variations, which are the language of graphics, the artist must communicate with people. As the area of a surface is the NUMBER of times a unit area goes into it, so the only possible graphic description of a visual sensation is through the *number* of times a unit occurs in a complex. The *unit* of the drawing is an angular contrast.

...The good picture is optical geometry. But more than, or rather through that geometry, the artist may express his sense of numerical variety. Which is a way of saying angular variation.

It is even possible to have a set formula for a good picture. The formula capable of adaptation to various associational ideas.

As in music, the blues, a set form, are always good and one might say that they express everything that can be expressed. A series of formula pictures carrying a sentimental association is possible and would be desirable.

The formula can only be arrived at through wholesale observation of nature and intellectual selection of the common denominator of varieties ... which can be rationalized and used over and over again with success...

Gloucester, 1933

I want you to get some idea of the facts (physical) of painting. By physical facts I do not mean permanency of colors. By physical facts I mean the two-dimensional

division of the surface on which you work. I mean the cultivation of the ability to quickly disassociate the associational and relative values of any subject from its two dimensional structural reality. This is necessary because your picture is a two-dimensional reality at all points of its conception, execution and finish, and to consider it in any other manner is to deal in fantasy...

May 17, 1942
A picture is only art when its subject matter has been transposed in a new dimensionality which is a new sensate order in nature.
The structure of a picture develops in sequential steps which I call serial configurations.

November 21, 1942
I can work from nature, from old sketches and paintings of my own, from photographs, and from other works of art. In each case the process consists of a transposition of the forms of the subject into a coherent, objective, color-space continuum, which evokes a direct sensate response to structure.

Mural for Studio B, WNYC (working notes) (1939)
3/23/39
...The subject matter of art is always the same in a general sense. In the particular sense it is never the same. The subject matter which is common to all works of art is constructive order and the achievement of it in the material of expression...

Abstract Painting Today (1940)
(Unpublished article commissioned by *Art for the Millions*)
...The best work of the last seventy-five years is great because it is real contemporary art, which expresses in the materials of art the new lights, speeds, and spaces of our epoch. Modern chemistry, physics, electricity, petroleum, radio, have produced a world in which all the conceptions of Time and Space have been enormously expanded and modern and abstract art both reflect and are an active agent in this expansion...

Is there a Revolution in the Arts? (1940)
(From *Bulletin of America's Town Meeting of the Air*, V, No.19, February 1940)

...An artist who has traveled on a steam train, driven an automobile, or flown an airplane doesn't feel the same way about form and space as one who has not. An artist who has used the telegraph, telephone, and radio doesn't feel the same way about time and space as one who has not. And an artist who lives in a world of the motion picture, electricity, and synthetic chemistry doesn't feel the same way about light and color as one who has not. An artist who has lived in a democratic society has a different view of what a human being really is than one who has not. These new experiences, emotions, and ideas are reflected in modern art, but not as a copy of them...

The Cube Root (1943)
(From *Art News*, February 1, 1943)
...Some of the things which have made me want to paint, outside of other paintings, are: American wood and iron work of the past; Civil War and skyscraper architecture; the brilliant colors on gasoline stations; chain-store fronts, and taxi-cabs; the music of Bach; synthetic chemistry; the poetry of Rimbaud; fast travel by train, auto, and aeroplane which brought new and multiple perspectives; electric signs; the landscape and boats of Gloucester, Mass.; 5 & 10 cent store kitchen utensils; movies and radio; Earl Hines hot piano and Negro jazz music in general, etc. In one way or another the quality of these things plays a role in determining the character of my paintings. Not in

the sense of describing them in graphic images, but by predetermining an analogous dynamics in the design, which becomes a new part of the American environment. Paris School, Abstraction, Escapism? Nope, just Color-Space Compositions celebrating the resolution in art of stresses set up by some aspects of the American scene...

The Place of Painting in Contemporary Culture: The Easel is a Cool Spot at an Arena of Hot Events (1957)

(From *Art News*, June 1957)

....My personal guess as to the Meaning and Enormous Popularity of Modern Painting goes somewhat as follows:

(I see the Artist as a Cool Spectator-Reporter at an Arena of Hot Events.)—Its continuing appeal to me since the Armory Show of 1913 is due, I believe, to its American Dynamics, even though the best Reporters then were Europeans operating in terms of European Identifications. Fortunately, we have our own share of Aces today...

Interview (1957)

(Excerpt from an interview published in *Stuart Davis*, catalogue of an exhibition at the Walker Art Center, Minneapolis, Minnesota, 1957, pp. 44–45.)

...I think that a painting is a logical process from the time you buy the stretcher. You buy one that is rectilinear because while it is possible to make other kinds of stretchers...a rectilinear shape fits in with the kind of houses we live in, it fits in with our being able to stand up straight, and is not disturbing. Whatever feeling there is about making a rectilinear canvas as the base on which we paint, the selection was made long ago and we don't feel it anymore. You just use it as a matter of common sense. So from that point on your composition, your design, your painting are implicitly conditioned by the original selection of a rectilinear area...

My pictures are developed without preconception as to the way they will be finished. They start with a simple impulse to make something which is always specific, something outside myself. It could be a box of matches on the table, it could be a news report, it could be a recording of the pianola rolls that Fats Waller made when he was twenty years old, it could be a political event. It could be anything that would be the initiation of an impulse to draw something....

From "The Downtown Gallery Papers"

The word "amazing" was in my thoughts at that period as being appropriate to the kind of painting I wanted to look at. The word "continuity" was also in my thoughts for many years as a definition of the experience of seeing the same thing in many paintings of completely different subject matter and style.

From "Stuart Davis," Rudi Blesh, Grove Press, New York, 1960

You have to have a subject. Why wander around? I take what I can get—even one of my own paintings.

I can take a painting I made forty years ago and use it as a basis for developing an idea today.

From D. Kelder (ed.), *Stuart Davis: A Documentary Monograph in Modern Art*, Praeger Publishers, New York, Washington and London 1971.

Night Beat. Television Interview with Stuart Davis by John Wingate, 1956

John Wingate (JW): Our guest has painted the American scene for more than forty years. He's Philadelphia-born Stuart Davis, admitted today as one of America's greatest painters. In 1947, *Life* magazine used his work as a case study on why artists are going abstract, despite Mr. Davis's assertion, from his earliest days, that his purpose is to make realistic pictures. *Memo*, 1956, is one of his latest paintings, currently part of a one-man-show at the Whitney Museum of American Art. Later on in the program, we'll try to find out what's realistic in this abstract painting. Mr. Davis, good evening and welcome tonight.

Stuart Davis (SD): Good evening to you, sir.

JW: Ten years ago, Winthrop Sargeant wrote about new trends in abstract art for *Life* magazine, the article was subtitled 'The Case of Stuart Davis,'[1] and this is what he said about you, sir: "...He goes about painting a picture in very much the spirit grandma had when she was making a patchwork quilt..." How do you feel about that comparison, sir, "...a grandma making a patchwork quilt...?"

SD: Well, I skipped it at the time.

JW: Well, would you not skip it now? How do you feel?

SD: I mean that things are... if you want to reach far out... and grandma was pretty good sometimes, you know. But, I must be frank in saying that I have other thoughts in mind than grandma had, in just putting together things that were pretty. It was a legitimate thing, the quilt, let's not disdain it.

JW: That was *legitimate*?

SD: Yes I think mine are... are appropriate to my purpose as her's were to her.

JW: All right, let's see if we can find out more right here, about that purpose. Let me hand you, here, a copy of the painting which the audience will see there, on the screen behind you. Could you take that sir?

SD: Oh yes.

JW: You hold it the right side up if you will, let's find out...

SD: That's easy.

JW: Yes, let's find out what's in this painting *Memo* 1956. Now, it's on the screen behind you—you've got your copy there.

SD: Yeah.

JW: Can you tell me what it means, sir?

SD: Well this is what you call a beat-up subject.

JW: U-huh?

SD: Meaning by that... that I think I've drawn it and painted it probably a dozen times in twenty-five years. The original subject—there's no need after this lapse of time to make a mystery out of it—was simply a normal landscape in Gloucester, Massachusetts.

JW: A "normal landscape"?

SD: Yeah, you know, wi....

JW: Yes, could you show me where, if it's there, the harbor is?

SD: The harbor didn't happen to be in this particular landscape. But I don't want to erase any of the mysteries from my work...

JW: We respect that.

SD: Yes? Well here, this is obviously the elegant lines of schooners and their rigging.

JW: U-huh.

SD: Unfortunately, they're no longer present, they don't use them any more. The foreground had its origins in some buildings and the ground and certain nautical elements that happened to be strewn about.

JW: Mr. Davis, let me ask you this, it's obviously quite clear to you...

SD: ...yes, it is...

JW: ...can you understand why the average man would find it perhaps unclear, and would not see the rigging of the schooners?

SD: Well, one of the reasons is that there is no rigging of schooners here. I was only describing the origin of the subject.

JW: Mmm, well, what *is* there? That's what we would like to get.

SD: What is here... is an objective order... do I need to hold this up?... no... It is an objective order consisting of colors in different positional relationships. That is a tangible, physical thing... a thing that makes it a public... a piece of public property. The particular order of this painting is established by a subjective determination, as in all art.

JW: As you see it, in other words?

SD: Well, as you *feel* it.

JW: Let's, ... let's get away from this which may, or may not be, quite clear-cut. Let's find out, if we can, how you call this "realistic." Your theory, your philosophy of painting in other words, perhaps...

SD: ...well, did I call it realistic?

JW: Well, is there realism in it? You've said that you paint "realistic"?

SD: Well, my attitude toward life is realistic, but realism doesn't include merely what one immediately sees with the eye at a given moment—one also relates it to past experience...

JW: ...yes...

SD: ...one relates it to feelings, ideas. And what is real about that experience is the totality of the awareness of it. So, I call it "realism." But, by "realism" I don't mean that it's a realism in any photographic sense—certainly not.

JW: Do you mean it's a realism that every man on the street can immediately see?

SD: A realism that every man in the street has the *potential* to see, but in order to see, would have to see it in himself first. He'd have to give value to those qualities which an artist gives.

JW: He'd have to be something of Stuart Davis wouldn't he?

SD: He'd have to be something of what *he* is, and give value to the... whatever is the artist in him. The man in the street understands that which he pays attention to... if it happens to be art, he understands it very well. I know a good many men in the street who do understand.

JW: This quick question sir—do you care what the so-called average man in the street thinks, or sees, of that painting?

SD: Not when I make it, but the more men in the street who enjoy it after I do it, well, the happier I'll be about it.

JW: All right, would you rather sell a canvas to the Whitney Museum or the Museum of Modern Art?

SD: I prefer to sell it to both.

JW: In other words, you do care how many people see it.

SD: Definitely, I make these pictures to represent my own development in being able

to understand life; and the more people that participate in that... what I've developed in myself, the better I feel.

JW: All right Mr. Davis, let's go to the price, the high price of pictures, all right?

SD: If you can go as high as you want... yes?

IN: All right, do you get any more satisfaction out of creating a painting that sells for $10,000, than you do when one sells for $200?

SD: I get more satisfaction out of the money, yes, not the painting.

JW: In recent years you've become a successful and a recognized artist; does it surprise you that a buyer is willing to pay as much as $10,000 for one of your paintings?

SD: No it doesn't.

JW: Inwardly, does it come as any surprise at all?

SD: Not in the least. It's been so gradual that I've been able to take it.

JW: Who sets the price on your work?

SD: Oh, the... ah... current esteem in which they are held, in relation to market prices in general.

JW: You don't do it?

SD: Oh, I have nothing to do with it whatsoever.

JW: You want as much as possible?

SD: I want whatever people will pay for it, of course.

JW: You wrote in *Art News* recently that "...art and culture were alright in that the artist makes his report..."—and we quote—"...to the very *hip* people..." What do you mean by that phrase, "the very hip people?"

SD: Well, I presume it means the... people who are... competent, and able, and demonstrate it in various ways, to know what other people are talking about.

JW: Alright, sir, who isn't "hip"?

SD: Those who don't pay attention.

JW: Why do you use an expression like "hip"?

SD: Well, that probably had its most general use in its origins in jazz parlors, cellars and what-not, but I understand that everybody uses it now.

JW: Where did you learn it? From everybody, or the jazz parlors and cellars?

SD: I learned it from the jazz parlors, cellars, saloons *et cetera*.

JW: Let's talk very briefly about some other well-known artists. Briefly, what do you think of Grandma Moses ?

SD: Well, I don't think about Grandma much, but I'm delighted that she's getting along as well as she has, it's very good.

JW: What about the *Saturday Evening Post* illustrations of Norman Rockwell?

SD: They don't send me, I must admit it.

JW: Al Capp's Lil' Abner?

SD: I haven't looked at the comic strips since they made them too small.

JW: The work of a recent *Night Beat* guest, Rockwell Kent?

SD: Well I've known Rockwell Kent for a number of years, but I haven't seen any of his work for probably forty years.

JW: You like Mr. Kent?

SD: I see him very little, I liked him when I met him as a young boy.

JW: Mr. Kent charged that today's American art is sterile. How would you answer him?

SD: Well I think I saw that program. As I recall, he said he hadn't been to any exhibitions, so I'd ask him how he knows.

JW: He also implied, though, that he keeps up, in his own way, with what's going on. You see—that criticism, after all, hits a little bit directly at you—because it's the work of the past twenty-five years, sir?

SD: Yes, it didn't disturb me...

JW: Others have made the charge of sterility, too.

SD: Is that so? Who?

JW: Well, take Ortega y Gasset, the late Spanish philosopher.

SD: Yes, I read that book some time ago.

JW: What about it?

SD: Well, that's an opinion.

JW: Well, what about the opinion, sir?

SD: I think the opinion is absurd because there's more painting being done today, more people are looking at paintings, more paintings are being bought, preserved, taken care of, there's more concern about art today than there ever was in the history of the world.

JW: Picasso—quick opinion?

SD: Well he's a genius.

JW: Mr. Davis, Picasso is well known for many different paintings and among the best known is *The White Dove of Peace*. How do you feel about the artist who propagandizes in his painting?

SD: Well, he signs a lot of things.

JW: Do *you* make political paintings?

SD: No, I... I don't.

JW: That's, that's not quite an answer: "...he signs a lot of things..."

SD: What I meant by that, is that he signs peace petitions *et cetera*... rather loosely... ah... it's disturbing to me, because I think that a man has a right to endorse any political ideas he wants...

JW: You do?

SD: ...but a man whose whole life has been spent in cultivating his own innate and enormous powers... shouldn't sign his name so freely to... propaganda of countries.

JW: Let me put it this way to you, if a political party was engaged in a campaign that you happened to like, regardless what the campaign was, and that party came to you and said "Stuart Davis, we want you to paint a cover for a pamphlet," would you do it?

SD: If I endorsed the ideas, I would, yes.

JW: Mmm. In an article the fellow artist Ben Shahn wrote "It may be a point of great pride to have a Van Gogh... (we are going back now to the beer-parlor days where you said you learned "hip")... it may be a great pride to have a Van Gogh on your living room wall, but the prospect of having Van Gogh himself *in the living room* would put a good many devoted art lovers to rout. Is this an accurate evaluation of the feeling about the artist in today's society?

SD: Ummm... I don't know what it means, Van Gogh has been so publicized in relation to his... his disturbances of one kind or another, that people don't realize that his paintings are... among the most serene, balanced, controlled and constructed works that were ever made.

JW: Well, I think that the disturbances probably don't stop with Van Gogh, they can be extended to, for example, to Toulouse-Lautrec and others. The artist is a man who's too emotional, he has an excess of emotional energy, let's put it like that...

SD: I don't think about it that way, I would think that there are different individuals and what is most admirable in a man would be that part of him in which he organizes his faculties, whatever they may be. Toulouse-Lautrec did it. Van Gogh did it. Every artist has done it.

JW: Do you do it?

SD: I think so ... yes.

JW: Are you accepted everywhere you go?

SD: Do you mean socially?

JW: Mmm.

SD: So far I haven't been thrown out.

JW: Do you care whether you are accepted?

SD: Oh yes...definitely, definitely.

JW: You do? Why? Why would an individual really care?

SD: Well I go out so seldom, that I... when I go somewhere I really want to get in. You know what I mean...

JW: Ha... ha... ha... Mr. Davis, last night we asked Columbia's football coach, "Buff" Donelli, what advice he'd give to mothers who worry about broken bones. Tonight, let's extend it... we'd like to find out about what you'd tell a mother who was worried about having a bohemian Greenwich Village artist in her family?

SD: Ummm... what I would...if I was asked whether he should go to the...?

JW: ...No, if she's got a kid there who has a great individuality—we'll use your phrase —and she's worried about him... what would you tell her?

SD: I'd tell her to let him go.

JW: Here's a question which has bothered a great many people—it's come up in criticism—what's happened to the nude, in modern painting?

SD: Well, I didn't know anything had happened to it, what did?

JW: It's disappeared, apparently, according to some critics...

SD: Oh I...I mean, would you call Matisse a modern painter?

JW: Yes, I suppose so...

SD: ...Or Picasso, or Braque or Léger?

JW: Let's come to the more modern—Pollock... you?

SD: Pollock... mmm... well I am not a *nude* painter. You're referring to naked women, is that it?

JW: Yes.

SD: Modern painting extends over a period of roughly a hundred years and it is filled with nudes. The fact that some artists don't paint them is not a contemporary phenomenon, some artists in the past didn't paint them.

JW: I think the point such critics mean to make is that obsession with the life form has gone and that a kind of... mechanical geometry comes into painting.

SD: In some paintings.

JW: Yes, yes that is the point.

SD: In some paintings, it's the exact opposite. I mean, you mentioned Pollock, you wouldn't find much geometry there.

JW: No.

SD: And where the nude is gone, I don't know. I mean, you can find thousands of nudes on the nearest newstand, you know.

JW: How much geometry is there in Stuart Davis?

SD: Quite a bit, quite a bit. I used to play chess.

IN: What does that have to do with geometry?

SD: Well... I make my own geometry. I use straight lines very often, as Mondrian did, but I break it up now and then a bit, too.

JW: Let's talk about you, even more personally, for a few minutes. A *Time* magazine article, March 15th of 1954, calls you "...as American as Bourbon-on-the-Rocks...," it went on to list some of the things which have influenced your work: pop-jazz, television, billboards, gasoline pumps, electric signs. Briefly, what has each meant to you? Jazz?

SD: Well, jazz... ah... I was interested in that from the time I was a kid, and I used to... my father used to take me to shows when I was a little boy and... I saw colored reviews, *Williams and Walker*, things like that. He liked music and I liked it and so I just... ah... maybe I have a talent for liking it. I even thought I wanted to play it, at one time or another, but I found out that I could do something else better.

JW: What about television, on which you are now? *Time* says you like to paint with your set turned on, but the sound turned off—what's your point?

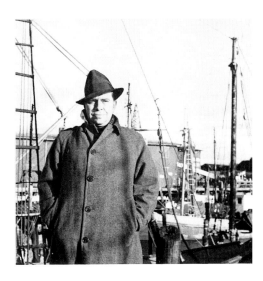

Stuart Davis, Gloucester Harbor, 1940s.
Photograph courtesy of Earl Davis

SD: Well, I like to see things going on. And ah..., I find that in the beginning I used to walk around a great deal and make sketches. Currently, the television is, in effect, a window in which many interesting things happen and...if I want to listen to it, I do, and if I don't, I turn it off... there may be some... I like to look at...

JW: Do you watch the commericals?

SD: What else? I mean, you can't help it. And ah, you know, I must say, I don't pretend to be crazy about the commercials. But there are many interesting scenes in television, in movies—it could be a lousy movie and still be visually interesting in some aspects.

JW: One last question, Stuart Davis, how accurate is the tag *Time* bestowed on you? Are you the "All American painter, as American as Bourbon-on-the-Rocks?"

SD: Well, I never thought about it until they mentioned it, but I'd be delighted to fill the bill.

JW: Do you think you have?

SD: Let's hope so.

JW: Thank you very much for coming on *Night Beat*.

SD: And thank you, Jack.

JW: As we've seen tonight, Stuart Davis speaks very much the way he paints, with verve, with sensitivity, and thorough disdain for the common ailment of much of American society—the disease of mass conformity.

[1] W. Sargeant, "Why Artists Are Going Abstract: The Case of Stuart Davis," in *Life*, 22, 7, February 17, 1947, pp. 78–83.

Catalogue

by Diane Kelder

1. **Chinatown**

1912
Oil on canvas
37 × 30¼ in. (94 x 76.8 cm.)
Collection Earl Davis.
Courtesy of Salander-O'Reilly Galleries,
New York

At the age of seventeen, Davis entered the New York Art School of Robert Henri, an admired and influential teacher of two generations of American painters, and the spearhead of a radically realistic approach to form and subject matter that was later characterized as the Ashcan School.

Henri's teaching encouraged students to look for inspiration in the world around them and held that any subject matter, even that deemed ugly, was valid material for an artist. His ideas about art were informed by progressive social and political views that were embraced by his pupils.

Searching for "life in the raw," Davis haunted the teeming streets of the lower east side of Manhattan and frequented saloons, music halls, burlesque houses, and other popular places of recreation and entertainment.

Although reminiscent of the dark palette and broadly painted canvases of Henri and another mentor, John Sloan, *Chinatown* differs by avoiding any suggestion of narrative. Already present in this work is an uncommon sensitivity to pictorial structure as well as a manifest concern with the compositional potentials of commercial and street signage that would become a hallmark of Davis's work.

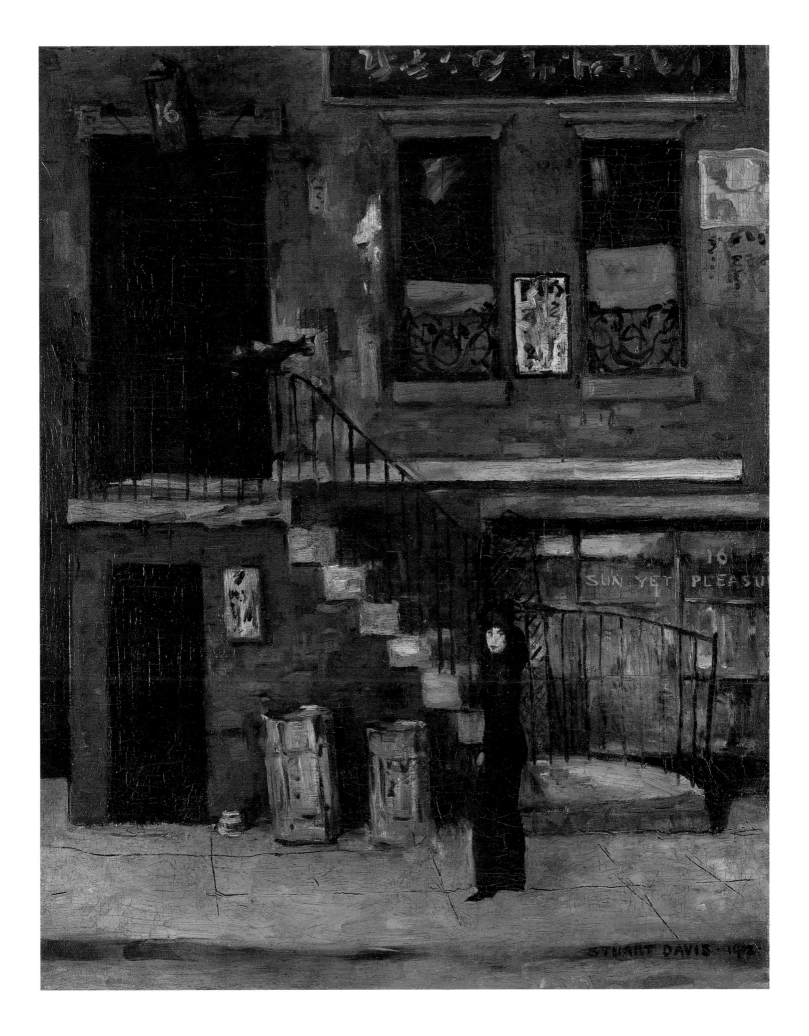

2. Consumer Coal Company

1912
Oil on canvas
29½ × 37½ in. (74.9 × 95.3 cm.)
Collection of Sunrise Museum, Charleston,
West Virginia. Gift of Amherst Coal Company

Davis's initial recognition as an artist came within the context of the Ashcan movement and he made his public debut in the celebrated 1910 "Exhibition of Independent Artists" in New York that showcased the painting of Henri and his circle.

Consumer Coal Company, painted when he was about to leave art school, differs from most of his contemporaneous street scenes since it depicts a quiet residential area with some private dwellings. It acknowledges his teacher's earlier, much admired urban snow scenes and reflects the young painter's determination to measure his growing accomplishments against those of Henri.

Davis deftly built a rich paint surface through a combination of broad brushwork and the use of a palette knife. The spatial organization is established through the interlocking planes of buildings, the railings of the stoops, and the vertical lampposts that define the distance between foreground and background. The angled coal wagon, its workers, and a female pedestrian provide contrasts of movement and scale.

In later paintings, while retaining his commitment to the physical reality of a given site, Davis would develop the pronounced sense of structure so evident in this work within a Cubist framework.

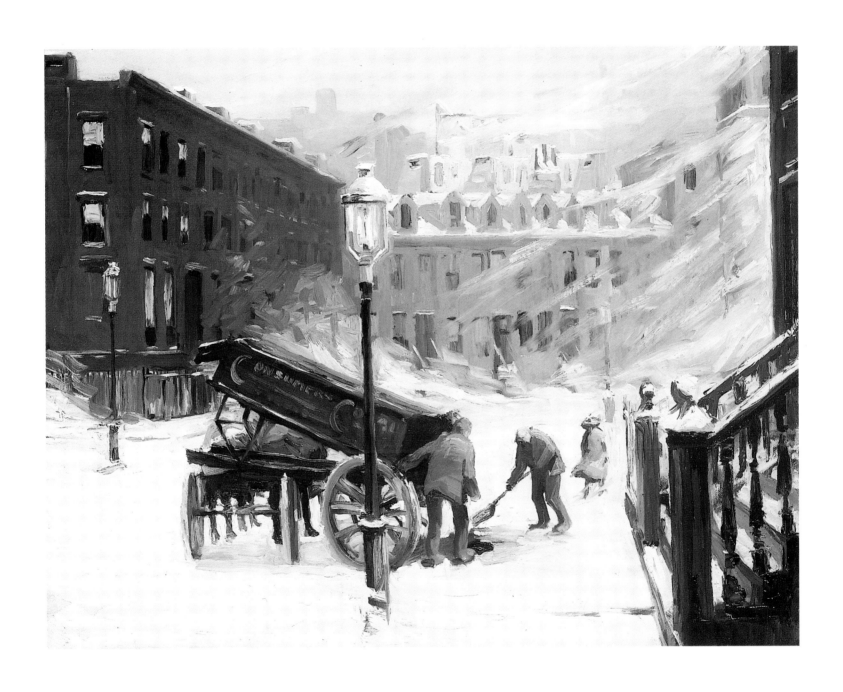

3. **Self-Portrait**

1912
Oil on canvas
32¼ × 26¼ in. (81.9 × 66.7 cm.)
Curtis Galleries, Minneapolis, Minnesota

In this disturbing *Self-Portrait* the juxtaposition of a large, uneasy male in the foreground and a tiny, dejected female in the industrialized background creates a palpable tension that is reinforced by emphatic contrasts of dark and light and curious spatial gaps. Although Davis focused on similarly confrontational aspects of male/female relationships in *The Front Page*, a watercolor executed the same year, the idea of combining self-portraiture with a narrative or anecdotal scene is unusual. No direct precedent for this penetrating study of psychological conflict existed in the paintings of Henri, but Davis may have been aware of works by Edvard Munch and other northern European artists that explored themes of alienation and anxiety.

In the absence of a definitive model, it is tempting to situate this painting within the context of contemporaneous American literature. With his bowler hat, dark suit, and high collar, the nineteen-year-old artist could easily be taken for a bank or office clerk, similar to those who populated the naturalist fiction of the period. Davis was an avid reader and reserved a special admiration for Theodore Dreiser. Patricia Hills has observed that the content of Davis's watercolors often reflect naturalist writers' themes and she sees a parallel between this self-image and the protagonist of Dreiser's *The Genius*, a young artist who comes to New York and becomes a successful illustrator and art director.[1]

It is not possible to relate the fragment of a factory, the railroad siding, or the other desolate elements of the background to a specific site, but they may have been inspired by one of the industrialized neighborhoods of Hoboken, New Jersey, where the artist then lived and shared a studio.

[1] P. Hills, *Stuart Davis*, Harry N. Abrams, Inc., Publishers, New York 1996, pp. 7, 28.

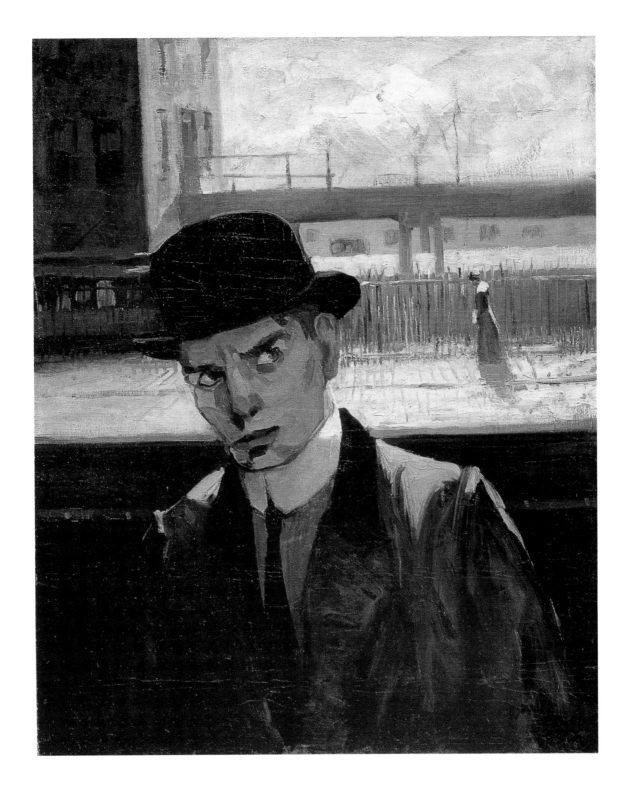

4. Babette

1912
Oil on canvas
30¼ × 38¼ in. (76.8 × 97.2 cm.)
Collection Earl Davis.
Courtesy of Salander-O'Reilly Galleries,
New York

From the mid-nineteenth century, images of performers and various forms of popular entertainment such as circuses and café-concerts had been a focus of modernist painting. Davis was surely familiar with images by Manet, Degas, Seurat, and Toulouse-Lautrec, among others, and his interest in their American counterparts is manifested in numerous watercolors, drawings, and paintings executed between 1910 and 1913.

Babette introduces the viewer to the raucous world of music halls and vaudeville that he and his friends from art school explored in New York and its environs. Davis provided a broad view of a congested stage seen midway from the orchestra level of a fairly large and darkened theater. Fixing the looming head of a male spectator as a point of reference, he makes our eye travel beyond the barely illuminated musicians and sheet music to focus on the spotlighted figure of the principal entertainer. Her bright green dress and hat stand out against the darker relief of wildly gyrating couples and other seated and standing performers.

While theater and café scenes were painted by a number of artists associated with the Ashcan circle, the considerable number of figures, careful delineation of the complex space, and skillful manipulation of artificial lighting in this ambitious composition suggest that Davis was attempting to match or even surpass their achievements.

Lowery Stokes Sims has noted similarities between this composition and those of two watercolors, *The Vaudeville Show* and *Babe La Tour*, from the same year.[1]

[1] L.S. Sims, *Stuart Davis: American Painter,* The Metropolitan Museum of Art, New York 1991, p. 116.

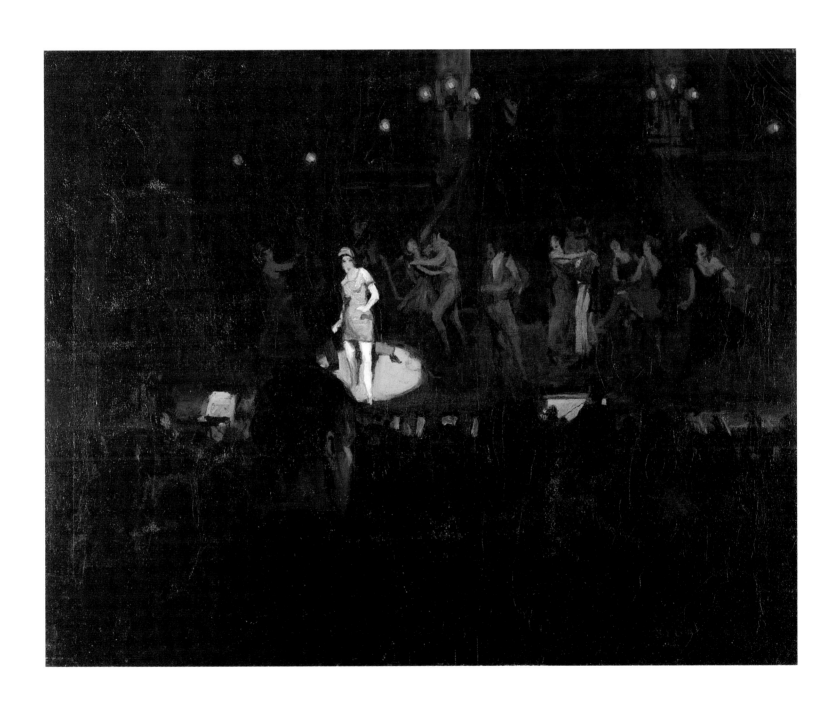

5. Bleecker Street

1913
Oil on canvas
38 × 30 in. (96.5 × 76.2 cm.)
Collection Earl Davis.
Courtesy of Salander-O'Reilly Galleries,
New York

In the early years of this century, New York's Greenwich Village was a vibrant center of progressive politics and avant-garde culture. The young Davis was strongly attracted to both, and his frequent presence in this area included visits to the clubs, coffee-houses, jazz establishments, and offices of the experimental magazines that were located there.

In *Bleecker Street*, the artist focused on a corner view of the long thoroughfare that cuts irregularly through the heart of Greenwich Village. He skews the perspective of the view so that the dark, freely-brushed façades of the tenements at the left ultimately converge with the curb of the lighter-hued sidewalk that contains a few pedestrians and some type of vehicle. The foreground is activated by the figure of a woman whose red coat provides a foil for the thickly-applied passages of green, orange, and yellow that suggest the contents of a vegetable stand at the left. In this pictorial slice of life, Davis generally kept anecdote to a minimum and stressed the ways in which paint can communicate the solidity of architecture as well as varied effects of weather and light. As in *Chinatown*, the prominent sign advertising a pharmacy both reinforces the structural framework of the composition and provides visual contrast with its limited areas of intense color.

The distant elevated rapid transit station may have furnished a further clue about the particular location of the scene since the line ran above Sixth Avenue at that time. But it also underscores Davis's fascination with this distinctive feature of New York's physical environment.

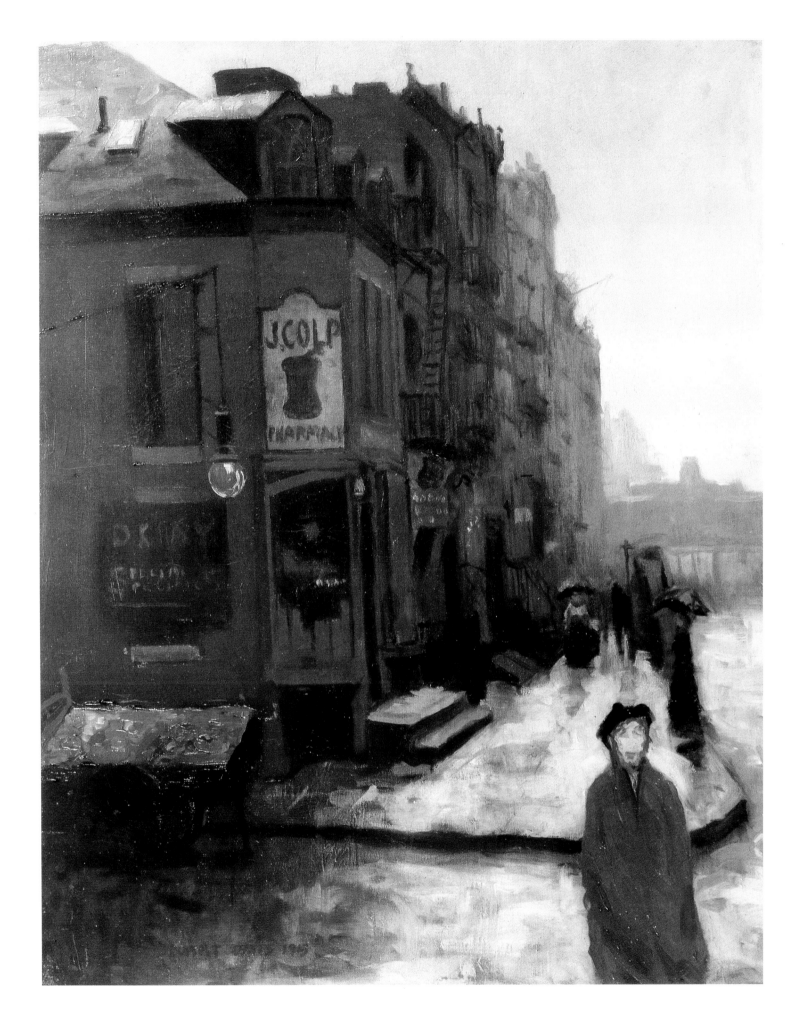

6. Ebb Tide, Provincetown

1913
Oil on canvas
38 × 30 in. (96.5 × 76.2 cm.)
Curtis Galleries, Minneapolis, Minnesota

The "International Exhibition of Modern Art" that was housed in New York's Sixty-Ninth Regiment Armory opened in February 1913. Organized by artists, the Armory Show introduced the American public to the work of European and American modernists. Davis, who exhibited five watercolors, later maintained that in looking at paintings by Gauguin, Van Gogh, and Matisse, he became conscious of "...an objective order which ... was lacking in my own." This discovery made him resolve "to become a 'modern' artist."[1]

Davis spent the summer of 1913 in Provincetown, Massachusetts, a historic fishing village that was beginning to attract numerous artists and writers. He was enthusiastic about his initial exposure to the New England coast, and annual summer visits to Provincetown (and subsequently to Gloucester) would be included in his working schedule for the next twenty years. The stimulating physical environment encouraged him to experiment with some of the modernist approaches to form and color he had confronted so recently.

While inspired by the local phenomenon of tidal sand flats, this canvas rejects the realism of his previous work. It displays a conspicuous stylization of natural form and an expressiveness of color that can be associated with Symbolist practices.

In his recollections of the Armory Show Davis never mentioned Edvard Munch, although a number of the artist's prints were exhibited there. If he was exposed to them, he would have recognized the Symbolist sensibility in their bold design and subjective color.

Apart from the solitary figure with the lantern and the surrounding areas at the bottom of the canvas, Davis made a clear effort to control brushwork. By simplifying the natural components of the scene and restricting his palette he gave a new decorative priority to color and shape.

[1] Stuart Davis, *Autobiography,* American Artists Group Monographs, 6, New York 1945, n.p.

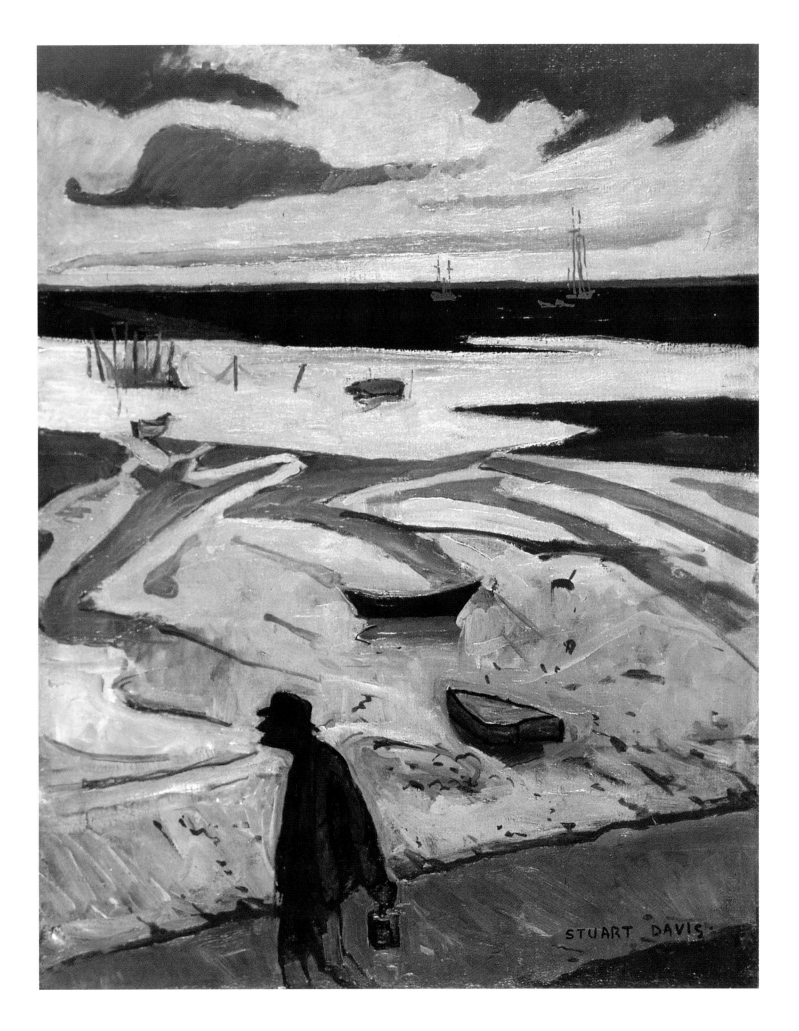

7. **Garage**

1917
Oil on canvas
19¼ × 23¼ in. (48.9 × 59.1 cm.)
Collection of Robert and Fern Hurst,
New York.

Venice only

Davis's efforts to educate himself about modernism by exploring the various options presented in the Armory Show continued between 1913 and 1919. That they did not proceed in a clear direction or result in any definitive change of style can be detected in *Garage*.

At a time when the automobile culture was not yet a prominent feature of American life, Davis was an enthusiastic motorist, proud of the second-hand roadster that he drove to Gloucester in the summer of 1914. Automobiles, gasoline pumps, road signs, and related motifs would figure prominently in the imagery of his paintings through the 1940s.

The generous paint surface, emphasis on frontality, and provocative display of signage in *Garage* are reminiscent of *Chinatown*. Yet on closer examination the windowed wall bearing the identifying word disengages itself from the rest of the structure and the viewer becomes keenly aware of the essentially flat shapes that vie for attention. If Davis incorporated signs for design purposes, he also used them in more subtle ways to suggest or even amplify the formal intentions of his paintings. At the left of the composition, the letters OSCH are barely visible: the B has been eliminated by the edge of the canvas, reminding us of its finite surface. This awareness of the two-dimensional is further emphasized by the sign above the open door whose functional identity is humorously checked by the STOP sign at the right edge. Thus what appears to be a fairly straightforward realist work actually embodies modernist strategies of contradiction and ambiguity.

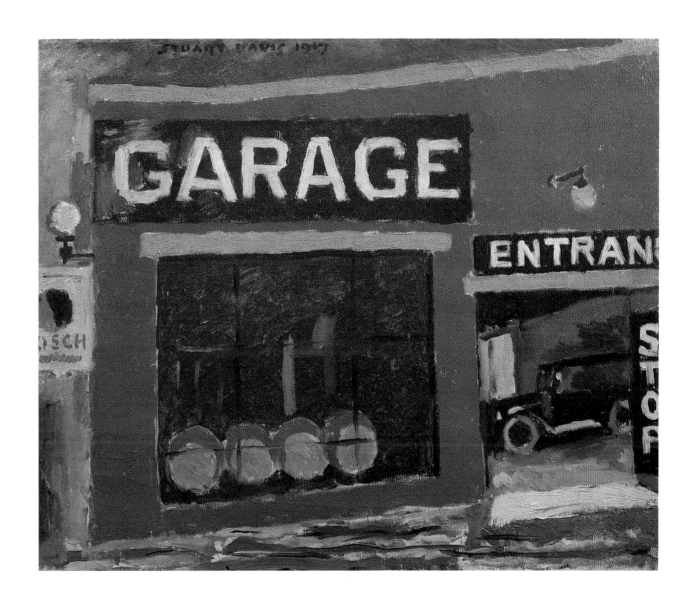

8. Setting Sun, Tioga, Pa.

1919
Oil on canvas
24 × 30 in. (61 × 76.2 cm.)
Collection Earl Davis.
Courtesy of Salander-O'Reilly Galleries,
New York

Davis's investigation of European modernism
was interrupted in 1918 by service as a car-
tographer in the United States Army. Instead of
returning to Gloucester the following summer,
he went to a place his family had rented in
Pennsylvania, where he painted landscapes of
cornfields whose dynamic colors and heavily im-
pastoed surfaces recall Van Gogh's views of the
countryside surrounding Arles.

In this densely-packed close-on view, the
small farm structures are almost overwhelmed
by the surrounding vegetation of trees and
sinewy corn plants. The intense yellow sky and
the vibrant green and bluish hues of the plants,
applied in vigorous, rhythmic strokes, transmit
a palpable sensation of unbridled growth.

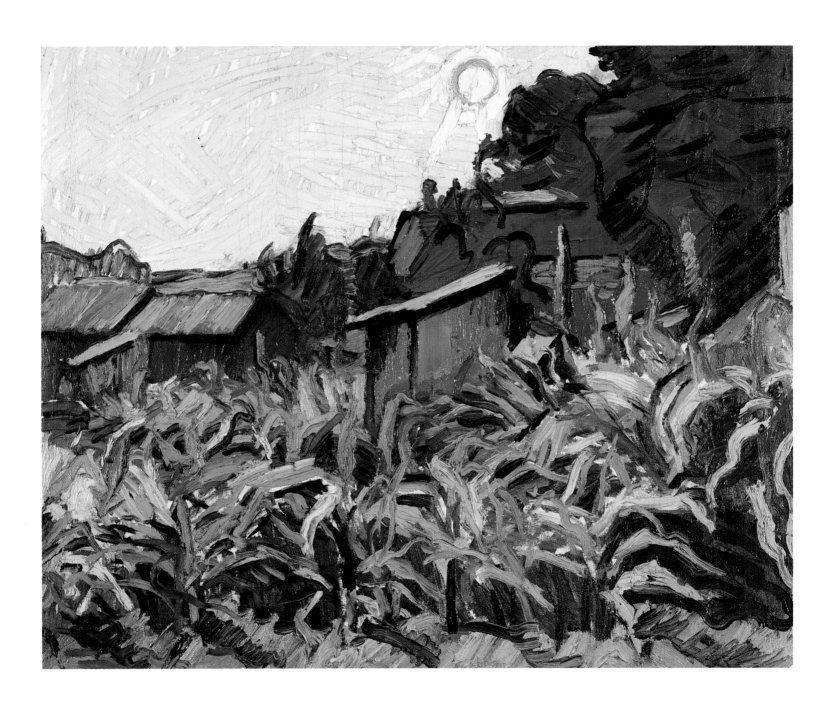

89

9. October Landscape, Gloucester

1919
Oil on canvas
22 × 32 in. (55.9 × 81.3 cm.)
Collection Earl Davis.
Courtesy of Salander-O'Reilly Galleries,
New York

In the fall of 1919 Davis traveled to Gloucester where he resumed his habit of hiking through the surrounding countryside in search of suitable motifs. Although the palette of *October Landscape* is not as intense as it had been in the preceding Tioga canvases, a similar expressionistic naturalism informs its composition. Passages of saturated green, orange, and yellow alternate with areas of scumbled browns and grays to convey the effects of shifting light. Animated strokes of black both reinforce the tonal contrasts and call attention to the patchlike character of the composition. By stressing the physicality of his pigments, Davis directs our attention to the surface of the canvas and makes us acknowledge its flatness.

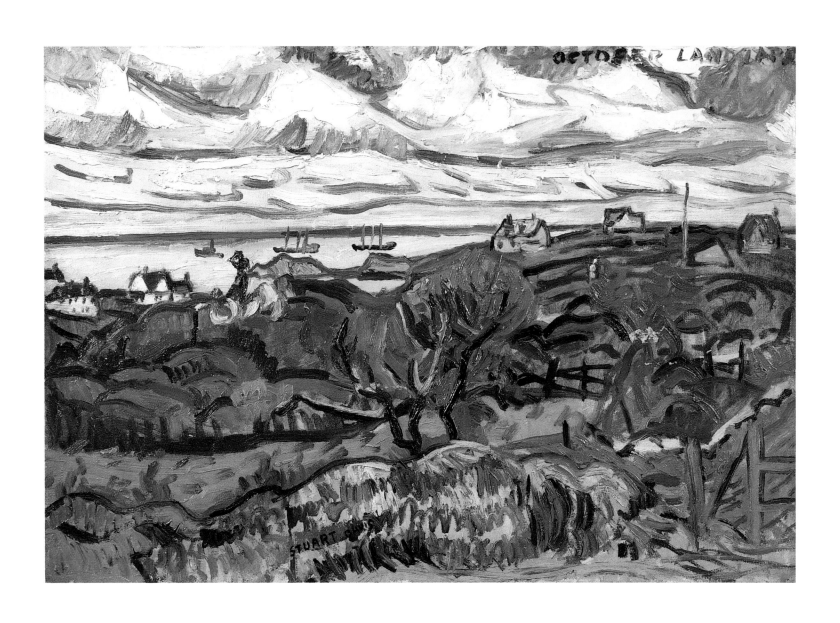

10. Self-Portrait

1919
Oil on canvas
23 × 19 in. (58.4 × 48.3 cm.)
Collection Earl Davis.
Courtesy of Salander-O'Reilly Galleries,
New York

In this searching examination of his own likeness, an impression of casual informality, suggested by the open-collared shirt, is repudiated by the studied exoticism of the Chinese hat that covers the top of his head. The warm yellow tones of the hat are echoed in the artist's face and neck, and he made a conscious effort to reconcile the contrasting blue and brown passages of the background by allowing them to reverberate in the freely-painted creases and shadows of the shirt.

There is a marked sobriety to the intense gaze and it has been suggested that the artist was still recovering from the effects of influenza that brought him close to death earlier that year.[1]

Davis finished this canvas shortly before departing for a brief trip to Cuba where he produced a group of delightful watercolors whose bright hues and decorative silhouettes convey his enthusiasm for the vitality of Havana's streets and cafés. Returning to New York in February 1920, he embarked on a decade of unprecedented investigation that would lead to his unique synthesis of Cubist structure and American content.

[1] See J.J. Sweeney, *Stuart Davis*, The Museum of Modern Art, New York 1945, p. 13.

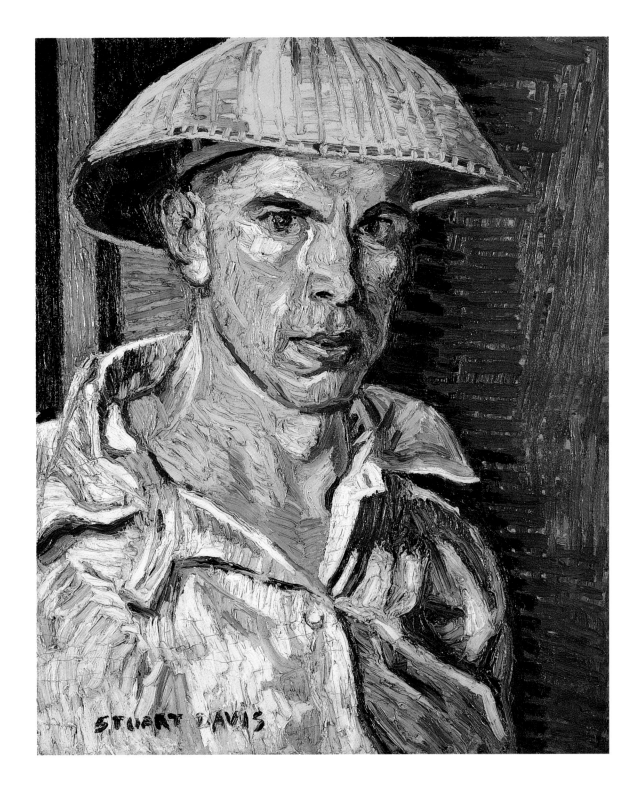

11. Garden Scene

1921
Oil on canvas
20 × 40 in. (50.8 × 101.6 cm.)
Collection Earl Davis.
Courtesy of Salander-O'Reilly Galleries,
New York

Before the 1920s, Davis's engagement with Cubism was sporadic. He had incorporated a quasi-Cubist approach to form in some of his 1916 Gloucester landscapes and adopted a composite system for addressing notions of time and simultaneity in his curious painting *Multiple Views*, 1918, where a series of conventionally-painted vignettes are represented in a collage-like fashion. While it is impossible to determine precisely what factors contributed to the new understanding of Cubist practice that would be revealed in some remarkable paintings produced between 1921 and 1923, it is safe to say that further exposure to vanguard art as well as increased contacts with modernist writers, such as the poet William Carlos Williams, enlarged his perception of both the physical character and content of painting.

Garden Scene is one of a group of landscape "fragments" that articulate a clear though somewhat primitive sense of Cubist space which William Agee has likened to Braque's proto-Cubist paintings of 1908–09. Its natural and architectural forms have been condensed into interlocking, irregular shapes of evenly-brushed green, brown, black, and gray that stretch across the entire surface. However, the application of stippling to certain of these shapes introduces a textural variety in the composition that disrupts the apparent continuity of the surface and forces us to acknowledge spatial ambiguities.

Karen Wilkin has cited the importance of this canvas to the development of a number of Davis's inventive paintings of the early 1940s including *Arboretum by Flashbulb*.[1]

[1] K. Wilkin, "Becoming a Modern Artist: The 1920s," in L.S. Sims, *Stuart Davis: American Painter,* The Metropolitan Museum of Art, New York 1991, pp. 48–49.

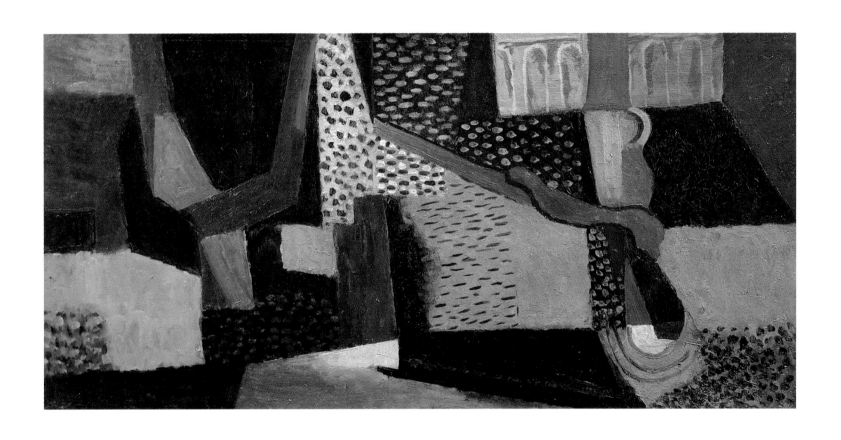

12. **Lucky Strike**

1921
Oil on canvas
33¼ × 18 in. (84.5 × 45.7 cm.)
The Museum of Modern Art, New York.
Gift of The American Tobacco Company, Inc.

Venice only

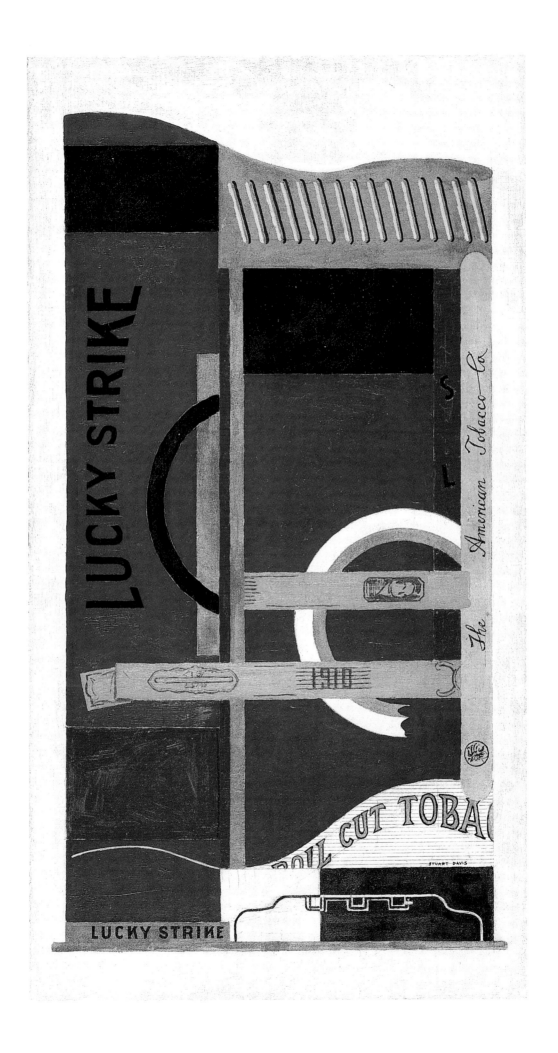

13. **Bull Durham**

1921
Oil on canvas
30¼ × 15¼ in. (76.8 × 38.7 cm.)
The Baltimore Museum of Art,
Baltimore, Maryland. Edward Joseph
Gallagher III Memorial Collection

Washington, D.C. only

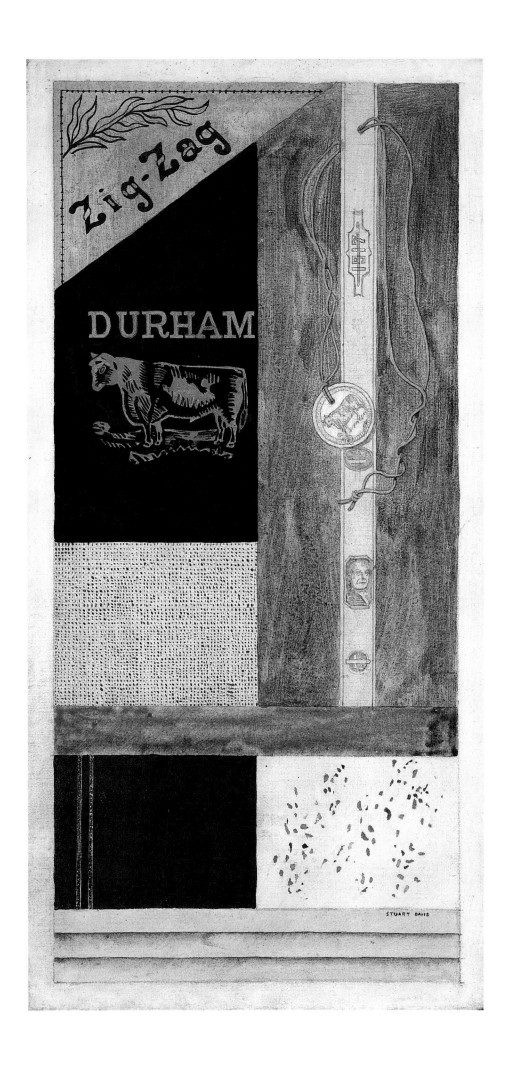

14. Cigarette Papers

1921
Oil, bronze paint, and graphite
pencil on canvas
19 × 14 in. (48.3 × 35.6 cm.)
The Menil Collection, Houston, Texas

Davis's goal of integrating his new awareness of the functions of color and shape into a coherent plastic whole was increasingly informed by the model of Synthetic Cubism. To clarify his efforts, he began writing about the theory and practice of painting on a regular basis in 1920. Surviving notebooks and journals from the period illuminate the gestation of contemporaneous works and provide insights into the different elements of past art and of his daily environment that stimulated him to paint.

In 1921, he made a number of witty watercolors, incorporating collage or imitating collage, that have affinities with the so-called machine portraits that Francis Picabia had exhibited in New York some years earlier. In a March journal entry, he wrote, "Words can be used in paintings... as Apollinaire's poetry encroaches on painting, let painting encroach on poetry... The hint of JOURNAL in Cubism should be carried on." He noted also that he wished to make paintings "from an alphabet of letters, numbers, canned goods labels, tobacco labels... let these well-known, purely objective things be used to indicate location and size."[1]

The series of paintings that pursue these ideas derived from cigarette packages, labels from cigarette papers, and tobacco packages. Although they are painted to look like collages, their enlarged scale immediately cancels the illusion. Whereas the Cubists had introduced smoking paraphernalia as part of a café table still life, Davis's arbitrary arrangement of the label and packing components presses them against the surface of the canvas as objects of contemplation divorced from environment or context.

The planar structure, and the pervasive frontality of these "Tobacco Still Lifes" also reflect the increasing emphasis Davis was placing on the two dimensional character of his medium in his theoretical writings.

While their flatness and formal clarity proclaim the unity of this series of canvases, there is variety in the handling of the paint. *Cigarette Papers*, combining oil, metallic pigment, and pencil, is the most delicately brushed and perplexing composition. It contains elements of overt illusionism that are not present in the other paintings, such as the folded triangle of paper, the printed ribbon with its logotype and cross, and the twisted string at the bottom whose carefully rendered shadow is cast on the thinly painted surface.[2]

Lucky Strike provides the boldest contrasts of color, and the generous but tight application of paint gives its shapes a hard-edged quality that distinguishes it from the other works. Davis's notebooks make it clear that he admired the techniques of advertising and sophisticated graphic design. He gave considerable thought to the ways in which commercial design, with its accessibility of subject matter and clarity of form, might contribute to an art that was both rigorously modern and had popular appeal. The ready-made consumer imagery of the "Tobacco Still Lifes" enabled him to appropriate successfully the means of advanced French painting to the end of making distinctly American work, and he was aware of his accomplishment: "I feel that my tobacco pictures are an original note without parallel so far as I can see."[3]

[1] Notebook 1920–1922, March 11, 12, 1921. Private collection.
[2] James Johnson Sweeney was the first to suggest this link with the nineteenth century trompe l'oeil paintings of W. Harnett and J. Frederick Peto in *Stuart Davis,* The Museum of Modern Art, New York 1945, p. 13.
[3] Notebook 1920–1922, May 29, 1921. Private collection.

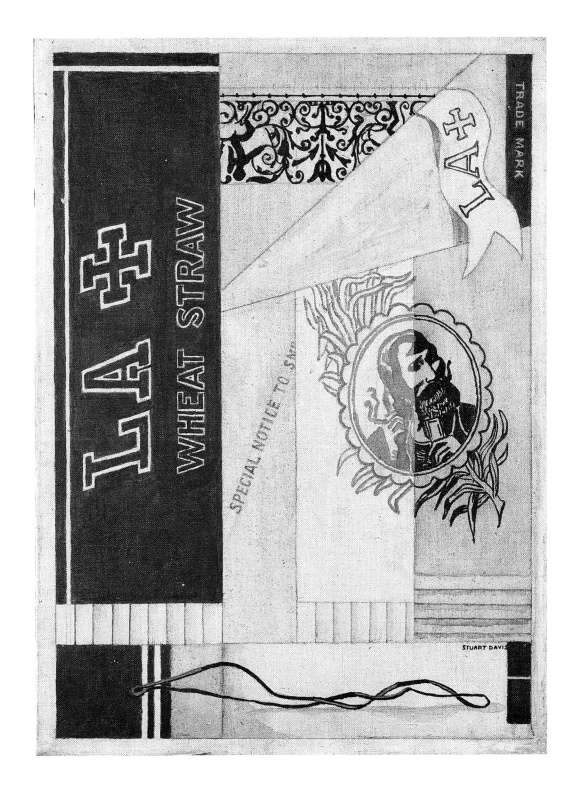

101

15. **Still Life with Dial**

1922
Oil on canvas
50 × 32 in. (127 × 81.3 cm.)
Collection Earl Davis.
Courtesy of Salander-O'Reilly Galleries,
New York

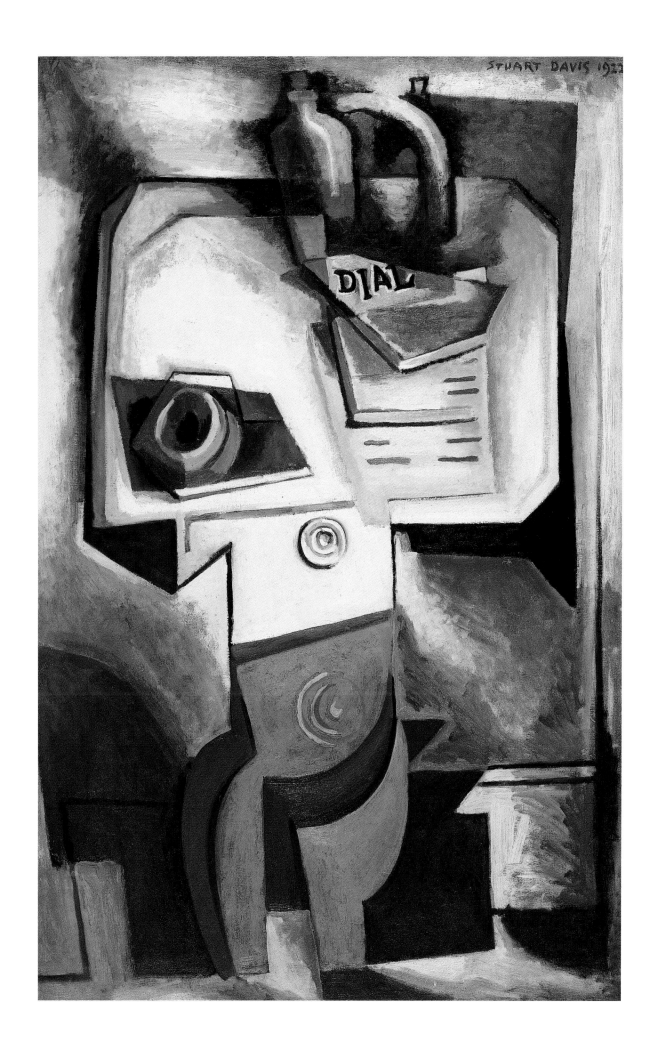

103

16. Still Life (Red)

1922
Oil on canvas
50 × 32 in. (127 × 81.3 cm.)
Collection Earl Davis.
Courtesy of Salander-O'Reilly Galleries,
New York

In 1922, Davis abandoned his experiments with simulated collage and popular imagery and began working on a group of six still life paintings that reflected his renewed interest in pictorial space. The large scale, compositional ambition, and more consciously European character of these pictures invite comparison with the work of Georges Braque and Juan Gris.

Three of the canvases, *Still Life with Dial, Still Life (Red)*, and *Still Life (Brown)* appear to be interrelated, and William Agee has discerned in them a progression from a simple to a more complex and sophisticated command of space and design.[1] In the latter two paintings, the placement of the table is identical and the tonal range is similar. However, in *Still Life (Brown)*, the investigation of Cubist notions of contingency and simultaneity results in more acute fragmentation.

The decidedly frontal placement of *Still Life with Dial* distinguishes it from the other compositions as do its lighter coloring and formal simplicity. In contrast to the more traditional elements found in the other paintings, such as fruit, dishes, vases and glasses, it contains objects—an inkwell or an ashtray, a notebook, and superimposed copies of the magazine *The Dial* that seem to have more personal significance. Between 1920 and 1929 *The Dial* published the work of modernist writers as well as the art criticism of Clive Bell, Roger Fry, and Julius Meier-Graefe. Davis had contributed drawings to the magazine between 1920 and 1923, and his association with it stimulated contact with the avant-garde literary world of New York.

[1] W.C. Agee, *Stuart Davis (1892-1964): The Breakthrough Years (1922–1924)*, Salander-O'Reilly Galleries, New York 1987, n.p.

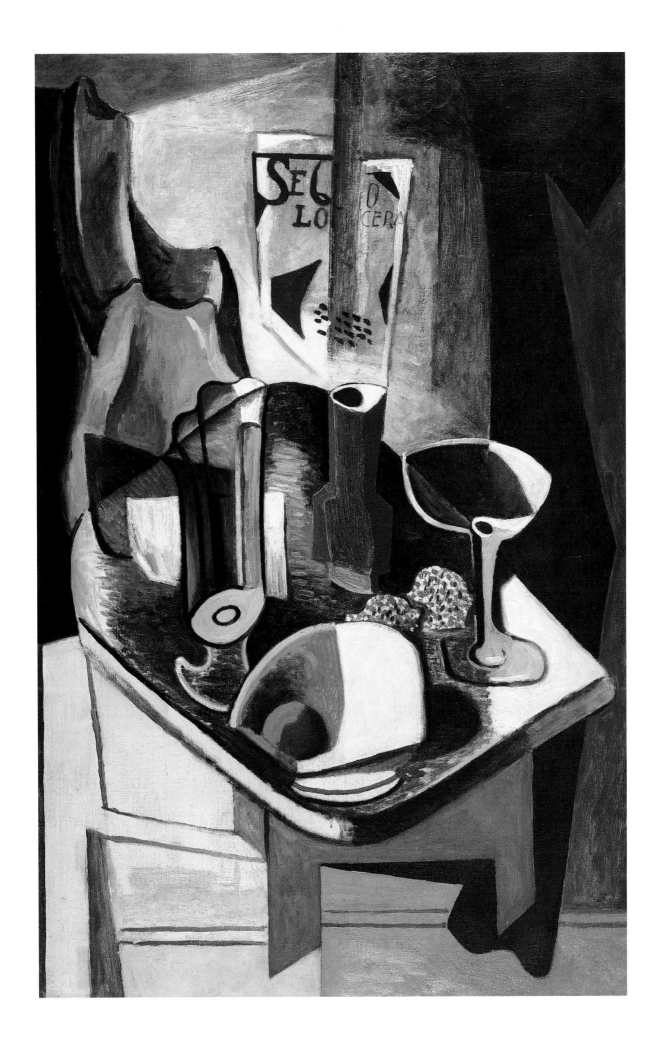

105

17. Apples and Jug

1923
Oil on composition board
21⅜ × 17¾ in. (54.3 × 45.1 cm.)
Museum of Fine Arts, Boston, Massachusetts.
Gift of the William H. Lane Foundation

Davis's growing confidence in his ability to absorb and expand upon Cubist strategies resulted in significant shifts in subject matter and style during the early 1920s. During the summer of 1923, he produced essentially monochromatic paintings of an oversized eggbeater, followed by a saw, and he continued to paint still-life arrangements of simple objects—a lemon and a glass, an electric light bulb, and other household items—through 1924.

Eschewing the spatial complexities and eminently painterly surfaces of the monumental still lifes of the previous year, he now sought what he termed "a head-on view of an incised plane, and not an exaggerated symbolizing of forms in perspective."[1] The heavy outlines and pristine execution of works like *Apples and Jug* indicate an awareness of Fernand Léger, but also remind us of Davis's interest in the formal qualities of advertising and commercial art.

Unlike the previous series of Cubist still lifes, planes do not generally overlap but rather "function as a clear and independent element. In the few cases where they do overlap, each is nevertheless made a concrete entity, with no illusion involved."[2]

[1] Stuart Davis Papers, Fogg Art Museum, Cambridge, Mass., Index April 20, 1923 quoted in J.R. Lane, *Stuart Davis: Art and Art Theory*, The Brooklyn Museum, New York 1978, p. 100.
[2] W.C. Agee, *Stuart Davis (1892-1964): The Breakthrough Years (1922–1924)*, Salander-O'Reilly Galleries, New York 1987, n.p.

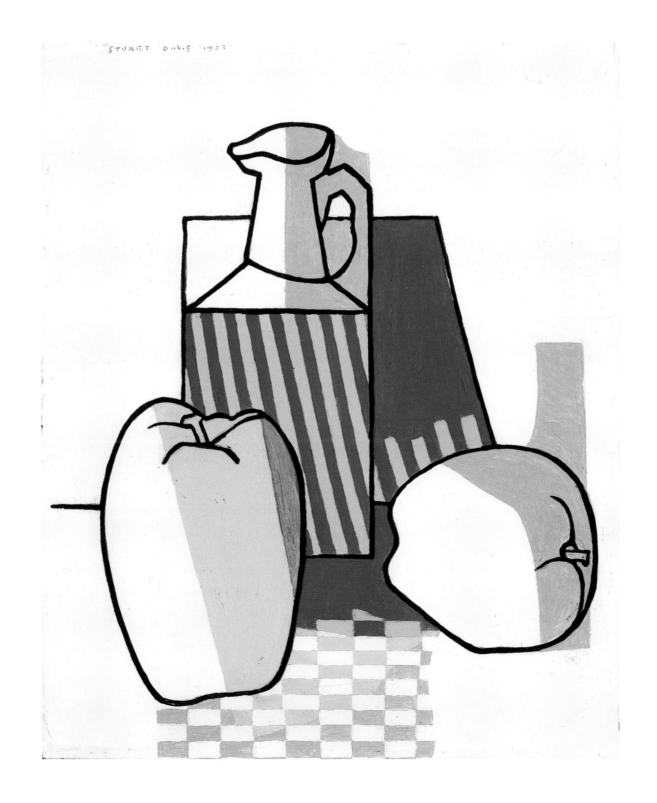

18. Electric Bulb

1924
Oil on board
24 × 18 in. (61 × 45.7 cm.)
Dallas Museum of Art, Dallas, Texas.
Fine Arts Collectible Fund

Davis's interest in expanding the traditional repertory of still life to accommodate distinctly modern objects is manifested in *Electric Bulb,* in which he utilizes a familiar emblem of scientific progress and its corrugated paper container.

While the forms are recognizable, the persistent black outlines give them a clarity and presence that transcend their actuality.

Davis's determination to eliminate illusionistic effects is signalled by his use of unmodulated colors, and is particularly evident in the treatment of the light bulb where the three shades of blue belie the uniform color of the glass. The slight hint of its reflective property is reduced to a white triangle of crusty white paint.

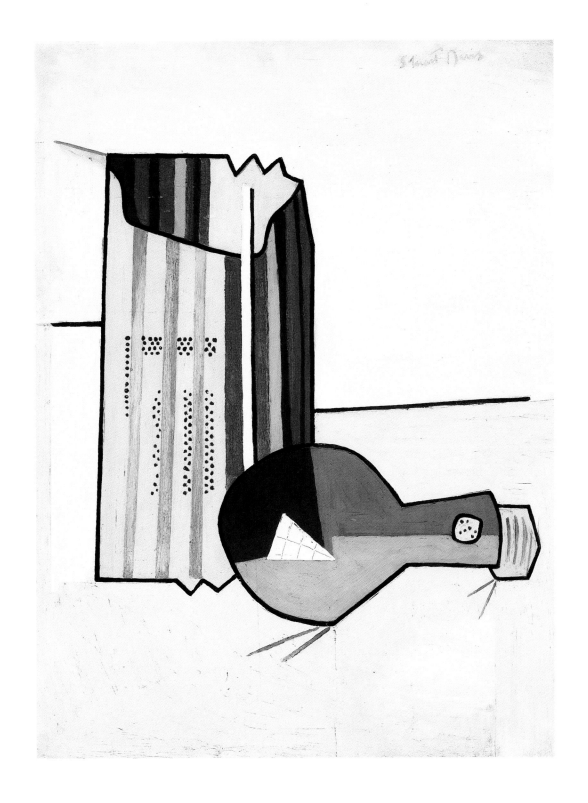

19. Odol

1924
Oil on canvas
24 × 18 in. (61 × 45.7 cm.)
The Crispo Collection

In 1924 Davis continued his depiction of common household objects. Karen Wilkin has observed that their "very familiarity and ordinariness allowed Davis to concentrate on color and structure, while at the same time their obvious difference from traditional still life objects"[1] made them seem like viable modern alternatives.

Unlike the hardware or lightbulbs which he had treated objectively, Davis emphasizes *Odol*'s explicit identity as an oral hygiene product that had been an international consumer item for about thirty years. Even from the vantage point of the 1990s, Davis's choice of subject seems provocative: while the "Tobacco Still Lifes" reflected an age when smoking had social, if not sexual allure, the bathroom practices of tooth brushing and disinfecting the mouth were still extremely private when Davis undertook this painting.

In *Odol*, the overscale, centralized, and visually concise image privileges the product name and the advertising slogan that proclaims its effectiveness: "It Purifies." A tilted transparent form (perhaps an allusion to a medicine cabinet) frames the bottle's distinctive profile, creating spatial confusion between the thinly painted area of white on which the bottle seems to reside and the green and white checkered pattern that suggests the tiled floor of a 1920s bathroom.

Lowery Stokes Sims has pointed out that this was not the first time that the Odol logotype had been incorporated into a work of art, citing Carlo Carrà's 1914 *Free Word Painting: Manifesto for Intervention* as an example.[2] However, there it functions as a small element of a dynamic collage of labels and newspaper clippings, that was calculated to encourage Italy's participation in the First World War, whereas Davis's pristine isolation of the object/product invested it with the aura of an icon.

In the early 1960s, Davis's pioneering exploration of the world of packaging and advertising often would be seen as a precedent for the works of Pop artists. However, in using familiar products or labels, Davis always subjected them to color-space investigations that ultimately transformed their identity, whereas painters such as Andy Warhol incorporated the techniques of their manufacture to reinforce their inherent banality and subvert traditional assumptions about the subject matter and procedures of fine versus commercial art.

[1] K. Wilkin, "Stuart Davis and Drawing," in K. Wilkin and L. Kachur, *The Drawings of Stuart Davis,* The American Federation of Arts, New York 1992, p. 21.
[2] L.S. Sims, *Stuart Davis: American Painter*, The Metropolitan Museum of Art, New York 1991, p. 192.

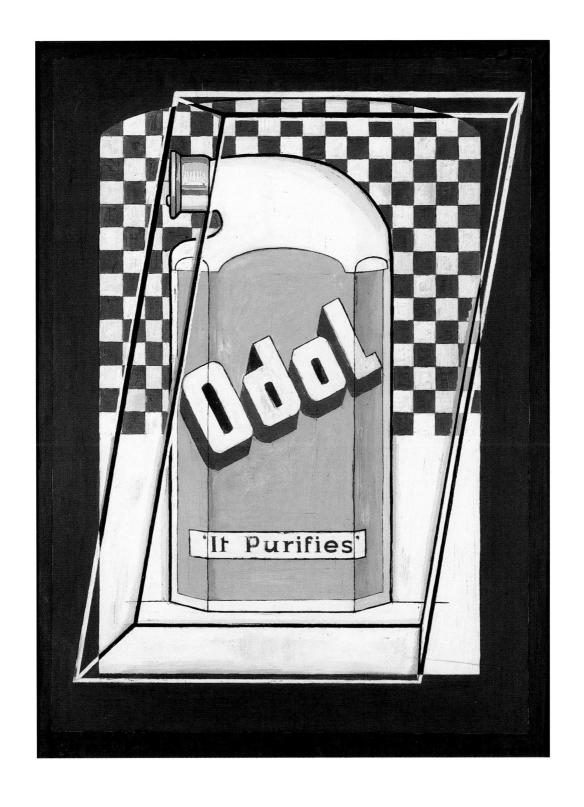

20. **Matches**

1927
Oil on canvas
26 × 21 in. (66 × 53.3 cm.)
The Chrysler Museum of Art, Norfolk,
Virginia. Bequest of Walter P. Chrysler, Jr.

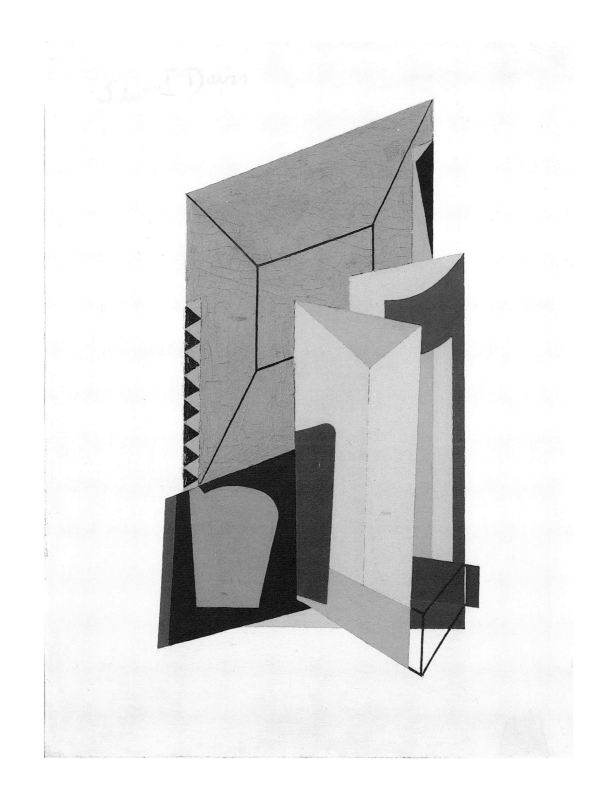

21. Egg Beater No. 1

1927
Oil on canvas
29⅛ × 36 in. (74 × 91.4 cm.)
Collection of Whitney Museum
of American Art, New York.
Gift of Gertrude Vanderbilt Whitney

Venice only

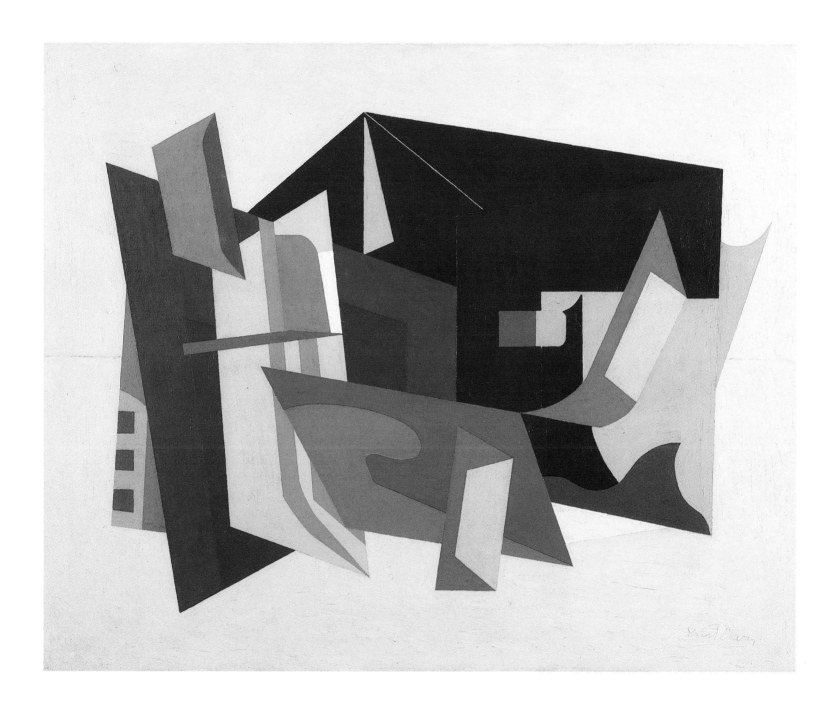

22. Egg Beater No. 3

1927–28
Oil on canvas
25⅛ × 39⅛ in. (63.8 × 99.4 cm.)
Museum of Fine Arts, Boston, Massachusetts.
Gift of the William H. Lane Foundation

In the mid-1920s Davis's work was gaining wider recognition; he was given his first solo museum show at the Newark Museum in 1925, and a retrospective was organized the following year at the Whitney Studio Club, which had been promoting contemporary American art since 1918.

Patricia Hills has observed that reviews of the exhibition stressed the experimental character of Davis's paintings and that this may have persuaded the Whitney's director, Juliana Force, that the artist needed time to focus his ideas. Shortly thereafter, he was the recipient of a monthly stipend from Gertrude Vanderbilt Whitney that would enable him to put his theoretical concerns with color and space into practice.[1]

The successful climax of Davis's efforts to master Cubist structure came in 1927–28, when he made paintings based on his analyses of matchbooks, percolators, and eggbeaters. Nearly twenty years later, he described these works as "an invented series of planes... They were a bit on the severe side, but the ideas invoked have continued to serve me... I got away from naturalistic forms. I invented the geometrical elements. Gradually through this concentration I focused on the logical elements."[2] As preparatory drawings and related works attest, Davis arrived at abstraction through a deliberate process of observation, clarification, distillation, and synthesis.

A number of sources informed the development of this remarkable series: Davis certainly had been exposed to European and American manifestations of the "machine aesthetic" that was prominent in the 1917 exhibition of the Society of Independent Artists. A more direct inspiration may have been the "Machine Age Exposition" organized in 1927 by the *Little Review*, a magazine to which Davis had contributed drawings.[3]

Matches is a centralized composition of geometric forms whose precarious identity is established through vertical planes of contrasting color. Extending above and behind these planes is an orange parallelogram, with variegated black and green patterns that may be a reference to the container for the books of matches. The black lines in this form and the red lines that project from the configuration at its lower

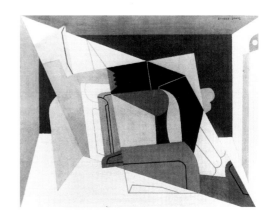

Stuart Davis, *Egg Beater No. 2*, 1928
Gouache on cardboard
Munson-Williams-Proctor Institute
Museum of Art, Utica, New York

right corner allude to their interior spaces.

Matches is one of the first paintings to incorporate what Davis would later term his "color-space logic," a shorthand description of "his intuitive but disciplined method of using prismatic juxtapositions of color relationships to suggest spatial relationships."[4]

Davis's justly celebrated "Egg Beater" series was inaugurated later that year when he "nailed an electric fan, a rubber glove, and an eggbeater to a table" and devoted nearly a year to developing compositions based on their formal relationships. He later maintained that his intention was not to eliminate reality, but "to strip a subject down to the real physical source of its stimulus."[5] The arduous process of focusing on the formal and planar relationships of these objects resulted in four oils, several gouaches, and drawings. There are consistencies within the series, such as the meticulous application of paint, the repeated presence of the eggbeater on the left side of the composition, and the tendency to thwart any indications of depth.

Whereas *Egg Beater No. 1* places the deconstructed elements against a neutral background similar to that of *Matches*, *Egg Beater No. 3* presents them within the context of an interior.

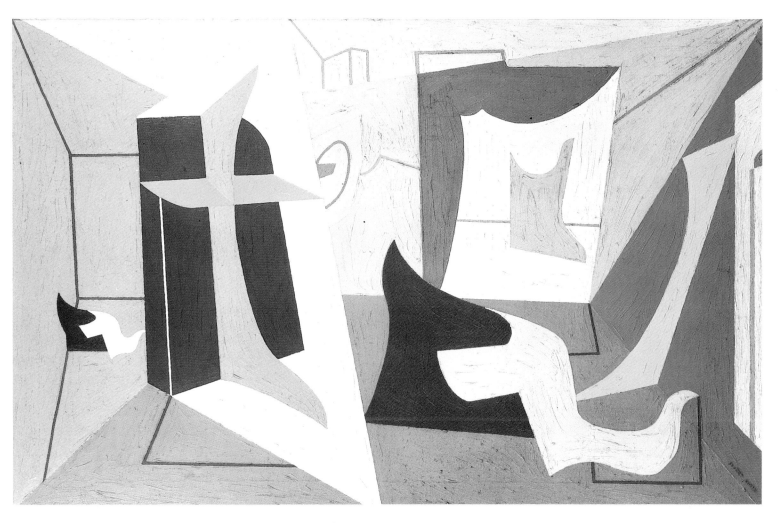

John Lane has shown that Davis developed this composition by working with an interior view of his studio and subsequently incorporating the abstracted still life elements to suggest a stage-like space.[6] On the left, the eggbeater's form is discernible within an angular white plane and an irregular black plane that appears to support it. Stretching from the top to the bottom of the canvas, the diagonal edge of this plane divides it into two unequal areas. The smaller area seems fairly coherent due to its tonal harmony and the receding lines that suggest the walls of a room. However, the abrupt shifts of color and conflicting linear signals in the larger area force us to reconsider our as-

sumptions about the character of the space.

Davis acknowledged the centrality of this series to his development when he observed "You might say that everything I have done since has been based on the eggbeater idea."[7] Its influence can be detected in a number of his landscapes of the early 1930s, but specific canvases also served as the basis for some of his most important paintings of the 1940s and 1950s.

[1] P. Hills, *Stuart Davis*, Harry N. Abrams, Inc., Publishers, New York 1996, pp. 73–74.
[2] J.J. Sweeney, *Stuart Davis*, The Museum of Modern Art, New York 1945, p. 17.
[3] P. Hills, *op. cit.*, p. 74.
[4] K. Wilkin, "Becoming a Modern Artist: The 1920s," in L.S. Sims, *Stuart Davis: American Painter*, The Metropolitan Museum of Art, New York 1992, p. 52.
[5] J.J. Sweeney, *op. cit.*, p. 17.
[6] J.R. Lane, *Stuart Davis: Art and Art Theory*, The Brooklyn Museum, New York 1978, pp. 104–105.
[7] J.J. Sweeney, *op. cit.*, p. 17.

23. **Place des Vosges No. 1**

1928
Oil on canvas
21 × 28¾ in. (53.6 × 73 cm.)
Collection of The Newark Museum,
Newark, New Jersey. Anonymous Gift, 1937

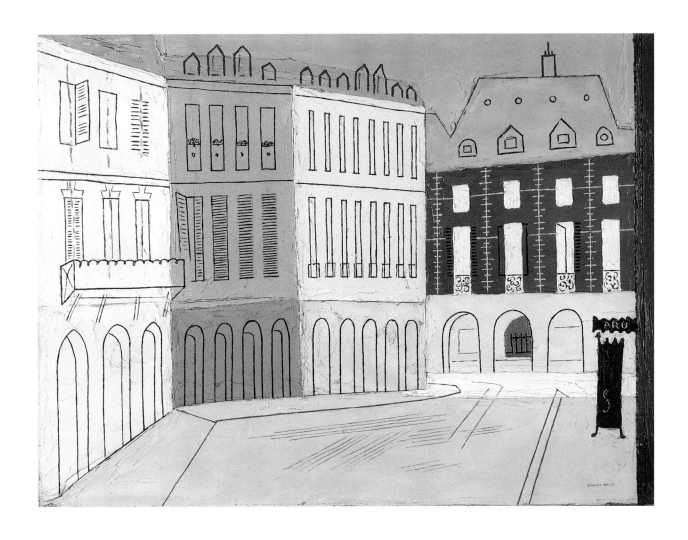

24. **Place des Vosges No. 2**

1928
Oil on canvas
25⅝ × 36¼ in. (65 x 92.1 cm.)
The Herbert F. Johnson Museum of Art,
Cornell University, Ithaca, New York.
Dr. and Mrs. Milton Lurie Kramer,
Class of 1936, Collection. Bequest
of Helen Kroll Kramer

In 1928 Davis's grasp of Cubism reached a level of sophistication unmatched by any other American artist: when the "Egg Beater" paintings were shown in April, a critic compared him favorably to Gris, Picasso, and Braque.[1] The sale of two works to Juliana Force and a subsidy from Gertrude Vanderbilt Whitney enabled him to undertake a trip to Paris. Evidently pleased with the reception of the "Egg Beater" series, he took two of the canvases with him.

On arrival he rented a studio in Montparnasse and began to frequent a world of American artists and writers that included Alexander Calder, Isamu Noguchi, Elliot Paul, and Robert Carlton Brown. Besides providing Davis with introductions to such legendary figures as Gertrude Stein and Fernand Léger, Paul, a founder of the avant-garde magazine *transition*, wrote an article on his work in its Fall issue, accompanied by illustrations and a cover that reproduced a recent painting of a Paris street scene.

As an American, Davis was fascinated by the "otherness" of the city, its human scale, and sense of continuous history. He later observed that he had felt compelled "to paint it just as it was."[2]

First impressions of the street scenes seem to confirm his statement: there is a selective naturalism and an abundance of detail that suggest a retreat from the geometric austerity of the "Egg Beater" series. However, closer examination reveals his determination to impose an independent structural order that transcends their topographical character.

Resuming a practice of his art school days, Davis used his sketchbooks to record the visually engaging motifs he encountered in his ex-

peditions throughout the city. At times he was drawn to ordinary working class neighborhoods and to anonymous hotels and cafés, but he also responded to areas of historical significance. He was particularly intrigued by the Place des Vosges, a seventeenth century complex of stately houses with a small park, which he painted twice. Instead of emphasizing the long, continuous expanse of the uniform brick façade that greets the visitor to the square, his canvas introduces contrasting planes of color that make the architecture seem to advance and recede simultaneously. Davis further emphasized the implicitly two-dimensional character of these colored planes by reducing the arches, windows, mansards, and chimneys of the building to linear patterns.

Of the two paintings, *Place des Vosges No. 2* is the more adventurous. Davis took advantage of its larger scale by intensifying the colors so that the fictive quality of the space is more pronounced. He also situated the *pissoir*, that had been a discrete element of the initial painting, in the foreground so as to stress its modern, functional identity. Davis provided an explanation of his compositional aims in 1944: "The picture looks like the Place des Vosges, but it looks only like certain color-shape relations which are inherently there. The beauty of these color-shape relations is independent of the objects they are associated with."[3]

[1] *New York Sun*, April 1928, quoted in P. Hills, *Stuart Davis*, Harry N. Abrams, Inc., Publishers, New York 1996, p. 78.
[2] J.J. Sweeney, *Stuart Davis*, The Museum of Modern Art, New York 1945, p. 23.
[3] Statement for the Newark Museum, quoted in P. Hills, *op. cit.*, p. 84.

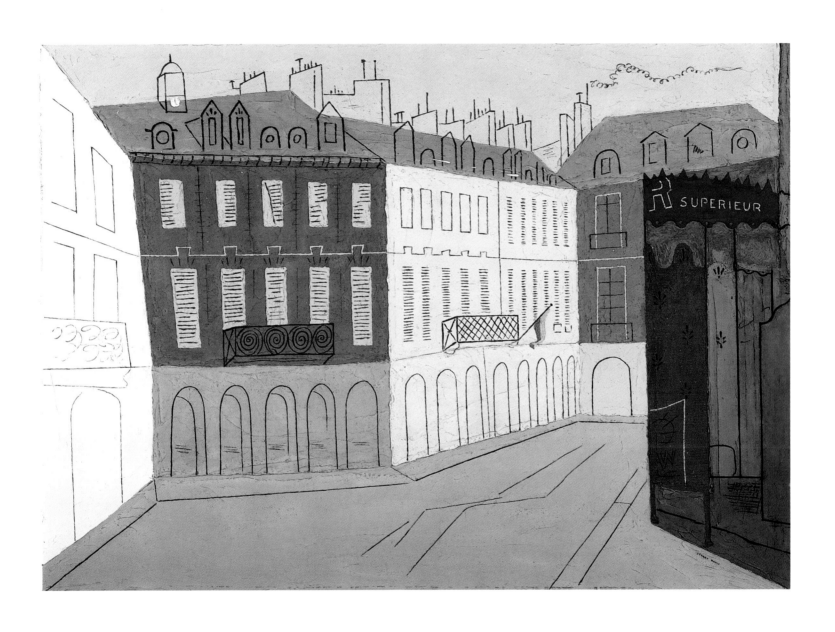

121

25. **Place Pasdeloup**

1928
Oil on canvas
36¼ × 28¾ in. (92.1 × 73 cm.)
Collection of Whitney Museum of American
Art, New York. Gift of Gertrude Vanderbilt
Whitney

Venice only

Davis's enthusiasm for his new environment is evident in a letter written about three months after his arrival in Paris: "I am principally interested in the streets. There is a great variety, from the most commonplace to the unique. A street of the regular French working class houses of 100 years ago is always interesting because they are all different in regard to size, surface, number of windows, etc."[1]

Although this view of *Place Pasdeloup*, a small square near the Boulevard du Temple, incorporates many features of the site, one is immediately aware that Davis has used color to alter the character of the space so that it conforms to the two-dimensional priorities of his composition. For example, the assertively textured bands of red, white, and blue paint in the façade of a more distant building pull it forward so that it intersects the structures in the foreground. Similarly, the band of green below effectively cancels the hint of perspective created by the delicate lines that define its narrow entrance.

[1] S. Davis, Letter to his father, September 17, 1928. Collection Earl Davis.

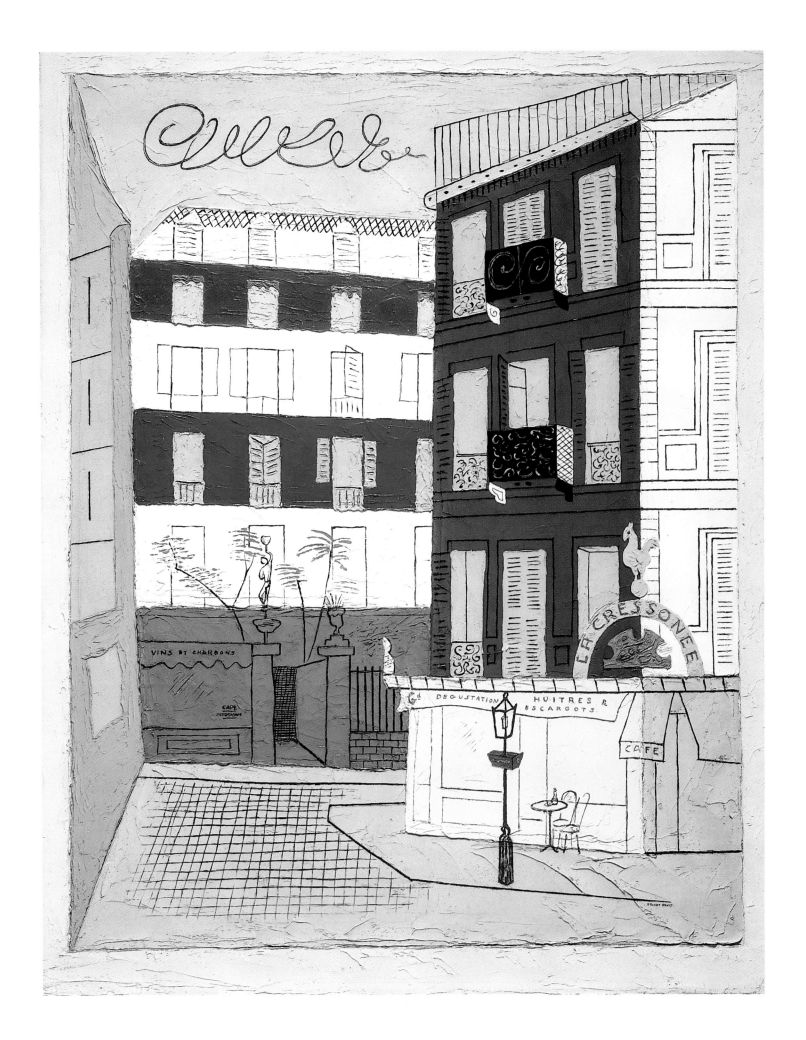

26. **Rue Lipp**

1928
Oil on canvas
32 × 39 in. (81.3 × 99.1 cm.)
The Crispo Collection

In this unique composition Davis dealt with the relationship of external and internal space. The title does not refer to an actual street, but rather to the famed Brasserie Lipp where the artist was a habitué. Lewis Kachur's careful study of the imagery has revealed its particular association with Davis's old friend, the writer Robert Carlton Brown, who was in Paris at the time it was painted. The right wall in the foreground contains a summarily defined poster advertising Brown's poems which were indebted to the model of Guillaume Apollinaire's *Calligrammes*. According to Kachur, Brown's poetry may have prompted Davis to "make Rue Lipp into a word-picture,"[1] and indeed, the condensed stage-like space of the composition is animated by an unprecedented number of French words.

In developing the painting Davis combined motifs from numerous drawings, taking a sketch of the street scene and placing the carafe, beer stein, and syphon bottle in its foreground to suggest a café patron's vantage point. By writing the words *Bière Hatt* on the stein, he called attention to the visual pun within the object, namely, the top hat created by the beer and the plate beneath it. As in the other Paris scenes, the absence of figures insures maximum focus on the dynamics of space.

Although Davis never returned to Paris, he did return to *Rue Lipp*, using its composition as the matrix for a gouache and a large canvas in 1959.

[1] L. Kachur, *Stuart Davis: An American in Paris*, Whitney Museum of American Art at Philip Morris, New York 1987, p. 10.

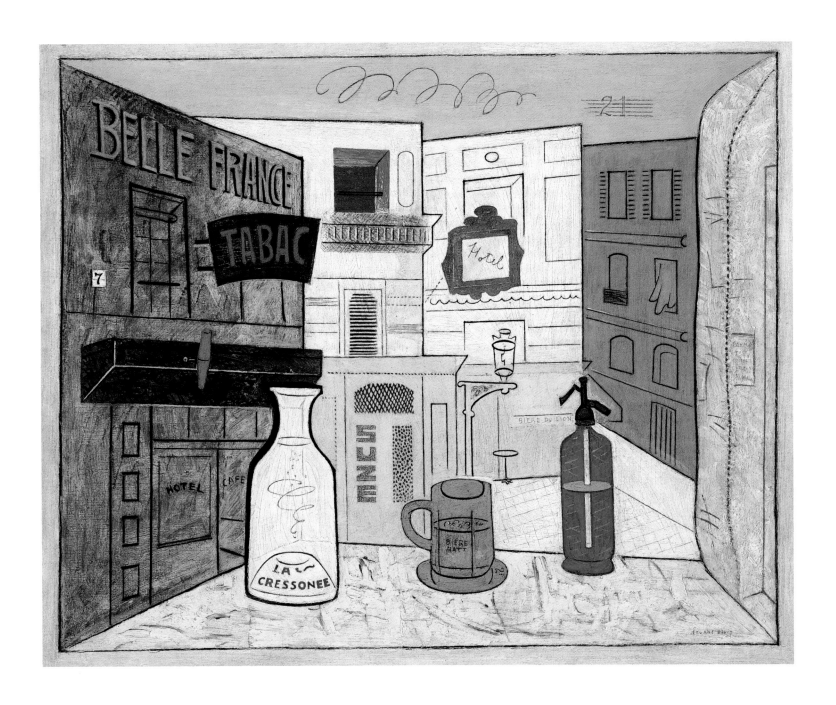

27. **Rue des Rats, No. 2**

1928
Oil and sand on canvas
20 × 29 in. (50.8 × 73 cm.)
Hirshhorn Museum and Sculpture Garden,
Smithsonian Institution, Washington, D.C.
Gift of Joseph H. Hirshhorn, 1972

If the Paris views appear less analytical than the "Egg Beater" series, they also reveal a renewed interest in the sensuous properties of the medium of painting. *Rue des Rats, No. 2* provides a compelling demonstration. Instead of using strong color contrasts to establish individual elements as he had previously done, Davis painted large areas in a uniform blue-gray tone that challenges our experience of their distinctiveness. Following the example of Picasso and Braque he mixed sand with the pigments to create a tactile stucco-like effect quite different from the smooth character of the adjacent areas.

Apart from the word VIN and the numbers 712 that appear on a faintly incised musical staff at the top, lines have diminished in importance in this composition. An exception, and a likely indication of his fascination with urban graffiti, is the prominent rendering of the horse's head and envelope on the large wall at the right. Davis had made a drawing of this image with the notation: child's wall drawing. Evidently, while painting *Rue des Rats, No. 2*,

he became intrigued by the possibility of giving the image a new but appropriate "home." The title of the painting probably reflects the artist's very limited knowledge of French. There is no record of a street of this name in Parisian street guides. Jane Myers has suggested that it is the Rue Rataud, a narrow street in the 5th arrondissement, an area Davis frequented.[1]

While some earlier critics have dismissed the Paris scenes as decorative work divorced from the seriousness of his modernist achievements, it is now clear that they played a vital role in Davis's development of color and, more fundamentally, they "provided both a ready-made spatial structure and a specific sense of locale" that he would continue to exploit in the early 1930s.[2]

[1] J. Myers, *Stuart Davis: Graphic Work and Related Paintings, With a Catalogue Raisonné of the Prints*, Amon Carter Museum, Fort Worth 1986, p. 24.
[2] L. Kachur, *Stuart Davis: An American in Paris*, Whitney Museum of American Art at Philip Morris, New York 1987, p. 9.

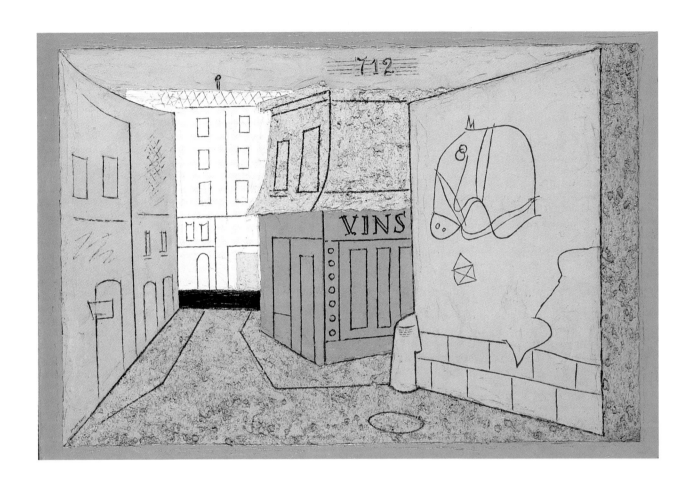

28. Summer Landscape

1930
Oil on canvas
29 × 42 in. (73.7 × 106.7 cm.)
The Museum of Modern Art, New York.

Venice only

In January 1930 Davis exhibited thirteen of his Paris pictures at the Downtown Gallery, New York. Critical reaction to the work was generally favorable, and a reviewer for the *New York Post* presciently identified some of their spatial qualities with musical compositions: "The paintings of these old corners of Paris do not suggest the actual character... filled with the ebb and flow of life, but are brilliant improvisations on such themes, using familiar notes and chords to produce quite an unfamiliar and highly modern Melody."[1]

The particular tension between selective reality and abstraction that was a *modus operandi* in the Paris scenes is also evident in *Summer Landscape*, a view of Gloucester, Massachusetts. Though trees, buildings, and boats are simplified or flattened into colors, shapes, and lines, they never lose their original identity. Davis deployed vertical elements present in the actual site, such as tree trunks, the factory chimney, and an electrical pole, to define the three distinctive areas of the composition, but he carefully placed white shapes in each of these areas to establish continuity and maintain visual equilibrium. The paint surface in this and subsequent Gloucester landscapes is notably thinner than that of the Paris pictures. Whereas Davis's acute sensitivity to the topographical character of the French capital had prompted him to make his paint and structure equivalents for narrow, crowded streets, he now wanted them to convey the open, light-filled quality of the seaport.

In 1940, Davis sold this painting to the Museum of Modern Art. Three years later, when the museum's director Alfred H. Barr, Jr. published his book *What is Modern Painting?*, he offered this account of the artist's transformation of the original landscape elements: "First he drew the forms in simple outlines, leaving out unimportant and confusing details and reducing board fences, clouds and ripples to a lively linear shorthand. By omitting all shadows he lets you see these essential shapes and patterns more clearly."[2]

[1] Quoted in P. Hills, *Stuart Davis*, Harry N. Abrams, Inc., Publishers, New York 1996, p. 89.
[2] *Ibidem.*

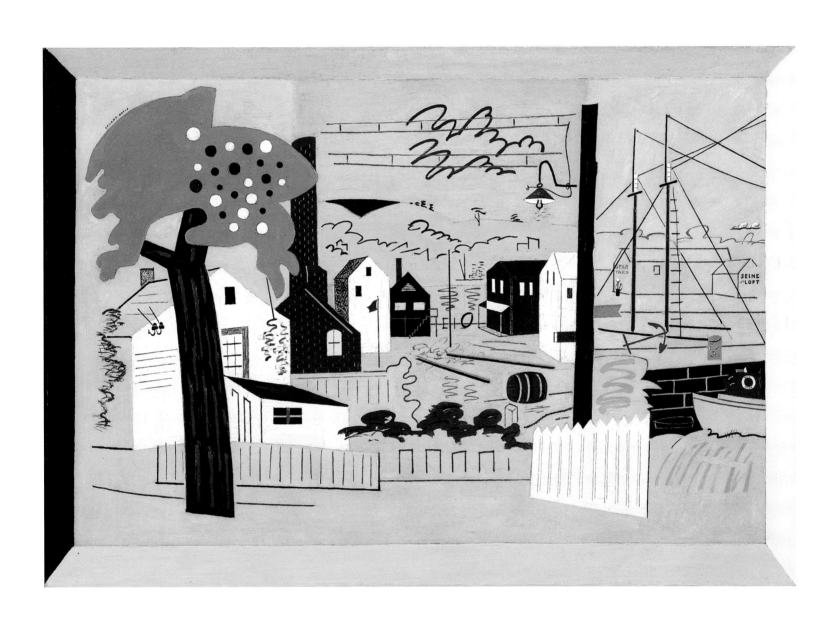

29. Salt Shaker

1931
Oil on canvas
49⅞ × 32 in. (126.5 × 81.3 cm.)
The Museum of Modern Art, New York.
Gift of Edith Gregor Halpert

Venice only

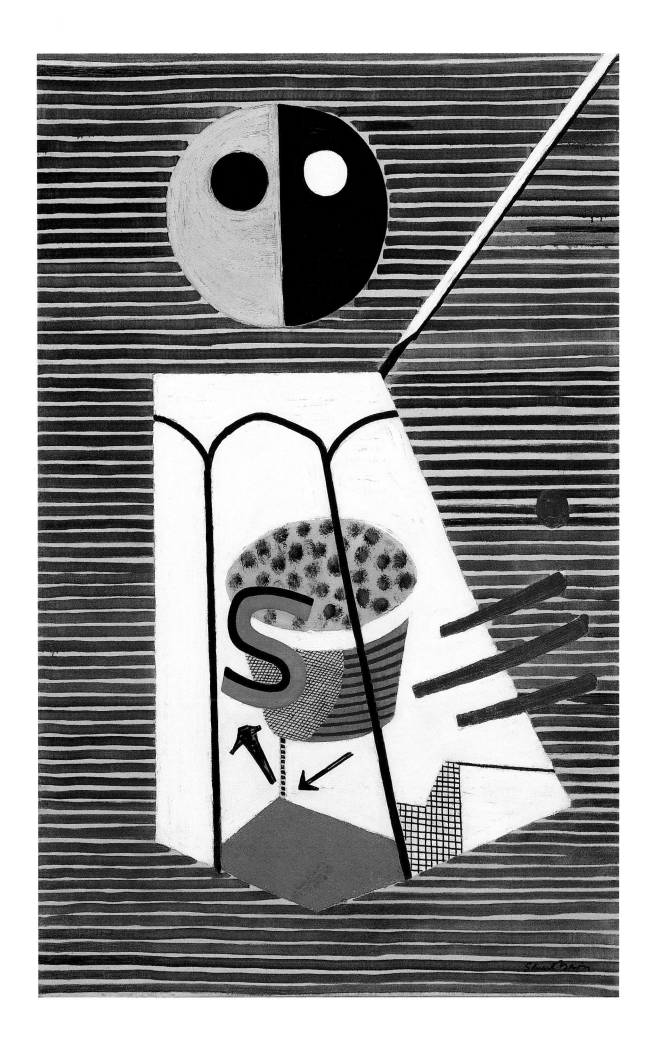

131

30. **Radio Tubes**

1931
Oil on canvas
50 × 32 ¼ in. (127 × 81.9 cm.)
Rose Art Museum, Brandeis University,
Waltham, Massachusetts. Bequest
of Louis Schapiro

After his return from Paris, Davis focused on views of New York and Gloucester, but occasionally turned to still life. In 1931, he painted two large canvases, *Salt Shaker* and *Radio Tubes*, in which the physical properties of small, common objects were imaginatively deconstructed to suggest a new identity. The general flatness of the composition and the presence of decorative cross-hatching and stippling to provide contrast with the smoothly brushed areas recall Synthetic Cubist procedures, but a major characteristic of both images is an evident anthropomorphism that evokes the work of Marcel Duchamp and Francis Picabia. "*Radio Tubes*, by its very subject, is a response to Picabia's personification of the 'jeune fille americaine' as a spark plug."[1]

In *Radio Tubes*, the abstraction of the various components is more complete, whereas in *Salt Shaker,* the black lines and the s on the curiously skewed and flattened white shape provide clues to its original identity, and the directional arrows imply the object's movement when it is being used However, the anthropomorphic character of the *Salt Shaker* is reiterated by the bifurcated circular form which alludes to the top of the object, but also suggests a flattened head or mask in relation to the "body" below.

In each of these paintings, Davis introduced an unusual striped background that reinforces the surface of the canvas and provides a dominant textural contrast with the smooth passages of color and the smaller areas of pattern.

[1] L.S. Sims, *Stuart Davis: American Painter*, The Metropolitan Museum of Art, New York 1991, p. 213.

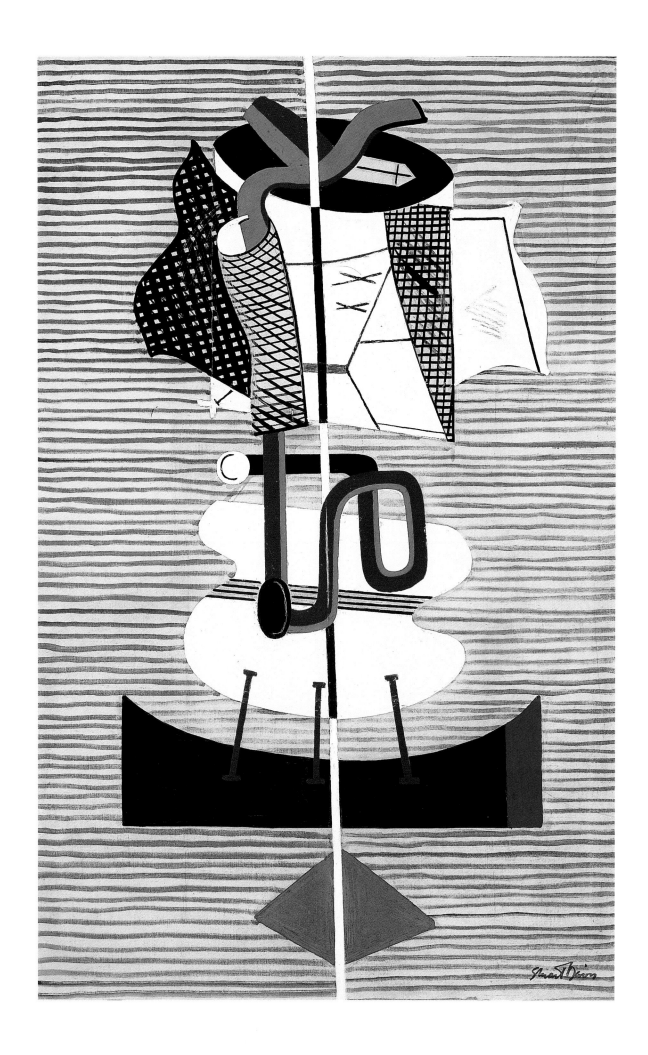

133

31. Landscape with Garage Lights

1932
Oil on canvas
32 × 41⅞ in. (81.3 × 106.2 cm.)
Memorial Art Gallery
of the University of Rochester, Rochester,
New York. Marion Stratton Gould Fund

Davis had not concerned himself with theory in the years following his departure for Paris, but a statement published in the catalogue of his show at the Downtown Gallery, New York, in the spring of 1931 indicates some of the new concepts that were beginning to inform his painting at the time: "These pictures are in part the result of the following ideas: that a picture must tell a story. This story can have a pictorial existence only through the artist's concept of form. There are an infinite number of form concepts available. My own is very simple and based on the assumption that space is continuous and that matter is discontinuous... I conceive of form (matter) as existing in space, in terms of linear direction. It follows then that the forms of the subject are analyzed in terms of angular variation from successive bases of directional radiation. The phenomena of color, size, shape and texture are the result of such variation."[1]

Later that year, this new emphasis on the angle as a principle component of pictorial construction would be tested in a number of paintings, such as *Landscape with Garage Lights*. The elements of the composition, a fish-processing plant, a coal storage tower, two structures that may be factories or warehouses, and the prominent gasoline pumps, bear witness to the industrialization that had taken place since Davis's first visit to Gloucester in 1915. In developing the painting, Davis first made a diagram of the essential diagonal planes that would provide its structure and establish its character. In a second drawing, he imposed the simplified but recognizable features of the waterfront over this diagram in preparation for the final stage, which was the application of the unmodulated planes of contrasting color to the canvas.[2]

This painting was shown at the Downtown Gallery in 1932, in an exhibition that Davis's dealer titled "The American Scene," capitalizing on the growing popular appeal of the eponymous movement that had come to dominate American painting. Davis's relationship to this movement was complicated: he had long shared its concern with native subject matter but he abhorred its xenophobic rejection of European art and its uncritical advocacy of representational styles. In the early 1930s, as the poles of abstract painting versus various forms of realism drew apart, Davis's fusion of modernist technique and American content was a unique achievement.

[1] *Recent Paintings in Oil and Watercolors by Stuart Davis*, The Downtown Gallery, New York 1931. n.p.
[2] J.R. Lane, *Stuart Davis: Art and Art Theory*, The Brooklyn Museum, New York 1978, p. 23.

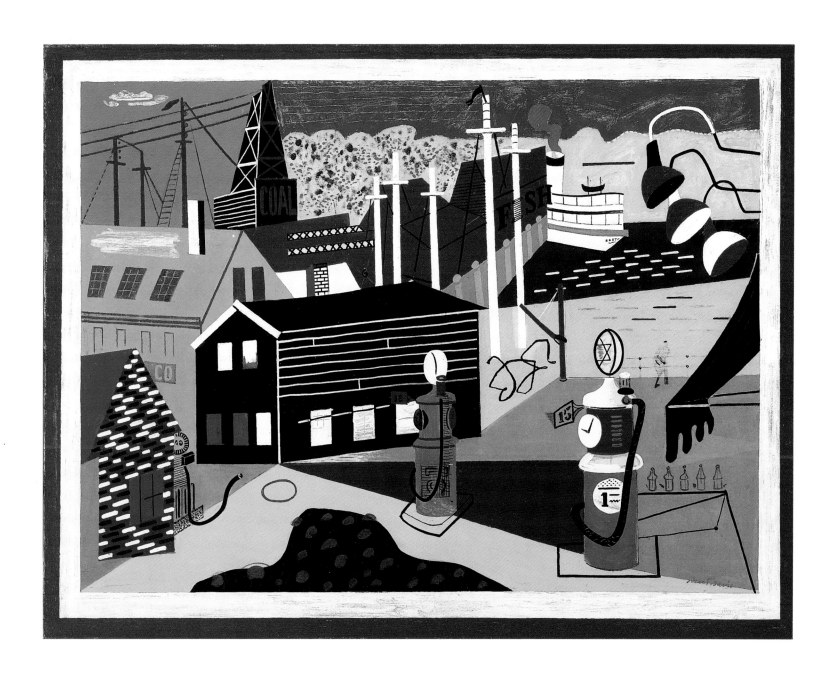

32. **Red Cart**

1932
Oil on canvas
32¼ × 50 in. (81.9 × 127 cm.)
Addison Gallery of American Art,
Phillips Academy, Andover, Massachusetts

Venice only

In 1932, despite the increasing severity of the economic depression that had gripped the United States for nearly three years, Davis was kept busy by new opportunities. He participated in an exhibition of mural projects that celebrated the Museum of Modern Art's move to a new space on West 53rd Street, and was given a prestigious commission to paint a mural for the men's lounge of the recently constructed Radio City Music Hall in Rockefeller Center.

Red Cart, painted at a time when Davis was developing his angle theory, is based on a 1931–32 drawing of a dock area in Gloucester.

Identifiable forms, such as a crenellated tower, chimneys, a large cart, and a barrel, are visible within the more abstract network of diagonal bands of color and line indicating fishnets that are hung from poles. The already fragmented spatial character of the composition is rendered more problematic by the bright colors and lively patterns that enhance its surface. An unusual feature of this painting is the dramatic use of black. It is tempting to speculate that Davis's recent experience with black and white lithographs made him more aware of its properties, and encouraged him to use it forcefully in this painting.

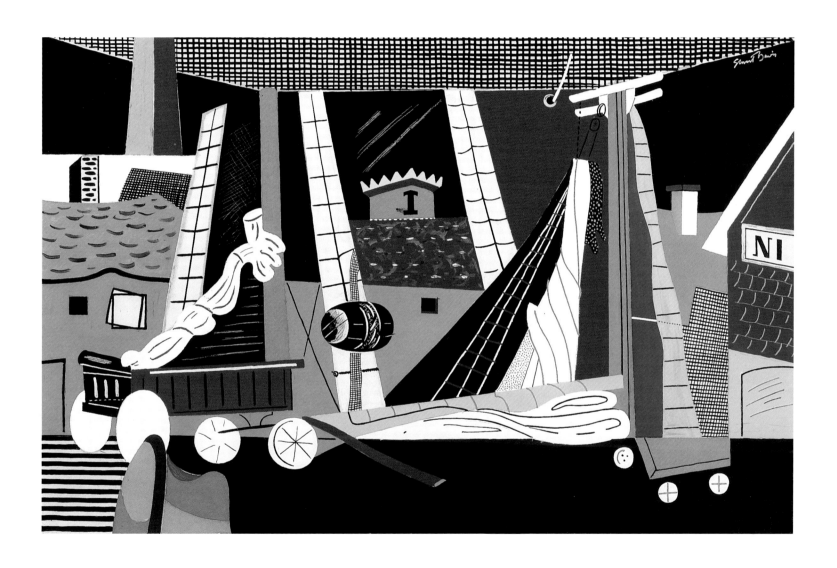

33. Composition

1935
Oil on canvas
22¼ × 30⅛ in. (56.4 × 76.5 cm.)
National Museum of American Art,
Smithsonian Institution, Washington, D.C.
Transfer from General Services
Administration through Evander Childs
High School

In the early 1930s the widespread economic and social devastation of the Depression began to take its toll on artists, significantly curtailing Davis's productivity and generating a period of sustained political activism. Although his ideas about the social responsibilities of artists were rooted in the progressivist and Socialist politics he had embraced since his youth, like many artists and intellectuals he was now drawn to Marxism. Davis was among the first to enroll when the United States government established relief programs to employ artists in the creation of works destined for public spaces. In 1934 he joined the newly-founded Artists Union, an organization concerned with artists' rights, the maintenance of federal subsidies, and the creation of an artist-administered municipal art gallery. As the editor of the Union's outspoken publication, *Art Front*, Davis re-peatedly exhorted fellow artists to assume leadership roles. Throughout the decade he was the foremost advocate of abstract art, and he frequently found himself in the position of defending it from attacks by proponents of American Scene painting who criticized it for being too European or Marxist and argued that its formalist character was incompatible with art's didactic mission.

Paintings from this period of political and social commitment reflect Davis's determination to reconcile his modernist sensibility with his wish to create meaningful social content. In *Composition*, he combined traditional symbols of the fine arts, such as the palette and classical bust, with emblems of the manual and mechanical trades in order to associate artists' concerns and functions with those of other workers.

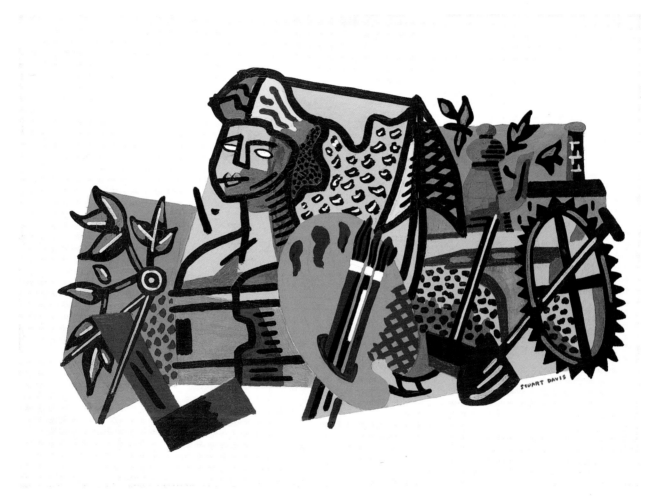

34. Waterfront Landscape

1936
oil on canvas
23⅛ × 30¼ in. (58.8 × 76.8 cm.)
National Museum of American Art,
Smithsonian Institution, Washington, D.C.
Transfer from the General Services
Administration

Davis's conviction that modernist painting could address the concerns of average Americans found its most powerful expression in the paintings and murals he executed between 1936 and 1939 for the Federal Arts Project. Rejecting the realist styles and narrative subjects embraced by most of the artists working in the Murals Division, he maintained that "the subject matter which is common to all works of art is constructive order."[1] He believed that prolonged exposure of the public to works that embodied constructive order would eventually lead to an understanding of the ways in which the forms and materials of modern art expressed "the new lights, speeds and spaces" of the contemporary environment.[2]

Arguing that the source of art was the "real physical order"[3] of nature, he rejected the geometric purity espoused by the founders of the organization known as American Abstract Artists. He criticized Constructivists and Neo-Plasticists for focusing on formal concerns, isolating art from its historical and social context, and divorcing it from the world of shared experience that was central to his conception of painting.

In works of the late 1930s, such as *Waterfront Landscape*, the synthesis of abstraction and realism, already present in previous canvases, reached new levels of sophistication and originality. Seeking what he described as a "unity of opposites,"[4] Davis arranged different dockside views recorded in four drawings from a 1933 Gloucester sketchbook in a dynamically bifurcated composition whose dual character is reinforced by contrasting colors and patterning.

The lively palette of *Waterfront Landscape* anticipates the brilliant hues of *Swing Landscape*, the 1938 mural designed for the Williamsburg Housing Project in Brooklyn. The two paintings also share particular forms, notably, the ladder, ship rigging, and striped poles that are visible in the right sections of each.

[1] S. Davis, "Working Notes for Mural for B," WNYC, March 23, 1939, in D. Kelder, *Stuart Davis: A Documentary Monograph in Modern Art*, Praeger Publishers, New York, Washington and London 1971, p. 93.
[2] S. Davis, "Abstract Painting Today," unpublished article commissioned by Art for the millions, in D. Kelder, p. 120.
[3] S. Davis, "Mural for the Hall of Communications," January 2, 1939, in D. Kelder, p. 81.
[4] *Ibid.*, p. 80.

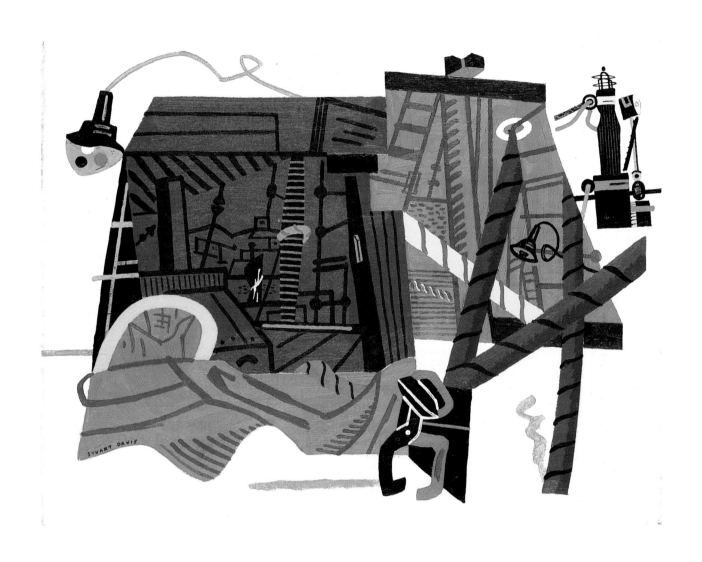

35. Cape Ann Landscape

1938
oil on canvas
20 × 30¼ in. (50.8 × 76.8 cm.)
Courtesy of Salander-O'Reilly Galleries,
New York

In this painting Davis has taken the essential features of a 1933 pen and ink sketchbook drawing of Gloucester and given it an entirely new persona. Recognizable elements such as hills, houses, church spires, chimneys, and smoke stacks, painted in intense autumn colors, now advance and recede from its busy framework. Using the diagonal of what appears to be a ladder, he creates a dynamically bifurcated composition that effectively thwarts any efforts to read the space three-dimensionally. Davis would return to this compositional device in the last ten years of his life in paintings such as *Deuce*, 1951–54, and *Punch Card Flutter No. 3*, 1963 (cat. no. 62).

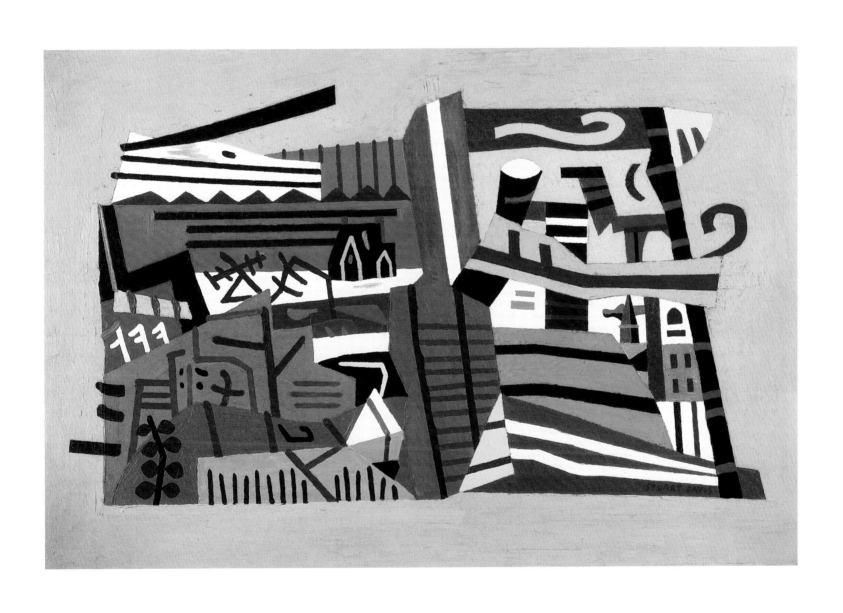

36. New York under Gaslight

1941
Oil on canvas
32 × 45 in. (81.3 × 114.3 cm.)
The Israel Museum, Jerusalem

As Davis's political activities came to an end in the late 1930s, he resumed his investigation of formal problems, now focusing on a way of integrating color into his established system of drawing. Calling this new synthesis "color-space," he produced a remarkable group of paintings, *Report from Rockport*, *Hot Still Scape for Six Colors – 7th Avenue Style*, and *New York under Gaslight*, that utilized earlier compositions to articulate a new tension between color and line, surface and depth.

New York under Gaslight adopts the basic structure of *The Barber Shop*, 1930, which included a group of tenements, office buildings, a house, barbershop, and tobacco store. According to the artist, this stage-like arrangement was a "composite of buildings around the Brooklyn Bridge and the Canal Street section,"[1] and, indeed, one of the piers of a bridge is visible on the right. Virtually every area of the canvas's surface is animated by eye-catching decorative shapes, and by a plethora of signs and bright colors.

Davis's wry sense of humor permeates the many details of the composition, but is explicit on the right, where the viewer is exhorted to "Dig this fine art jive." Above this phrase, a sign with a pointing hand directs the eye past the shops, with their adjacent images of a provocative woman and a large rearing "Stud," to the building on the left where the artist painted a dent in the first letter of the DENT[ist] sign, and where the ROOM sign in the window above is pointedly cut off in the final letter.[2]

Among the last of Davis's paintings to employ recognizable visual imagery, *New York under Gaslight* has been characterized as "his parting shot at all the things he was discarding from his style."[3]

[1] Quoted in B. Weber, *Stuart Davis' New York,* Norton Gallery and School of Art, West Palm Beach 1985, no. 64, p. 24.
[2] B. O'Doherty, *American Masters: The Voice and the Myth in Modern Art*, E.P. Dutton, Inc., New York 1982, p. 77
[3] E. Goossen, *Stuart Davis*, George Braziller, Inc., New York 1959, p. 29.

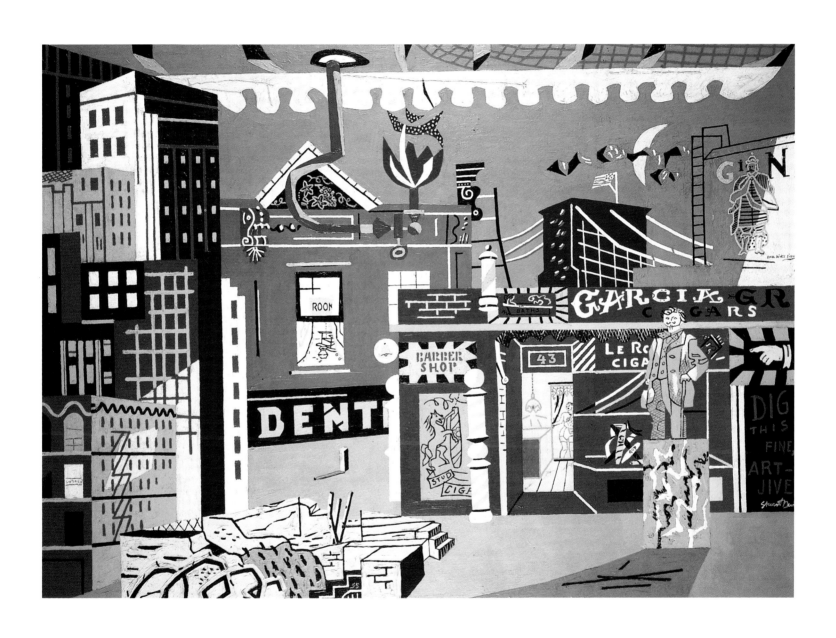

37. Arboretum by Flashbulb

1942
Oil on canvas
18 × 36 in. (45.7 × 91.4 cm.)
The Metropolitan Museum of Art, New York.
Edith and Milton Lowenthal Collection,
Bequest of Edith Abrahamson Lowenthal,
1991

Venice only

In 1942 and 1943, Davis executed a group of horizontal canvases, crowded with shapes painted in bright uninflected color. Although *Arboretum by Flashbulb* is small in scale, the complexity of its design makes it appear large. Naturalistic elements have been eliminated, but its dense surface is punctuated by irregular shapes whose colors still suggest the presence of trees, ponds, plants, paths, and fences. Near the top of the canvas, a singular yellow plane containing a red star may allude to the illuminated flashbulb in its title.

When the painting was exhibited in September 1942, the art critic of the *New York Times* called Davis an "abstractionist," prompting the artist to write a letter to the editor in which he repudiated the label and clarified his intentions: "My pictures are partly the product of a number of abstract notions about the general character of color-space dimensionality, but I do not paint them to describe these concepts... Every direction, color position, size and shape in my pictures—all the serial configurations—are designed in accordance with something I have seen, and wanted to capture in art, in the world in which we live."[1]

John Lane has shown how the theories of Gestalt psychology, "which hold that the process of vision integrates significant patterns, and that images can be extensively abstracted and still retain their affiliation with reality,"[2] stimulated further abstraction in Davis's painting and also provided the basis for a new type of pictorial scheme that he would call "configuration theory." Evidence of this new concern with the totality of the design can be seen in *Arboretum by Flashbulb* where the abstract color shapes are systematically organized to create a dynamic allover pattern that eliminates any single or central focus.

While the "configuration theory" provided a method that would enable Davis to develop a bolder and more explicitly decorative sense of surface in subsequent works, he also found inspiration in the "abundance of pictorial incident that characterized Miró's thirties art and... appeared in the Surrealist inspired works by Léger."[3]

Davis's profound engagement with jazz is often invoked as a general source for the manifest sense of rhythm in so many of his paintings. He once remarked that jazz was the first native expression of modernism and he clearly saw it as offering a system or structure that could inform his painting. When he included *Arboretum by Flashbulb* in his solo exhibition at the Downtown Gallery the following year, some of America's most distinguished jazz musicians, including W.C. Handy, Red Norvo, Duke Ellington, Pete Johnson, and George Wetling, performed at the opening, forcing critics to acknowledge the parallel riffs and rhythms in the canvases.[4]

[1] Stuart Davis, *New York Times,* September 22, 1942.
[2] J.R. Lane, "Stuart Davis in the 1940s," in *Stuart Davis: American Painter*, The Metropolitan Museum of Art, New York 1991, pp. 72–73.
[3] J.R. Lane, *Stuart Davis: Art and Art Theory*, The Brooklyn Museum, New York 1978, p. 61.
[4] For an account of the critical reaction, see P. Hills, *Stuart Davis*, Harry N. Abrams, Inc., Publishers, New York 1996, pp. 134–135.

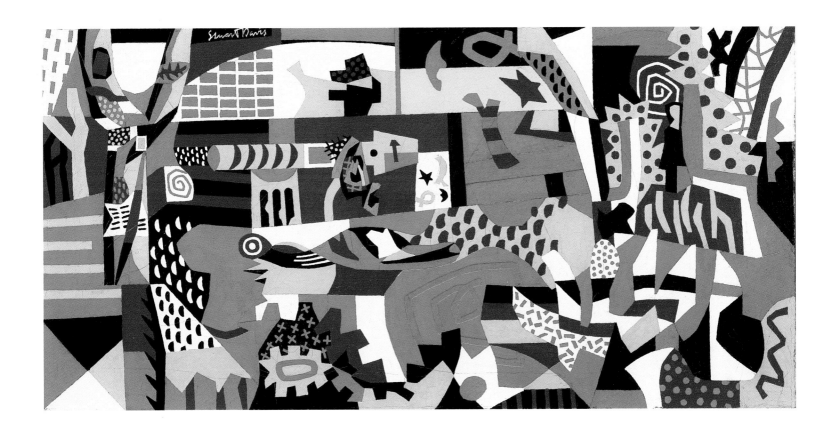

38. The Mellow Pad

1945–51
Oil on canvas
26 × 42 in. (66 × 106.7 cm.)
The Brooklyn Museum of Art, New York.
Bequest of Edith and Milton Lowenthal

Stuart Davis, *House and Street*, 1931
Oil on canvas
Collection of Whitney Museum
of American Art, New York

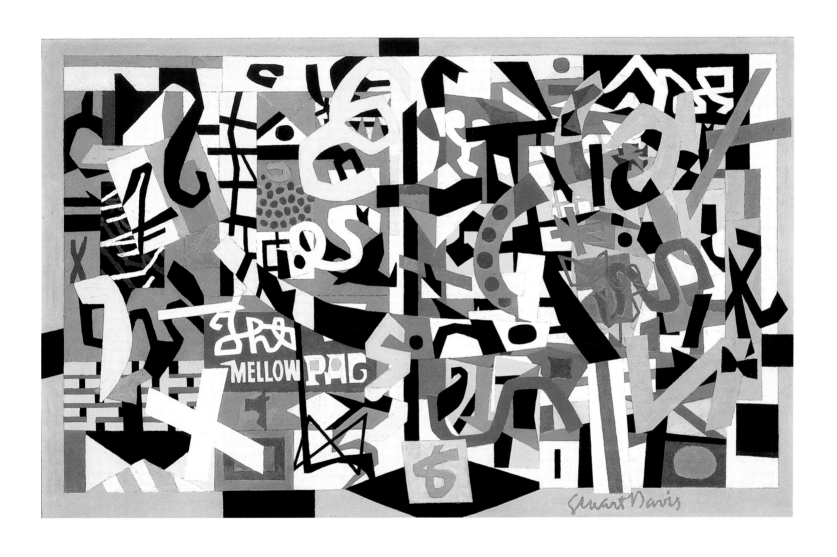

39. Pad No. 4

1947
Oil on canvas
14 × 18 in. (35.6 × 45.7 cm.)
The Brooklyn Museum of Art, New York.
Bequest of Edith and Milton Lowenthal

Begun in 1945 but not completed until 1951, the long gestation of *The Mellow Pad* was marked by the production of numerous sketchbook drawings and five related canvases.

Davis appropriated the compositional matrix of an earlier painting, *House and Street*, 1931, and later explained that he did so "on the premise that *House and Street* was a good painting and that its simplicity could be used as a base on which to develop new material."[1] Although Davis had previously engaged in this practice intermittently, it would become his principle method of working in the next two decades.

In *The Mellow Pad*, the original bi-partite composition is virtually obscured by the suffocating embellishments of its new allover design. Apart from the three words of the title Davis included specific letters and symbols that relate to the personal shorthand he developed in his art theorizing: "the letter X, N, and an inverted C...respectively stand for the notion of neutrality of subject matter, and configuration theory."[2] Davis effectively made his own theory the subject of the painting by "creating an iconography in which his abstract-art-theory concepts are symbolized by concrete shapes, and the formal...ideas on which the work was based, are represented visually on the surface of the painting."[3]

The inscribed title of the painting suggests the dual identity of the pad: a book of papers on which the artist makes drawings, and a home or personal space in the jazz language that so delighted Davis. It is tempting to see the relationship of the elaborate and vibrant forms that float above the underlying structure of the original painting as a parallel to the jazz practice of taking a theme and subjecting it to extensive improvisational variation.

The five small "Pads" that Davis painted over a four year period are not studies but satellites, so to speak. The single word appears in all but the last of these, implying that they share a common theme or problem. In the first three canvases, it is contained within a generally rectangular shape that tends to isolate it from the surrounding forms. In *Pad No. 4*, instead, the letters are positioned vertically on the left so that they are completely integrated with the other abstract elements of the composition.

While Davis was systematically developing his own version of post-Cubist space, younger painters in New York, notably his former friend Arshile Gorky, Willem de Kooning, and Jackson Pollock, were discovering allover strategies that would transgress Cubism and make it seem irrelevant to the newly perceived issues of painting. Pollock's abandonment of planar construction and his use of color and line as autonomous elements no longer obliged to define shapes represented a breakthrough that pushed American art in radical directions that were incompatible with Davis's essentially relational approach.

[1] Stuart Davis papers, July 26, 1947. Harvard University Art Museums, Fogg Art Museum, Cambridge, Massachusetts.
[2] J.R. Lane, "Stuart Davis in the 1940s," in *Stuart Davis: American Painter*, The Metropolitan Museum of Art, New York 1991, p. 75.
[3] *Ibidem.*

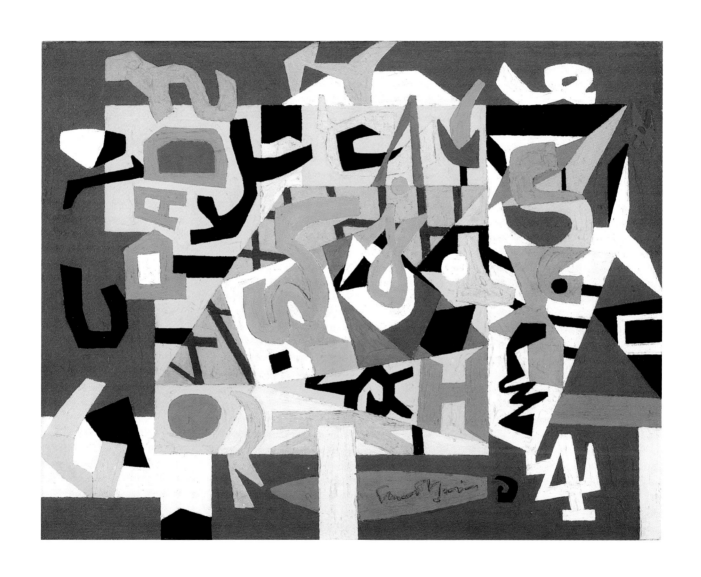

40. Little Giant Still Life

1950
Oil on canvas
33 × 43 in. (83.8 × 109.2 cm.)
Virginia Museum of Fine Arts, Richmond,
Virginia. The John Barton Payne Fund

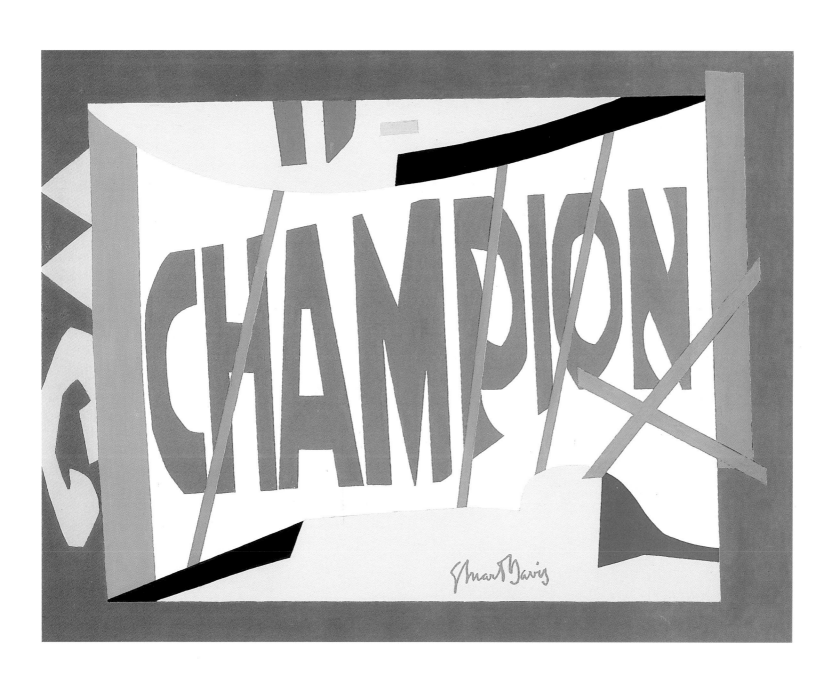

41. **Study After "Little Giant Still Life"**

c. 1950
Oil on canvas
12 x 16 in. (30.5 x 40.6 cm.)
Collection Earl Davis.
Courtesy of Salander-O'Reilly Galleries,
New York

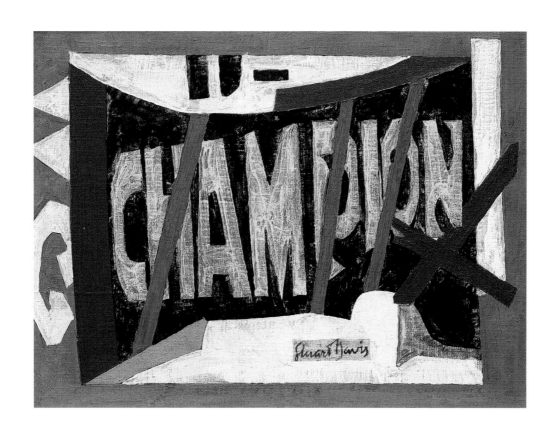

155

42. **Little Giant Still Life
(Black and White Version)**

c. 1950–53
Aqueous medium, possibly casein, on canvas
33 × 43 in. (83.8 × 109.2 cm.)
Collection Earl Davis.
Courtesy of Salander-O'Reilly Galleries,
New York

157

43. **Visa**

1951
Oil on canvas
40 × 52 in. (101.6 × 132.1 cm.)
The Museum of Modern Art, New York.
Gift of Mrs. Gertrud A. Mellon

Venice only

Davis's commitment to an empirical and objective approach to painting was antithetical to the spontaneity and subjectivism that were associated with Abstract Expressionism. In the 1950s, the decade of Abstract Expressionism's greatest influence, he increasingly withdrew from the New York art scene to engage in critical introspection. He set aside many of the theoretical principles that had guided his recent efforts to liberate himself from Cubism, reduced the formal complexity so manifest in *The Mellow Pad*, and made color his principal vehicle of composition. In his desire to achieve greater clarity and economy, he once again found inspiration in commercial graphics and packaging.

Little Giant Still Life was based on a matchbook cover advertising Champion Little Giant spark plugs. Davis maintained that while he had often used words "because they were part of urban subject matter... the design of this matchbook was singularly uninteresting and it was the challenge of the lack of interest... rather than the direct stimulus of a subject"[1] that had prompted its undertaking. Despite the apparent dismissal of its content, the extraordinary prominence accorded the single word of the matchbook's logotype represented a precedent in his use of popular commercial imagery. It has been argued that by maximizing his banal source, Davis was consciously declaring his opposition to the "heroic" and "sublime" content in the painting of Abstract Expressionists.[2]

The idea of producing variations on the matchbook theme came to Davis while he was completing *Little Giant Still Life*. In a small oil study, executed the same year, he explored a more subdued palette and softened the visual impact of the words by placing them against a black background. Davis's long-standing belief that the processes of painting and drawing were identical may have prompted him to undertake the black and white variation whose dimensions are the same as those of the initial oil. By making the painting's underlying structure the effective subject, he reaffirmed drawing's status as an autonomous work of art. In *Visa*, while retaining essential features of the initial composition, such as the diagonal bars that serve to cancel some of the letters, and the decorative shapes that surround the central image, he introduced more vibrant color, and added the word "Else" and the phrase "The Amazing Contin-uity," so that the pictorial surface became more lively. While the words "amazing continuity," may refer to his ongoing practice of reworking earlier compositions in the light of new concerns, the artist also injected a note of humor or irony, by hyphenating the second word.[3]

Davis's choice of title, with its implications of movement from country to country, has been related to his desire to create paintings of international significance and to his prescient observation that art works were becoming an international commodity. His participation in the first São Paulo Bienal in 1951 and his exhibition at the Venice Biennale the following year marked the onset of a period in which his work would gain much wider exposure.

[1] Stuart Davis, Statement for Alfred Barr, Director of The Museum of Modern Art, November 3, 1952 in D. Kelder (ed.), *Stuart Davis: A Documentary Monograph in Modern Art*, Praeger Publishers, New York, Washington and London 1971, p. 100.
[2] See L. Kachur, "Stuart Davis' Word-Pictures," in *Stuart Davis: American Painter*, The Metropolitan Museum of Art, New York 1991, p. 103. Reprinted in this catalogue: see p. 35 above.
[3] *Ibid.*, p. 102.

158

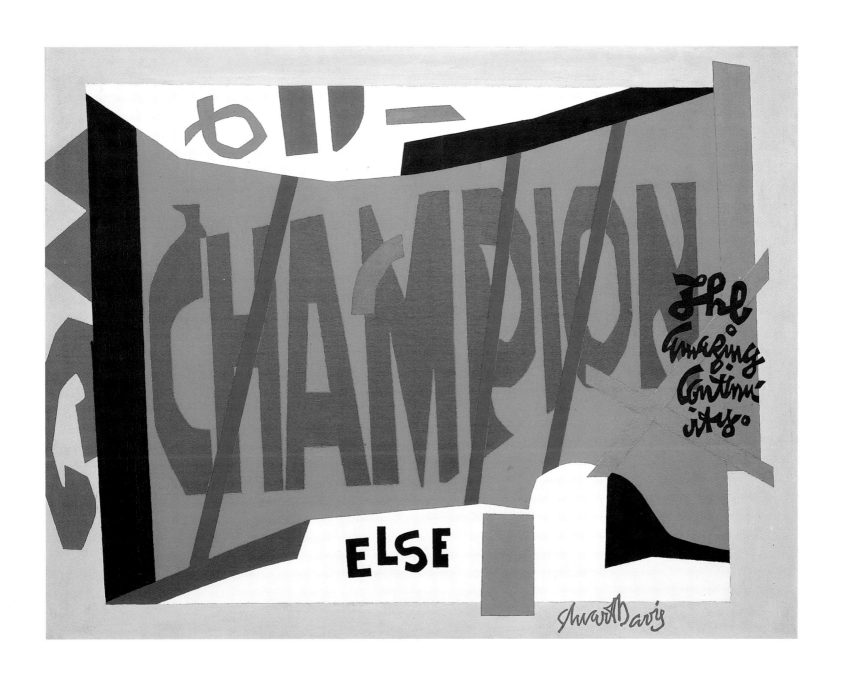

44. Owh! in San Pao

1951
Oil on canvas
52¼ × 41¾ in. (132.7 × 106 cm.)
Collection of Whitney Museum of American Art, New York

Venice only

Owh! in San Pao is a reworking of Davis's 1927 *Percolator*. In characterizing its transformation of the original still life object, Davis quipped: "Instead of a Utensil we see an Event."[1] Indeed the simplified planar construction and sober palette of the initial composition have been replaced by a complex orchestration of alternating hot and cool colors whose lively interaction is made even more evident by the electrifying yellow that surrounds them. Moreover, the addition of letters and animated calligraphy further deflects our attention from the center of the painting and subverts our reading of spatial relationships.

The significance of the word ELSE and the phrase "we used to be—Now" have been explained both in the light of Davis's theory and the particular time the painting was made, a period when the artist was intensely preoccupied with his own art as subject matter.

While Davis claimed that ELSE meant that all subjects were equal, he also used the word to suggest another dimension or time. Its juxtaposition with the curious phrase could be read as a comment on his "now" transformed subject. However, Lewis Kachur has suggested that it may be a mildly ironic "reflection of how 'now' or up-to-date Davis felt in the art world."[2]

The original title of this painting was *Motel,* but as it progressed and Davis contemplated the prospect of sending it to the first São Paulo Bienal in October, he changed the title. Despite a feverish campaign, the painting was not completed in time, to Davis's dismay. He later offered an explanation of the painting that underscored his growing antipathy to Abstract Expressionism and also clarified its jazzy onomatopœia: "there are no mathematics of Abstract or Naturalist Expressionistic Idealism to befuddle here, and the Department of Emotion and Feeling, the crucial Emulsion, is a dimension at right angle to the plane of the canvas... The title of my painting is reasonable in the same way as the image itself. It has been scientifically established that the acoustics of Idealism give off the Human Sounds of Snoring, whereas Reality always says 'Ouch!'. Clearly then, when the realism has San Pao as its locale, a proper regard for the protocol of alliteration changes is to 'Owh!'"[3]

Stuart Davis, *Percolator*, 1927
Oil on canvas
The Metropolitan Museum of Art,
New York. Arthur H. Hearn Fund, 1956

[1] Unpublished statement by Stuart Davis. Archives of Earl Davis.
[2] L. Kachur, "Stuart Davis's Word-Pictures," in *Stuart Davis: American Painter*, The Metropolitan Museum of Art, New York 1991, p. 105. Reprinted in this catalogue: see p. 37 above.
[3] D. Kelder, *Stuart Davis: A Documentary Monograph in Modern Art*, Praeger Publishers, New York, Washington and London 1971, p. 105.

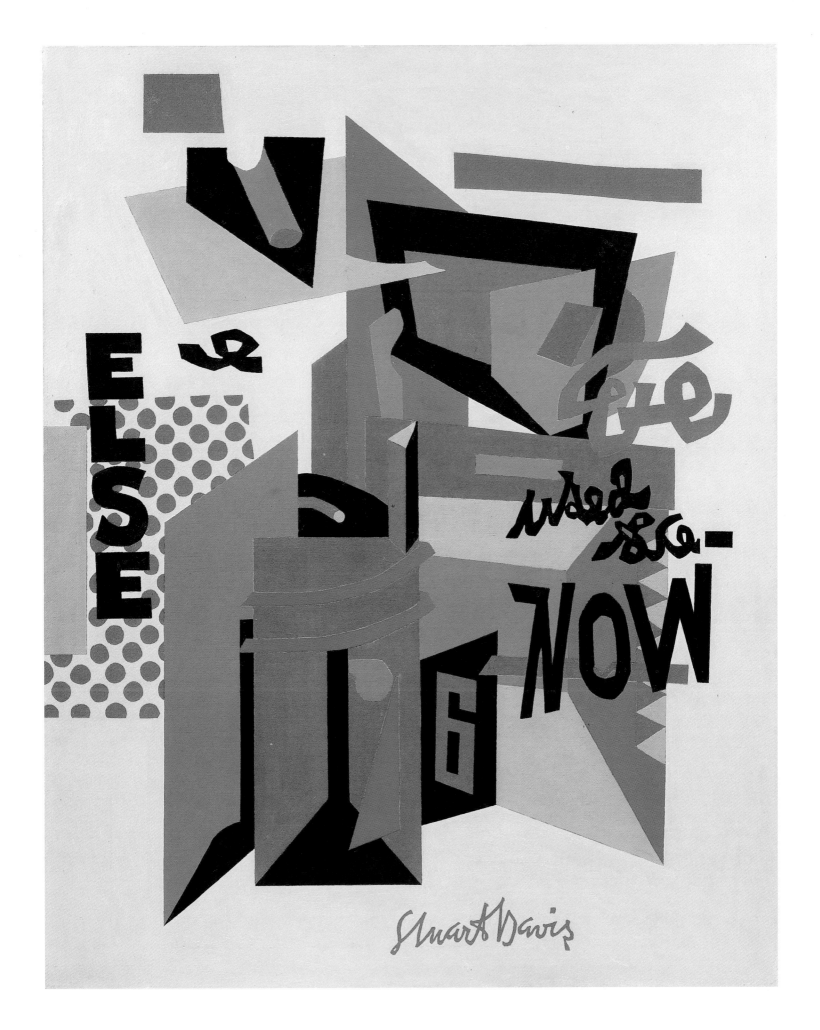

45. Rapt at Rappaport's

1952
oil on canvas
52 × 40 in. (132.1 × 101.6 cm.)
Hirshhorn Museum and Sculpture Garden,
Smithsonian Institution, Washington, D.C.
Gift of Joseph H. Hirshhorn Foundation,
1966

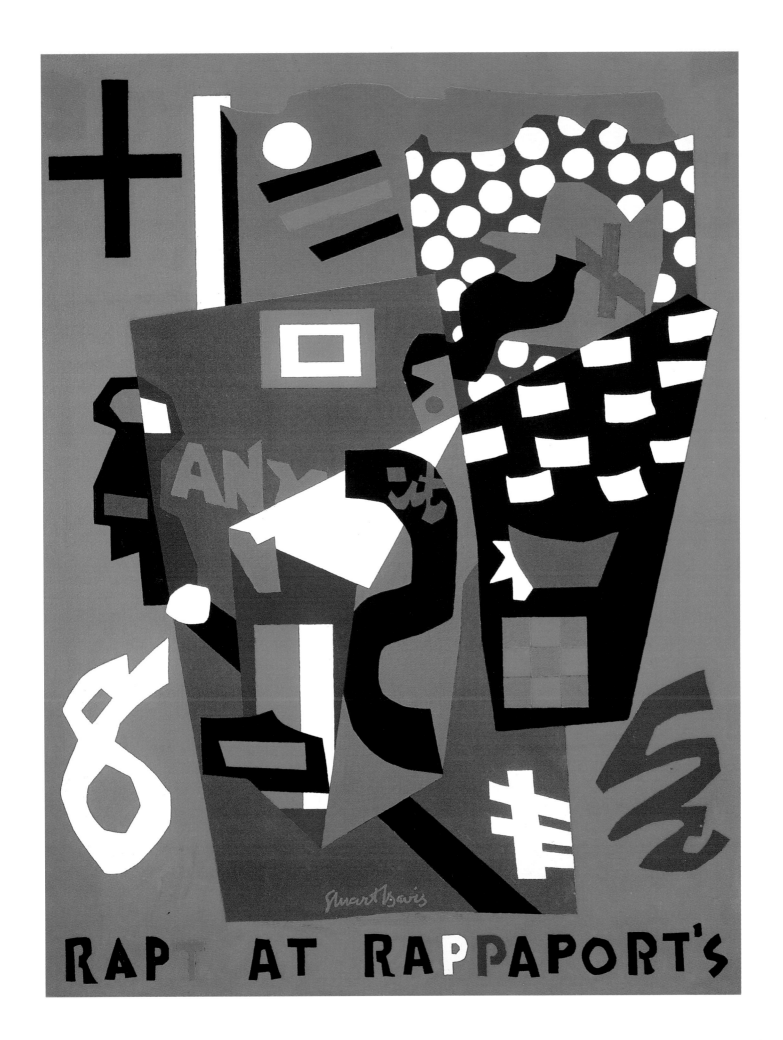

46. **Semé**

1953
Oil on canvas
52 × 40 in. (132.1 × 101.6 cm.)
The Metropolitan Museum of Art, New York.
George A. Hearn Fund, 1953

Venice only

In the 1950s Davis occasionally made pairs of paintings in which he explored opposing or, in the case of *Rapt at Rappaport's* and *Semé*, very similar resolutions of color-space problems. Their common source is a *Landscape* of 1922.

In 1953, Davis recounted that during the process of painting *Rapt at Rappaport's* "remembered shapes and colors, having nothing to do with the original point of departure, influenced what I put down, and even associations from sounds and imagined movements... contributed in the day-to-day change of the canvas."[1] He also explained that he had isolated areas of the canvas with a tape, in order to work on them separately for a time, so that rather than being preconceived, the composition proceeded from a series of decisions about individual units of color and shape whose larger functions and relationships were established as the work progressed.

The bold placement of the title accords it an unprecedented prominence in the visual field. A viewer unfamiliar with the English language or with the existence of the New York toystore, Rappaport's, would certainly recognize that Davis consciously integrated it into the composition, but might miss its humor. Whether or not Davis was playing on the sound similarities of the words "wrapped" and "rapt" (transported or engrossed), as has been suggested, the title generally reflects his breezy conversational style and frequent indulgence in witty, jazz-inspired alliteration.

Davis defined the French title *Semé* as "strewn—lots of things" or "scattered,"[2] thereby providing an apposite characterization of the seemingly random arrangement of brightly colored shapes that also applies to *Rapt at Rappaport's*. In describing how he had come to paint the two pictures Davis compared his procedures with those of a musician who takes a given melody and makes a variation. While virtually the same palette is employed in both compositions, the greater use of black in *Rapt at Rappaport's* results in a sense of gravity and spatial complexity that is not evident in *Semé*.

"The status of these two canvases as a 'color pair' ... is underscored by the inclusion in the upper left corners of a plus sign and a minus sign, respectively. With these symbols Davis signals a binary opposition, like posi-

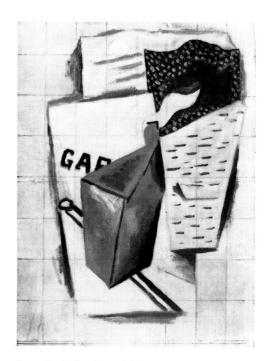

Stuart Davis, *Landscape,* 1922
Oil on artist board
Collection Earl Davis. Courtesy
of Salander-O'Reilly Galleries,
New York

tive and negative electrical charges, even though the dominant background color in both pictures is green (albeit different shades)."[3]

[1] D. Gees Seckler, "Stuart Davis Paints a Picture," in *Art News,* 52, 4, Summer 1953, p. 31.
[2] L.S. Sims, *Stuart Davis: American Painter,* The Metropolitan Museum of Art, New York 1991, p. 280.
[3] L. Kachur, "Stuart Davis's Word-Pictures," in L.S. Sims, *Stuart Davis: American Painter,* The Metropolitan Museum of Art, New York 1991, p. 105. Reprinted in this catalogue: see p. 37 above.

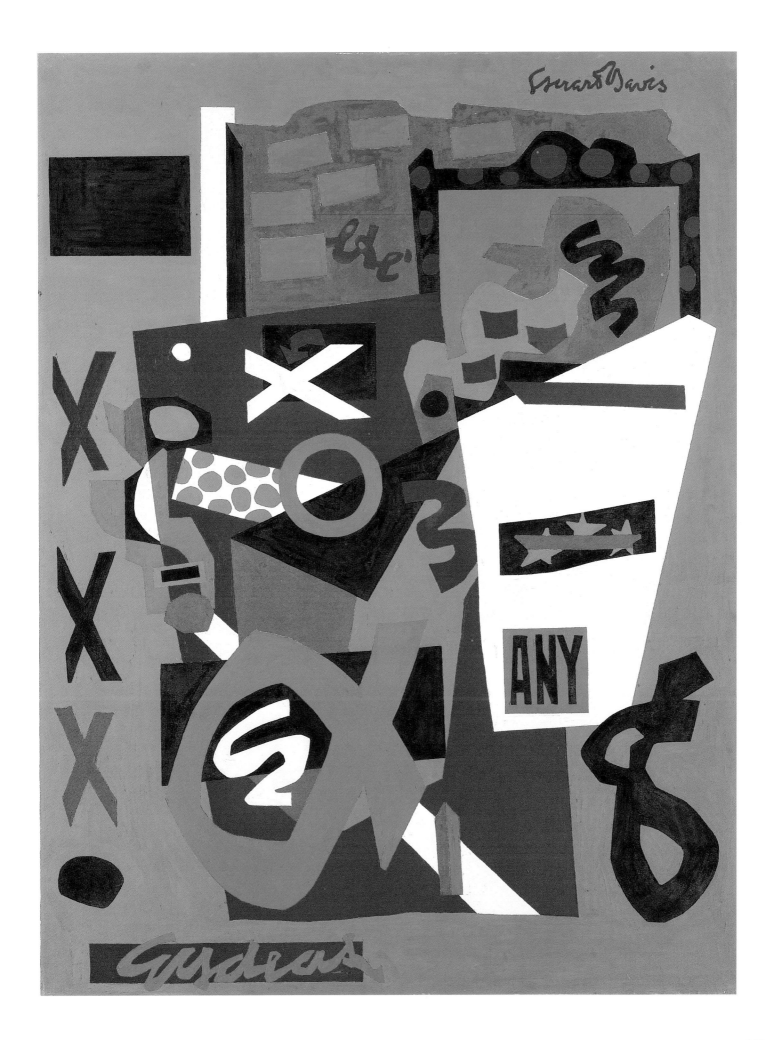

47. Something on the 8 Ball

1953–54
Oil on canvas
56 × 45 in. (142.2 × 114.3 cm.)
Philadelphia Museum of Art,
Philadelphia, Pennsylvania. Purchased
with the Adele Haas Turner and
Beatrice Pastorius Turner Memorial Fund

Davis's dialogue with his past work continues in *Something on the 8 Ball*, which is based on *Matches*. Here, the transformation of the original composition is more dramatic than in *Owh! in San Pao.* The dynamic yellow ground is permitted to penetrate the once discrete color planes and the generous distribution of colored shapes, numbers, letters and calligraphy create a more open and allover composition.

Again, words function not only as elements of design, but as references to the ideas and procedures that informed its creation. In addition to the familiar "any" and X, the word "Facilities" and the numbers 1928 appear on the right side of the canvas. While the numbers may be a mistaken recollection of the date of *Matches,* the word, written out as Facil-ities is a pun (facile, it is) that is open to interpretation. On one level it might be a comment on the process of self-appropriation that the painting embodies. On another, it could imply the artist's freedom to choose any subject matter, or "any IT, as he wrote in his notebooks and across the upper left part of the painting itself."[1]

The title conflates two well-known but contradictory American expressions, "Something on the ball" (positive) and "Behind the eight ball" (negative). Davis provided an explanation of its paradoxical character: "I select words or phrases in much the same way I apply them to a painting for purposes of identification when they seem appropriate in sound, not for any descriptive reason. *Something on the 8 Ball* is a switch on the usual phrase 'behind the eight ball.' I used it without knowledge of hearing it before in conversation with some jazz musicians and it got a laugh, causing me to remember it. Strangely enough, three days later a man I had not seen for twenty-five years phoned me long distance for advice on where to send a protege of his to study art in New York. In describing the unusual talents of this boy he ended by saying, 'I really think he's got something on the eight ball.' I decided then and there that I had a good usable title for the picture I was working on."[2]

[1] L. Kachur, "Stuart Davis's Word-Pictures," in L.S. Sims, *Stuart Davis: American Painter,* The Metropolitan Museum of Art, New York 1991, p. 106. Reprinted in this catalogue: see p. 38 above.
[2] D. Kelder (ed.), *Stuart Davis: A Documentary Monograph in Modern Art,* Praeger Publishers, New York, Washington and London 1971, p. 104.

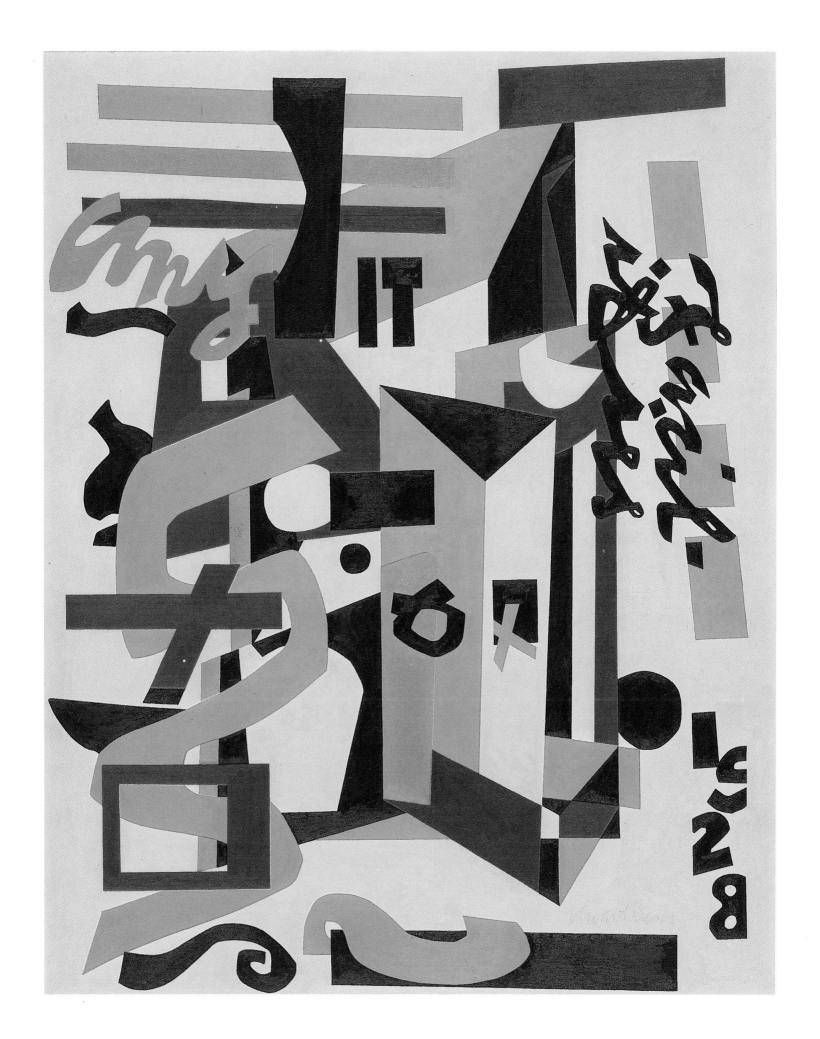

48. **Study for "Colonial Cubism"**

1954
Oil on canvas
12 x 15⅞ in. (30.5 x 40.3 cm.)
Collection Earl Davis.
Courtesy of Salander-O'Reilly Galleries,
New York

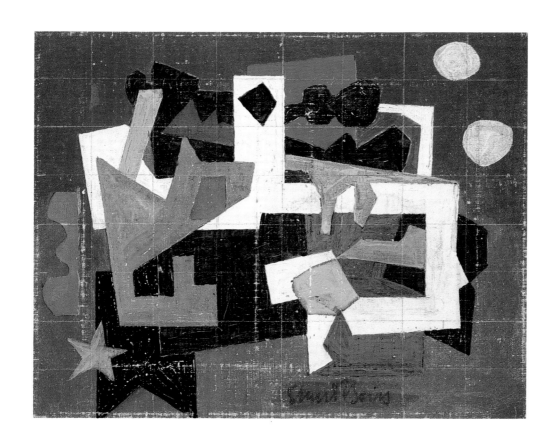

49. Colonial Cubism

1954
Oil on canvas
44⅞ × 60⅛ in. (114.3 × 152.7 cm.)
Collection Walker Art Center,
Minneapolis, Minnesota. Gift
of the T.B. Walker Foundation, 1955

In 1953 Davis wrote "I am strictly a European [French, that is] man myself although forced by birth and circumstance to live in the American Art Desert as exile."[1] This statement would appear to reflect the growing estrangement he experienced as the New York critical establishment increasingly defined the stylistic "breakthrough" of Abstract Expressionism against Cubism.

Davis boldly reasserted both his American identity and his artistic roots in *Colonial Cubism*, which recasts, in vivid color and pristine shapes, the formal relationships first examined in a 1922 landscape painting, *Abstraction.* Although the process of abstracting the actual topography, that was initiated in the earlier painting, is intensified, the interlocking planes of blue, orange, white, and black still suggest the experience of sea, sun, and other natural forms.

By eliminating calligraphic embellishment and centralizing the planar structure Davis achieved a signal harmony, simplicity, and monumentality in this painting. These new priorities may be reflected in the calculated placement of the artist's signature. Indeed, from the mid-1940s there had been a tendency to incorporate it, making it function as an element of the total design. As Davis explained it: "Manufacturers put their name on your refrigerator and ... automobiles. They're proud of it. So I thought if it's going to be there, it ought to be a decent-looking thing. In the context of a total composition you plan a place for it and regard it as an object."[2]

A few years after finishing *Colonial Cubism* Davis characterized his personal variation on this style as "uniquely American, in that it accepts the blatant tones of American life, and tunes it to the historical elegances of Art."[3]

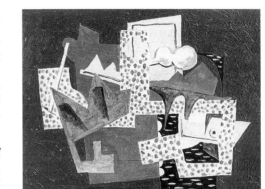

Stuart Davis, *Abstraction*, 1922
Oil on canvas
Collection John F. Lott, Lubbock, Texas

[1] Letter of August 11, 1953 to Edith Halpert, quoted in J.R. Lane, *Stuart Davis: Art and Art Theory,* The Brooklyn Museum, New York 1978, p. 76.
[2] B. O'Doherty, *American Masters: The Voice and the Myth,* E.P. Dutton, Inc., New York 1982, p. 82.
[3] J.R. Lane, *op. cit.,* p. 76.

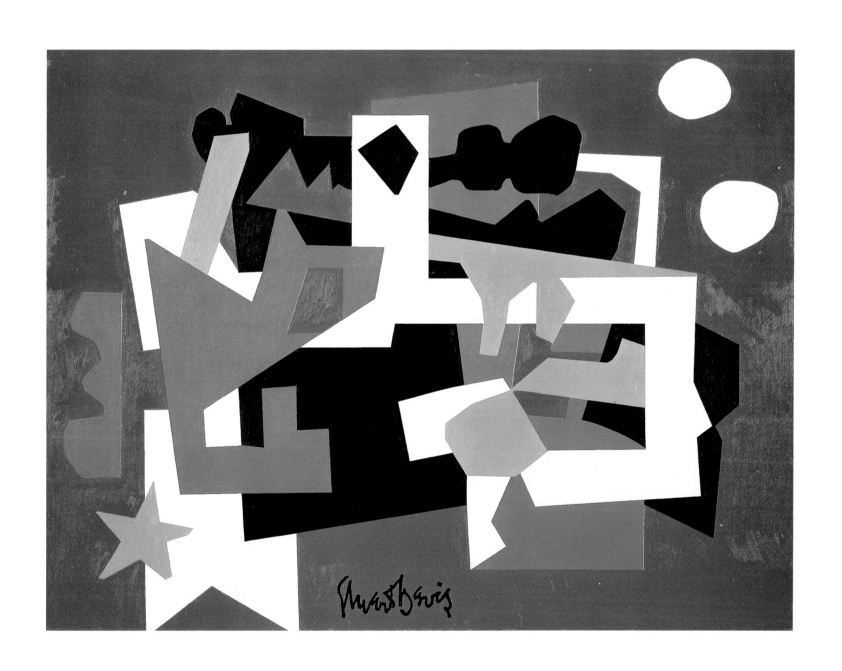

50. Midi

1954
Oil on canvas
28 × 36¼ in. (71.1 × 92.1 cm.)
Wadsworth Atheneum, Hartford,
Connecticut. The Henry Schnakenberg Fund

This painting is based on *Composition No. 5*, c. 1932–34, one of a series of black and white gouaches in which pure drawing was treated as an independent painting. Whereas the ship smokestacks, factory, and less distinguishable elements of this dockside view of Gloucester had been conveyed by a thick, fluid line, the introduction of strong color in *Midi* serves to disengage them from one another and sets up an animated dialogue with the background of hot, pulsating pinks.

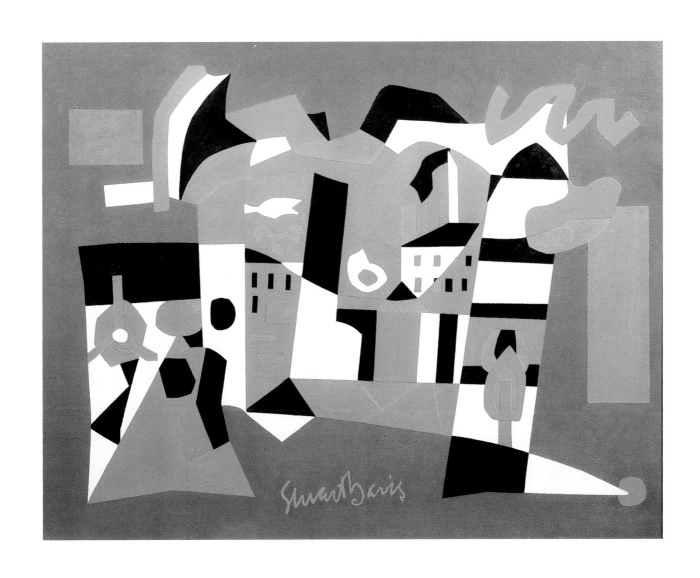

51. Ready-to-Wear

1955
Oil on canvas
56¼ × 42 in. (142.8 × 106.6 cm.)
The Art Institute of Chicago, Chicago, Illinois.
Gift of Mr. and Mrs. Sigmund Kunstadter
and Goodman Fund, 1956

Washington, D.C. only

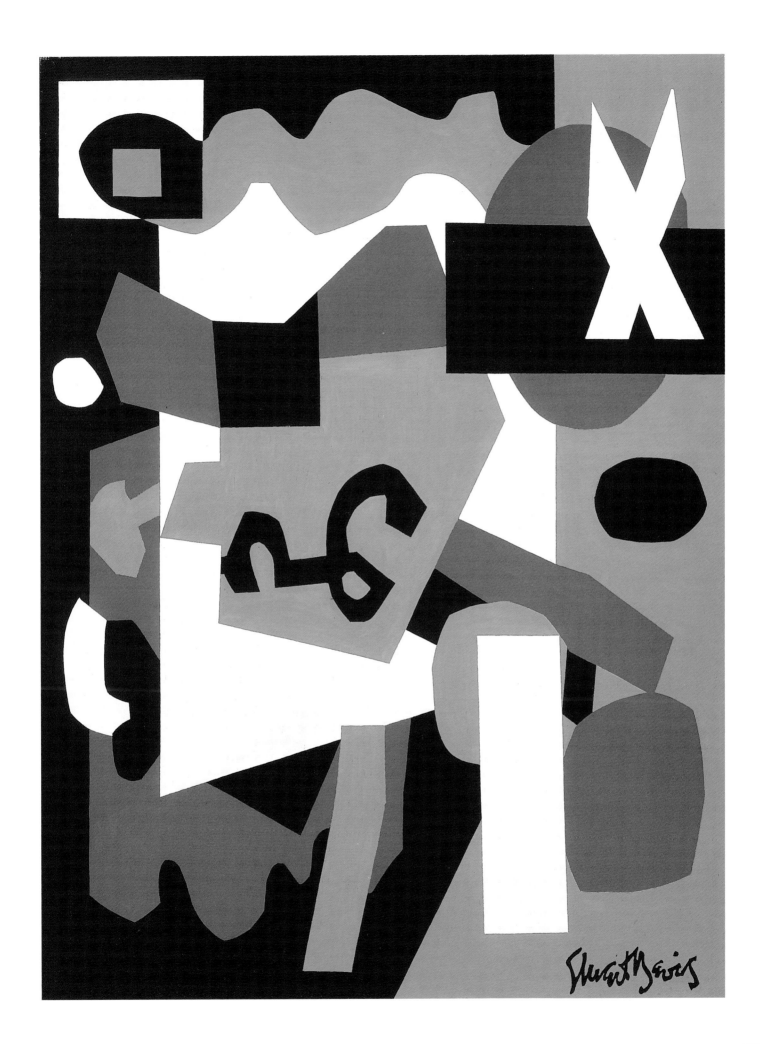

52. Cliché

1955
Oil on canvas
56 ¼ × 42 in. (142.8 × 106.6 cm.)
The Solomon R. Guggenheim Museum,
New York

Ready-to-Wear and *Cliché* explore different aspects of the artist's color-space theory, demonstrating how a common configuration could serve different pictorial objectives.

In *Ready-to-Wear* Davis adopted the red, white, blue and black color scheme that he employed in *Allée*, a mural for Drake University, executed the same year. The meticulous application of paint gives these discretely colored shapes a hard-edged, cut-out quality reminiscent of *Colonial Cubism,* and its planar organization is, in fact, more coherent and more decorative in intention.

In *Cliché* the contours of shapes that had formerly been defined by contrasting color are now identified as black outlines on a unified background of pulsating orange. Despite the relative economy of means, spatial nuance is still conveyed through variations in the character of these lines. In addition Davis subverts conventional assumptions about the painting's figure/ground relationship by arbitrarily interrupting the continuity of the lines. *Cliché* reminds us of the special role drawing played in Davis's creative process that is reflected in the contemporaneous observation "a painting is only a drawing, after all."[1] Although Davis continued to produce a considerable number of black and white canvases during the last decade of his life, this animated dialogue of line and intense color was unique. Again, the title plays ironically on the various English and French meanings of cliché, that is, a trite expression or practice as well as a mechanical reproduction.

[1] Downtown Gallery Papers, Reel 29/419, December 26, 1955, Archives of American Art, Smithsonian Institution, Washington, D.C.

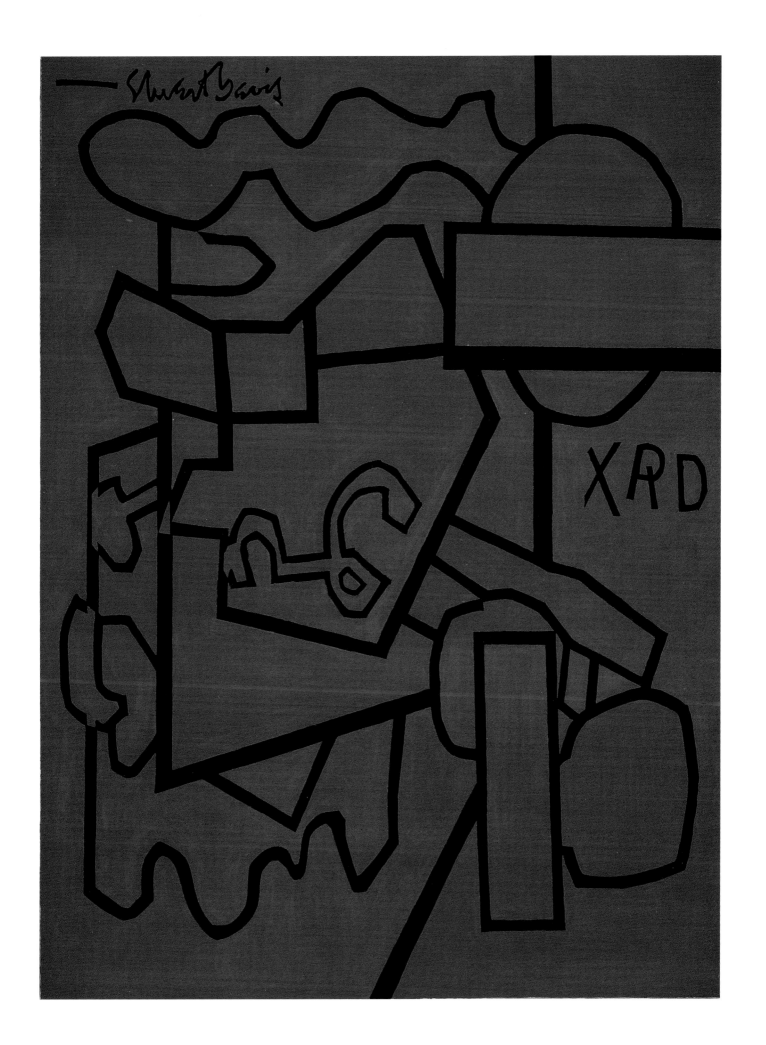

177

53. **Memo**

1956
Oil on linen
36 × 28¼ in. (91.4 × 71.7 cm.)
National Museum of American Art,
Smithsonian Institution, Washington, D.C.
Gift of the Sara Roby Foundation

Venice, Rome, Washington, D.C. only

The source of this painting, and of the three canvases, gouache, and lithograph that preceded it, was a 1932 sketchbook drawing which was accompanied by the notation "Directional analogy to natural subject of wharf and boats... the result of proportional space expansion and contradiction... Visualization in simple shape terms disregarding more detail incident than is the habit... with the idea of getting a simultaneous view instead of a sequential one."[1]

Davis first utilized this fertile configuration in a black and white painting *Landscape*, 1932–35. He then applied it to *Shapes of Landscape Space*, 1939, where he modified the linear character and introduced broad planes of color. In *Tournos*, 1954, the motif was further abstracted and the interaction of the planes heightened by more vivid color. In *Memo*, its final metamorphosis, Davis obliterated all traces of the original nautical elements and effected a dramatic contrast between the white lines and black background in the upper part of the canvas and the planes of pulsating color below. As was so often the case in the 1950s, he also included specific references to his art theory X: his shorthand for "external relations," which included perspective, color, size and position of shapes, 8 as the symbol of infinity, and "any" which alluded to his belief that any subject matter was appropriate since it was neutralized by art.

[1] Sketchbook, September 12, 1932. Collection Earl Davis.

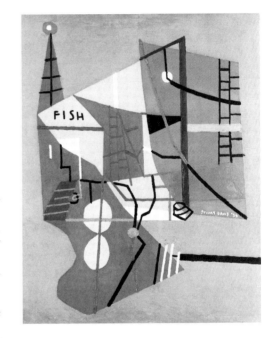

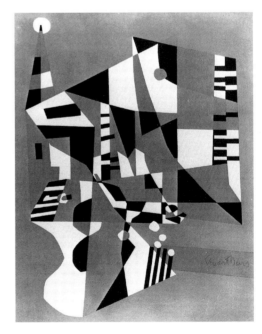

Stuart Davis, *Shapes of Landscape Space*,
1939
Oil on canvas
Collection Neuberger Museum
of Art, Purchase College,
State University of New York.
Gift of Roy R. Neuberger

Stuart Davis, *Tournos*, 1954
Oil on canvas
Munson Williams-Proctor Institute
Museum of Art, Utica, New York

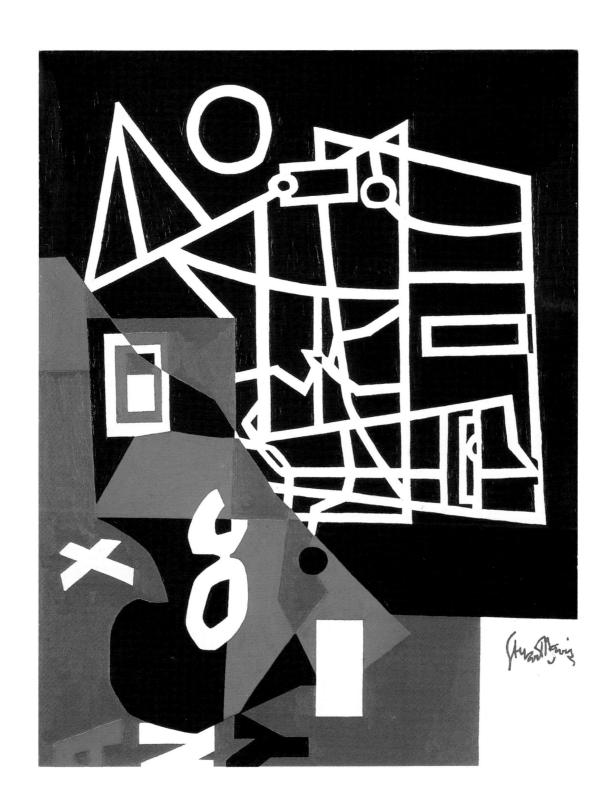

54. Composition Concrete
(Study for Mural)

1957
Oil on canvas
42¾ × 20⅛ in. (108.6 × 51 cm.)
The Cleveland Museum of Art,
Cleveland, Ohio. Contemporary Collection

This canvas is a study for the seventeen by eight foot mural Davis produced for the lobby of the Research Center of the H.J. Heinz Company in Pittsburgh, designed by Gordon Bunshaft and Eero Saarinen. Davis used a palette of red, white, black, and blue to convey the geometric integrity of his forms. Yet despite the general austerity of the abstract design, its source in landscape paintings of the early 1920s is established by the Y shape in the upper part of the composition which appeared as a tree in *Garden Scene,* 1921.

The title of the work reflects the artist's interest in the contemporaneous phenomena of concrete poetry and music. Davis was intrigued by the music of Edgard Varèse which utilized recorded sounds to create a new compositional fabric of "sound objects." "The picture as a thing in itself, an old notion that goes back to the Cubist *tableau-objet* is here given renewed life as an analogue to parallel developments in experimental music and literature."[1]

[1] L. Kachur, "The Language of Stuart Davis: Writing and Drawing," in K. Wilkin and L. Kachur, *The Drawings of Stuart Davis,* The American Federation of the Arts and Harry N. Abrams, Inc., Publishers, New York 1993, p.40.

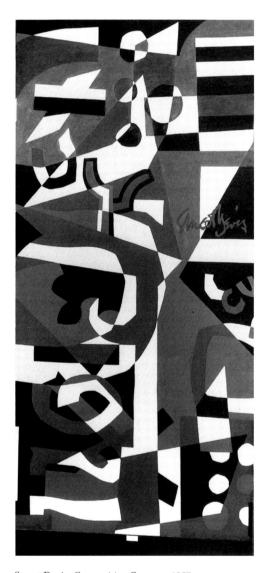

Stuart Davis, *Composition Concrete*, 1957
Oil on canvas
Carnegie Museum of Art, Pittsburgh.
Gift of the H.J. Heinz Company

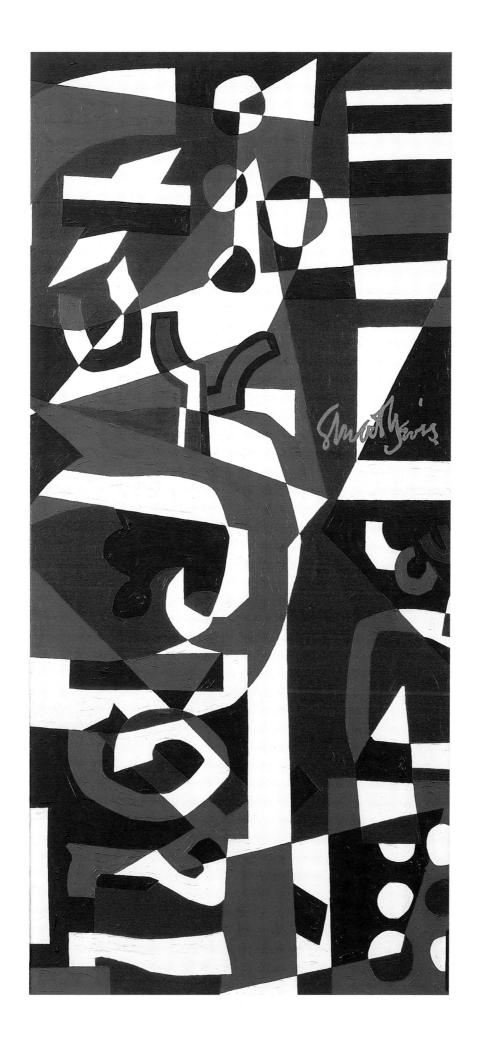

55. **Premiere**

1957
Oil on canvas
58 × 50 in. (147.3 × 127 cm.)
Los Angeles County Museum of Art,
Los Angeles, California. Museum Purchase,
Art Council Fund

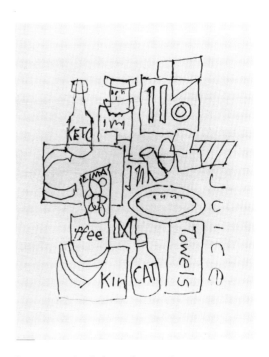

Stuart Davis, Study for *Package Deal*, 1956
Ink on paper
Collection Earl Davis.
Courtesy of Salander-O'Reilly Galleries,
New York

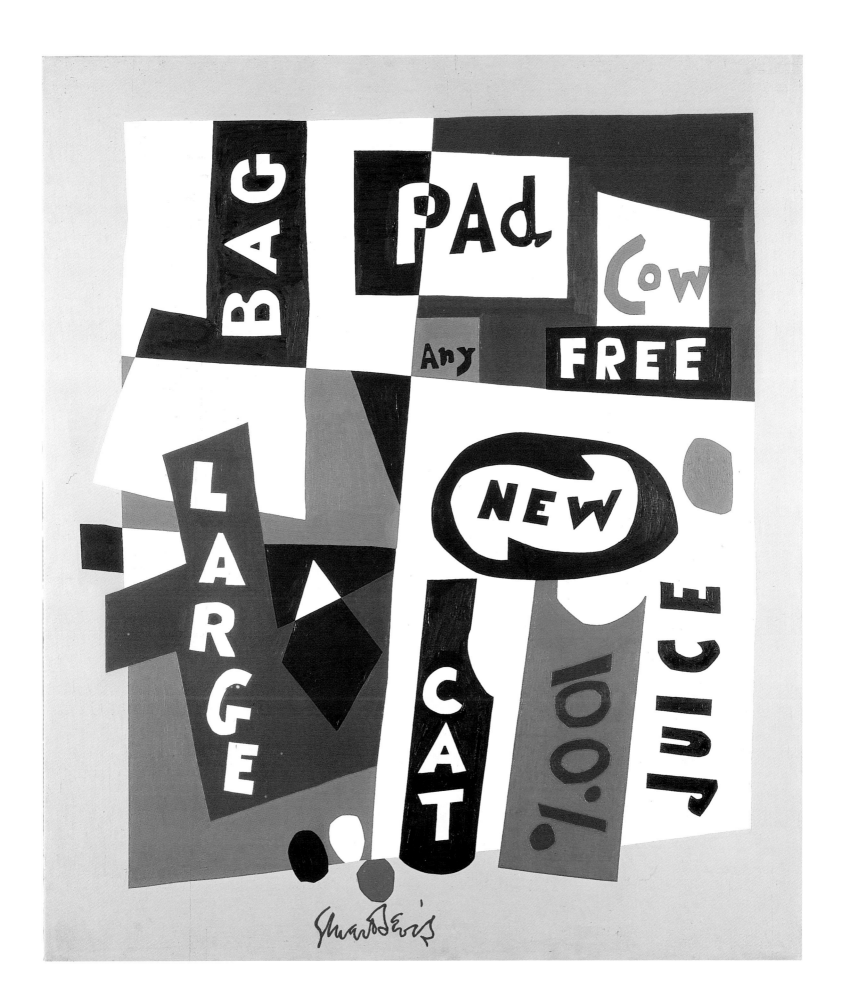

56. Int'l Surface No. 1

1960
Oil on canvas
57⅛ × 45⅛ in. (145.1 × 114.6 cm.)
National Museum of American Art,
Smithsonian Institution, Washington, D.C.
Gift of S.C. Johnson & Son, Inc.

Premiere is one of a series of works that had their origin in a commission from *Fortune* magazine. In 1956, Davis and six other artists were asked to create still life paintings from consumer products found in supermarkets. Davis purchased items from a local store, placed them on the floor of his studio, and worked on drawings until he found something "that... was paintable."[1] Some twenty-nine drawings reveal how the actual objects gradually became abstract shapes. Instead of focusing on logotypes as he had in the 1920s, he provided these shapes with words such as "cow" or "juice" that either imply their original identity or humorously suggest the promotional strategies used to sell them, for example, "New," "Large," "Free," and "100%."

After executing three small studies for the gouache that was ultimately reproduced in the magazine, Davis decided to make a larger version in oil. He explained that he undertook *Premiere* because he felt he could do more with the composition, and was interested in the intervals of color positions, particularly of Cadmium yellow. "I used this novel idea... of changing the position of the yellow from Lemon Cadmium to Medium Cadmium... well that sounds like an immaterial thing, but it was exciting and I've used it ever since."[2]

The initial impression of this new composition is one of simplicity and clarity; only gradually does the viewer perceive the complexity of its organization and realize that its apparent two-dimensionality is occasionally contradicted by the overlapping of shapes and "the negative/positive effects of the lettering."[3]

Words play an especially important role in determining the viewer's reaction to *Premiere*. While they existed as long-established abstract elements of pictorial design, the artist maintained that he had chosen them "with a certain wit."[4] However, without knowledge of the particular history of this painting, or of Davis's enthusiasm for jazz, the dual associations of such words as bag, pad, juice, and cat would be obscure.

In *Int'l Surface No. 1*, Davis reworked the composition of *Premiere*, eliminating yellow and blue from its palette, reducing the number of words and shapes, and introducing the French word "Celle" to provide it with an "international" character.

[1] J. Elliot, "Premiere," in *Los Angeles County Museum of Art Bulletin,* 14, 3, 1962, p. 9.
[2] *Ibid.,* p. 11.
[3] *Ibid.,* p. 12.
[4] *Ibid.,* p. 13.

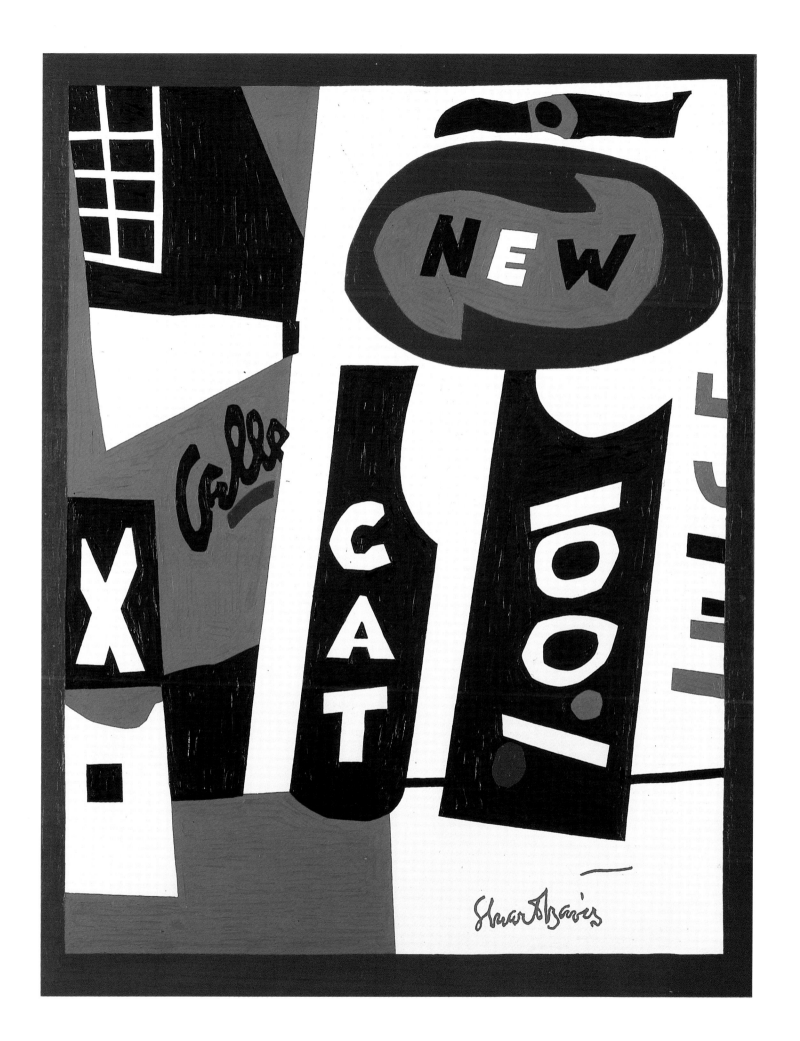

57. **Pochade**

1958
Oil on canvas
52 × 59⅞ in. (130 × 152 cm.)
Fundación Colección Thyssen-Bornemisza,
Madrid

Venice and Washington, D.C. only

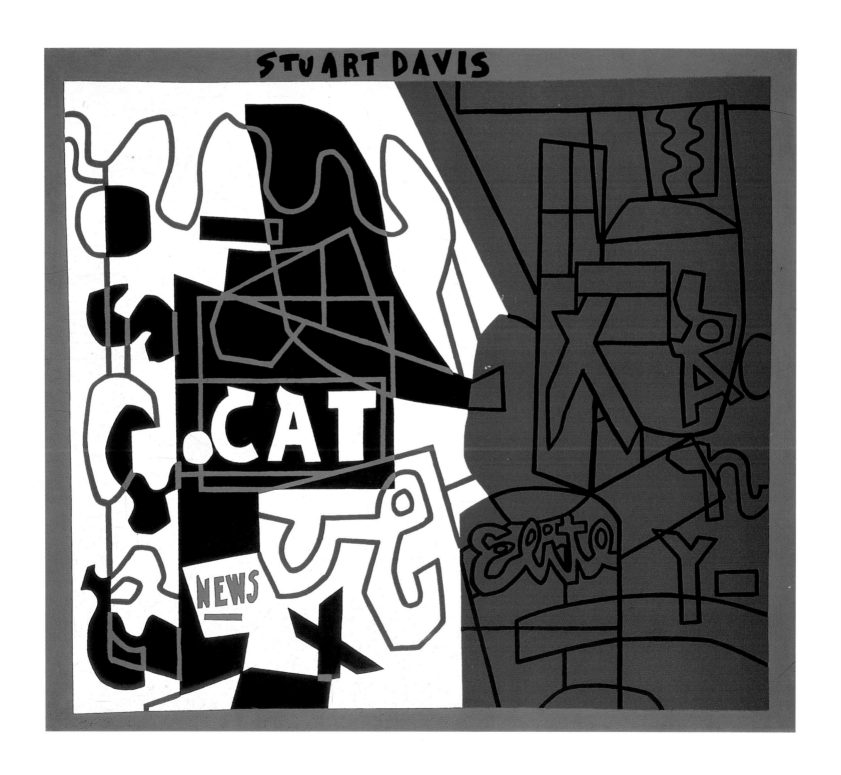

58. Untitled (Black and White Variation on "Pochade")

1958-61
aqueous medium, possibly casein,
on canvas
45 × 56 in. (114.3 × 142.2 cm.)
Collection Earl Davis.
Courtesy of Salander-O'Reilly Galleries,
New York

In *Pochade,* Davis utilized a bifurcated composition in order to consider figure/ground relations in the light of what he called "color-position." However, by dividing it into uneven areas of strong color, he imbued it with a distinctly confrontational character. One has no difficulty perceiving the explicitly two-dimensional nature of the right side of the painting where words and symbols appear as black outlines on the unifying red ground, but the spatial identity of its left side is rendered ambiguous by the interaction of black shapes and colored lines that challange the continuity of the white ground.

Utilizing the lower center and lower right quadrant of *Pochade* as his motif, Davis subsequently painted two identically-sized variations in black and white. In each, he varied the thickness and altered the character of the lines to suggest the ways in which drawing can convey movement and mood, independent of color.

Once again, Davis's sense of irony is reflected in the title. In French *pochade* means rough sketch, whereas this painting was actually preceded by numerous studies.

188

59. **Study for The Paris Bit**

1958–61
Oil on canvas
28 × 36 in. (71.1 × 91.4 cm.)
Curtis Galleries, Minneapolis, Minnesota

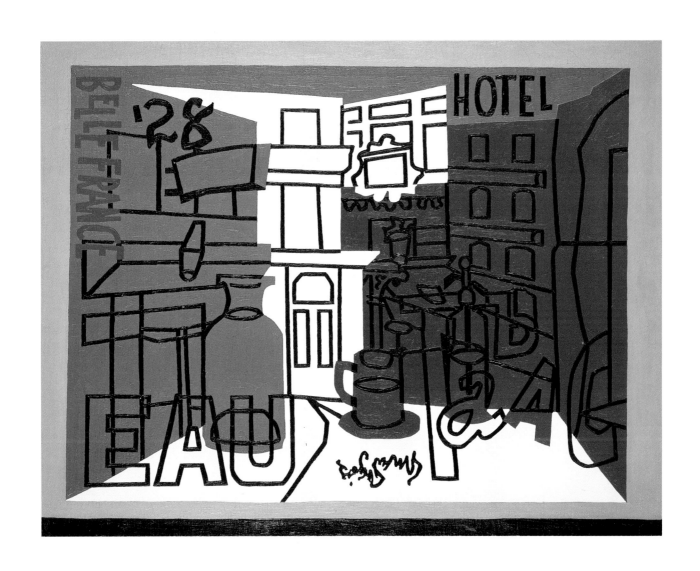

191

60. The Paris Bit

1959
Oil on canvas
46 × 60 in. (116.8 × 152.4 cm.)
Collection of Whitney Museum of American
Art, New York. Purchase, with funds
from the Friends of the Whitney Museum
of American Art

Venice only

An examination of Davis's paintings from the 1920s on reveals that he periodically alternated simple and complex pictorial construction, but nowhere is this practice so dramatically evidenced as in these two canvases based on *Rue Lipp*. Whereas the green, red, and orange of *Study for The Paris Bit* present a clear and planar structure that reveals the essential features of the original composition, the flag-inspired colors of *The Paris Bit* are accompanied by an overlay of calligraphy that significantly obscures it.

While many of the original French words and phrases of *Rue Lipp* are retained in *The Paris Bit*, the presence of English words introduces an element of linguistic and temporal displacement that is also reflected in its pictorial organization. The TABAC sign is now fractured and reappears as an element of the infrastructure on the lower right; the word EAU dominates the original water carafe and the building façade that was adjacent to it, but the new word "Eraser" adds a note of ambiguity. BELLE FRANCE, repositioned vertically on the upper left, and '28 remind us of the place and year in which the original picture was painted. However, PAD inevitably evokes New York, and the place where

he was most at home, namely, his studio. Other words, the ubiquitous "any" and X allude to art theory or reaffirm the practice of recycling motifs. At the top of the canvas, the phrase LINES THICKEN would seem to refer to their structural function in the composition.

If *The Paris Bit* is the most formally complex of Davis's late works, it is also uniquely poignant. His old friend and Paris companion Robert Carlton Brown died four days before the artist began the canvas. "Instead of including Brown's name, as he had at the right side of *Rue Lipp*, Davis created a concrete mixture of word and image, in the spirit of Brown's experimental 'image poems.' The exuberance of the word play is dampened by the rather somber tones of the saturated hues, with the black casting a funereal note."[1]

By writing his signature in reverse at the bottom of the canvas, Davis may be signalling the emotional "upset" provoked by the news of his friend's death.

[1] Lewis Kachur, catalogue entry 162, in L.S. Sims, *Stuart Davis: American Painter*, The Metropolitan Museum of Art, New York 1991, p. 300.

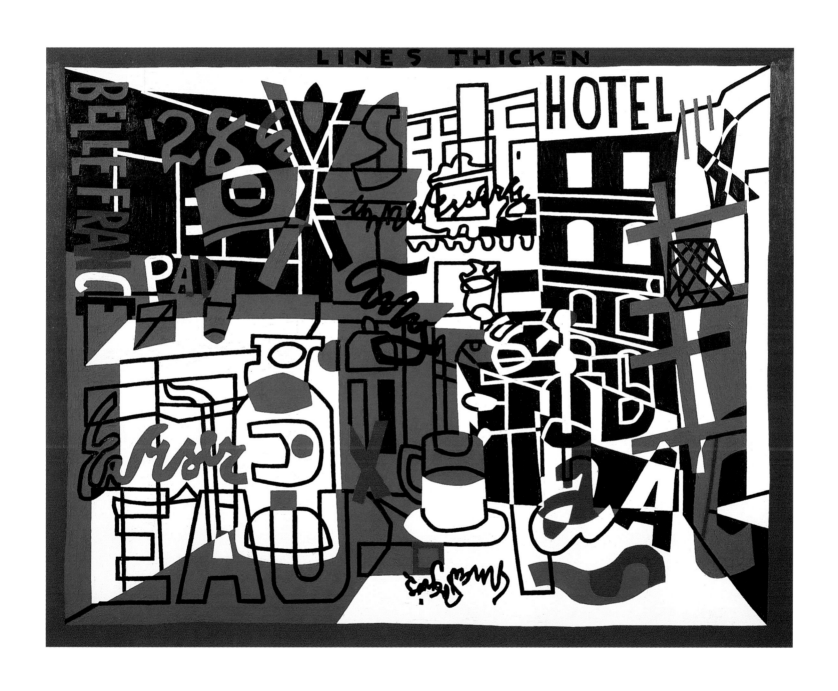

61. Unfinished Business

1962
Oil on canvas
36 × 45 in. (91.4 × 114.3 cm.)
Museum of Fine Arts, Boston, Massachusetts.
The William H. Lane Collection

Increasingly in the 1960s, Davis used a palette limited to four or five colors, favoring red, yellow, green, and black. *Unfinished Business* takes the central panel of the 1955 mural *Alleé* as its point of departure, adding a few new shapes, the word PAD, and familiar references to his art theory. The initial impression of the essentially flat character and vertical alignment of the central checkerboard configuration is contradicted by the triangular wedges of color that create rapid optical shifts and introduce a destabilizing diagonal movement.

It has been observed that the title of this work suggests a dissatisfaction or urgency that may have been prompted by a realization that he had not yet achieved his artistic goals.[1] However, since both this painting and its immediate source derived from an ink drawing in a 1932 sketchbook, Davis might be alerting us to the fact that he had not exhausted the motif's creative potential and would return to it in the future.

When the work was shown in a solo exhibition at the Downtown Gallery, Donald Judd, then a young sculptor exploring a vocabulary of pure geometric forms, wrote an enthusiastic review acknowledging the subtlety and complexity of Davis's art and praising him for his aesthetic steadfastness: "The 'amazing continuity' of Davis's work does not seem to have been kept with blinders... Neither has Davis been startled into compromises with newer developments. Some older artists abandoned developed styles for one of the various ideas included under 'Abstract Expressionism,' spoiling both... Instead of compromising, he kept all that he had learned and invented, and taking the new power into consideration, benefited."[2]

[1] L.S. Sims, *Stuart Davis, American Painter,* The Metropolitan Museum of Art, New York 1991, p. 310.
[2] D. Judd, "In the Galleries; Stuart Davis," in *Arts Magazine,* 36, 10, September 1962, p. 44.

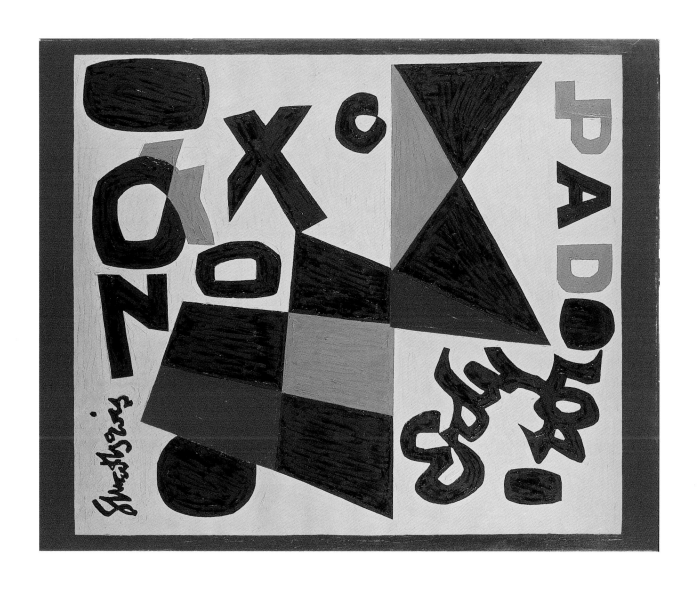

195

62. Punch Card Flutter No. 3

1963
Oil on canvas
24 × 33 in. (61 × 83.8 cm.)
Collection Earl Davis.
Courtesy of Salander-O'Reilly Galleries,
New York

Between 1961 and 1963, Davis produced a series of small oils and related gouaches and drawings—some twenty-five works—that highlight the importance of reworking an initial theme through extended variation. Rather than turning to his own art for inspiration, he found it in a newspaper image. Like the other compositions, *Punch Card Flutter No. 3* is based on a photograph view of the medieval town of Carcassone, France, that the artist clipped from the *New York Times.*

Davis takes the essential physical information of the photograph—a large tree and beyond it the walls of the town with a turret on the left and arches to the right—and transforms it into a jigsaw-like pattern of irregular red, yellow, black, and green shapes set against a luminous white ground. Extending from the thick green border at the top to the thin one below, the black tree trunk serves as a compositional anchor that divides the visual field into two not quite equal parts. While bi-partite compositions were hardly a novelty for Davis, their recurrence in the last decade of his life reflects his desire to make the process of painting its effective subject. "By dividing a painting in half, Davis created, in a sense, two separate paintings, each of which becomes removed from the overall design and from the known and familiar image of the subject. This was one method Davis used to make a painting more abstract and to focus the spectator's attention on the process of art making as the content of the work. "[1]

Davis once again made his signature—inverted and barely legible—an integral part of the painting. However, notes from 1961 make it clear that he now regarded it as having both a psychological and symbolic function. According to William Agee, "the signature represented the act of completing a process, a painting, and, ultimately, with it a lifetime of making art. "[2]

When Davis died in June 1964, Brian O'Doherty prasied him as "one of the limited company of major painters America has produced... he was never out of date. Whatever happened in the world of art already seemed to have a precedent in his painting."[3]

Documentary photograph of
A View of Carcassonne France
Clipping from the *New York Times*
Courtesy of Salander-O'Reilly Galleries,
New York

[1] W.C. Agee, "Stuart Davis in the 1960s: 'The Amazing Continuity,'" in L.S. Sims, *Stuart Davis, American Painter*, The Metropolitan Museum of Art, New York 1991, p. 92.
[2] *Ibid.*, p. 90.
[3] B. O'Doherty, "Davis's Work Was Never Out of Date – He Anticipated Movements in Art," in the *New York Times*, June 26, 1964, p. 26.

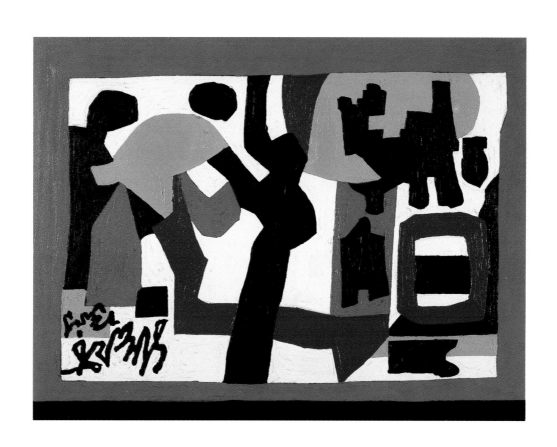

Appendices

Chronology

1892
Stuart Davis is born in Philadelphia, December 7, to Edward Wyatt Davis, art director of the *Philadelphia Press*, and Helen Stuart Foulke Davis, sculptor.

1901
The Davis family moves to East Orange, New Jersey.

1910
Davis attends Robert Henri's art school in New York. Beginning of his association with John Sloan, Glenn O. Coleman, Henry Glintenkamp. Exhibits for the first time at the "Exhibition of Independent Artists."

1913
Shows five watercolors in the Armory Show. Submits drawings to the socialist magazine *The Masses* and to *Harper's Weekly*. Passes the summer in Provincetown, Massachusetts. Sets up studio in Manhattan with Glintenkamp.

1915
Spends summers in Gloucester, Massachusetts, where he returns annually through 1934.

1916
Davis, Sloan and Coleman resign from *The Masses* after argument about editorial policy. Exhibits with "Independents."

1917
First one-man show at Sheridan Square Gallery, New York.

1918
Service in Great War as map-maker in U.S. Army Intelligence Department.

1921
Begins "Tobacco Still Life" series and a group of Cubist landscapes, and exhibits at The Whitney Studio Club, New York.

1922
Organizes the Gloucester Society of Arts and becomes chairman.

1923
Spends summer in Santa Fe, New Mexico, with brother Wyatt, and John and Dolly Sloan.

1925
First solo museum exhibition, at the Newark Museum, New Jersey.

1926
Retrospective exhibition at the Whitney Studio Club, and receives monthly stipend (for one year) from Gertrude Vanderbilt Whitney.

1927
Edith Halpert becomes his dealer, followed by the first of many shows at The Downtown Gallery, New York. Begins "Egg Beater" series.

1928
Juliana Force of the Whitney Studio Club purchases two of his paintings, enabling him to leave for Paris, where he meets Fernand Léger, Gertrude Stein, and American expatriate painters living in Montparnasse district. Late in the year, or early in 1929, marries Bessie Chosak from Brooklyn.

1929
Summer: returns to New York.

1930
Rue des Rats, No. 2 included in the inaugural U.S. Pavilion exhibition at the XVIIth Biennale of Venice, Italy.

1932
Spring: teaches at the Art Students League, New York; contributes to the mural exhibition at The Museum of Modern Art, New York; paints mural for Men's Lounge, Radio City Music Hall, New York. June: Davis's wife dies. Contributes to the "First Biennial of Contemporary American Painting" at the Whitney Museum of American Art.

1933
December: joins the Public Works of Art program set up by the Treasury Section to employ artists to make public art.

1934
Member of Artists Union and, later, Artists Congress, of which he becomes national secretary in 1936. A painting (*Place Pasdeloup*) and a watercolor included in Juliana Force's Whitney exhibition at the XIXth Venice Biennale. December: becomes Editor-in-Chief of *Art Front* (till January 1936), published by the Artists Union.

1935
August: joins the Federal Art Project, which, under the aegis of the Works Progress Administration (W.P.A.), assists needy artists.

1936
Elected executive secretary of the American Artists Congress (later becoming national chairman).

1937
Begins W.P.A. mural, *Swing Landscape*, for the Williamsburg Housing Project, Brooklyn (completed 1938, now Indiana University, Bloomington).

1938
February: marries Roselle Springer.

1939
Executes mural, *The History of Communications,* for the New York World's Fair (destroyed). Leaves the Federal Art Project.

1940
Resigns from Artists Congress. Begins teaching at the New School of Social Research (through 1950).

1941
Retrospective exhibition with Marsden Hartley at the Cincinnati Modern Art Society.

1942
Included in the exhibition "Artists for Victory" at the Metropolitan Museum of Art, New York.

1944
Wins first prize at Pepsi-Cola's "Portrait of America" exhibition.

1945
Retrospective exhibition at The Museum of Modern Art, New York, organized by James Johnson Sweeney. His autobiography is published in the monograph series of American Artists Group.

1946
His work is included in the exhibition "Advancing American Art" circulated by the United States Information Agency.

1948
Look magazine includes Davis in a list of the ten best painters in America, based on a poll of

museum directors and critics. Henceforth Davis is the recipient of prizes and awards from many museums and art organizations.

1950
Davis wins the John Barton Payne Medal and Purchase Prize of the Virginia Museum of Arts, Richmond (*Little Giant Still Life*).

1951
Visiting art instructor, Yale University. Represented in first Bienal, São Paulo, Brazil.

1952
One-man show at U.S. Pavilion, XXVIth Venice Biennale. Winner of a John Simon Guggenheim Memorial Foundation fellowship. April: birth of his son, George Earl.

1955
Executes mural, *Alleé*, for Drake University, Des Moines, Iowa.

1956
Elected a member of the National Institute of Arts and Letters. *Something on the 8 Ball* included in Katherine Kuh's exhibition "American Artists Paint the City," U.S. Pavilion, XXVIIIth Venice Biennale.

1957
Executes mural, *Composition Concrete*, for H.J. Heinz Research Center, Pittsburgh. Retrospective exhibition at the Walker Art Center, Minneapolis (traveling to Des Moines, San Francisco and New York).

1958
Winner of the Solomon R. Guggenheim Museum International Award.

1959
Represented in "American Painting and Sculpture" exhibition, Moscow.

1960
Winner of the Guggenheim International Award for the second time.

1962
Winner of the Fine Arts Gold Medal of the American Institute of Architects.

1964
June 24: dies of a stroke in New York.

Selected Bibliography

W.C. Agee, *Stuart Davis (1892-1964): The Breakthrough Years (1922-1924)*, exhibition catalogue, Salander-O'Reilly Galleries, New York 1987.

H.H. Arnason, *Stuart Davis*, exhibition catalogue, Walker Art Center, Minneapolis 1957.

R. Blesh, *Stuart Davis*, Grove Press, Inc., New York 1960.

E. Davis, "Stuart Davis: Scapes, 1910-1923," in *Stuart Davis: Scapes. An Exhibition of Landscapes, Cityscapes and Seascapes Made between 1910 and 1923,* exhibition catalogue, Salander-O'Reilly Galleries, New York 1990.

E. Davis, "Stuart Davis: A Celebration in Jazz." in Earl Davis (ed.), *The Fine Art of Jazz: A Stuart Davis Centennial Celebration*, The Jazz Foundation of America, New York 1991.

S. Davis, Autobiographical statement in *Stuart Davis*, American Artists Group, New York 1945.

E.C. Goossen, *Stuart Davis*, George Braziller, New York 1959.

B.L. Grad, "Stuart Davis and Contemporary Culture," in *Artibus et Historiae*, no. 24, 1991, pp. 165–191.

P. Hills, *Stuart Davis*, Harry N. Abrams, Inc., New York 1996.

L. Kachur, "Stuart Davis and Bob Brown: 'The Masses' to 'The Paris Bit,'" in *Arts Magazine*, no. 57, 2, October 1982, pp. 70–73.

L. Kachur, *Stuart Davis: An American in Paris*, exhibition catalogue, Whitney Museum of American Art at Philip Morris, New York 1987.

L. Kachur, "Stuart Davis: A Classicist Eclipsed," in *Art International*, no. 4, Autumn 1988, pp. 17–21.

D. Kelder (ed.), *Stuart Davis: A Documentary Monograph in Modern Art*, Praeger Publishers, New York, Washington and London 1971.

M. Kozloff, "Larry Rivers, Stuart Davis and Slang Idiom," in *Artforum*, no. 4, November 1965, pp. 20–24.

K. Kuh, *The Artist's Voice. Talks with Seventeen Artists*, Harper & Row Publishers, New York and Evanston 1960.

J.R. Lane, *Stuart Davis: Art and Art Theory*, exhibition catalogue, The Brooklyn Museum, Brooklyn, New York, 1978.

G. McCoy (ed.), "An Interview with Stuart Davis," in *Archives of American Art Journal*, 31, no. 2, 1991, pp. 4–13.

J. Myers (ed.), *Stuart Davis: Graphic Work and Related Paintings with a Catalogue Raisonné of the Prints*, essay by D. Kelder, Catalogue Raisonné by S. Cole and J. Myers, exhibition catalogue, Amon Carter Museum, Fort Worth 1986.

L.S. Sims, *Stuart Davis: American Painter,* essays by Sims, W.C. Agee, R. Hunter, L. Kachur, D. Kelder, J.R. Lane, and K. Wilkin. exhibition catalogue, The Metropolitan Museum of Art, distributed by Harry N. Abrams, Inc., New York 1991.

P. Sims, *Stuart Davis: A Concentration of Works from the Permanent Collection of the Whitney Museum of American Art*, exhibition catalogue, Whitney Museum of American Art, New York 1980.

Stuart Davis: Retrospective, 1995, essays by E. Davis and W. Roosa, chronology by P. Hills, exhibition catalogue, The Yomiuri Shimbun and the Japan Association of Art Museums, Tokyo 1995.

J.J. Sweeney, *Stuart Davis,* The Museum of Modern Art, New York 1945.

B. Urdang, *Stuart Davis: Murals*, Zabriskie Gallery, New York 1976.

B. Weber, *Stuart Davis' New York*, exhibition catalogue, Norton Gallery and School of Art, West Palm Beach, Florida, 1985.

K. Wilkin, *Stuart Davis*, Abbeville Press, New York 1987.

K. Wilkin, "Stuart Davis in His Own Time," in *The New Criterion*, no. 6, January 1988, pp. 50–55.

K. Wilkin, "Stuart Davis: The Cuban Watercolors," in *Latin American Art*, no. 2, Spring 1990, pp. 39–43.

K. Wilkin, L. Kachur. *The Drawings of Stuart Davis: The Amazing Continuity*, exhibition catalogue, The American Federation of Arts in association with Harry N. Abrams Publishers, Inc., New York 1992.

K. Wilkin, L. Potolsky, *Stuart Davis (1892-1964): Motifs and Versions*, exhibition catalogue, Salander-O'Reilly Galleries, New York 1988.

W. Wilson, *Stuart Davis's Abstract Argot*, Pomegranate Artbooks, San Francisco 1993.

B. Zabel, "Stuart Davis's Appropriation of Advertising: 'The Tobacco Series' 1921–1924," in *American Art*, no. 5, Fall 1991, pp. 57–67.

205

Photograph Credits

This volume was printed by Elemond S.p.a.
at the plant in Martellago (Venice) in 1997